MISERICORDIA

Together
We
Celebrate

Steve Schapiro

INTRODUCTION BY
Sr. Rosemary Connelly, RSM

pH powerHouse Books BROOKLYN, NY

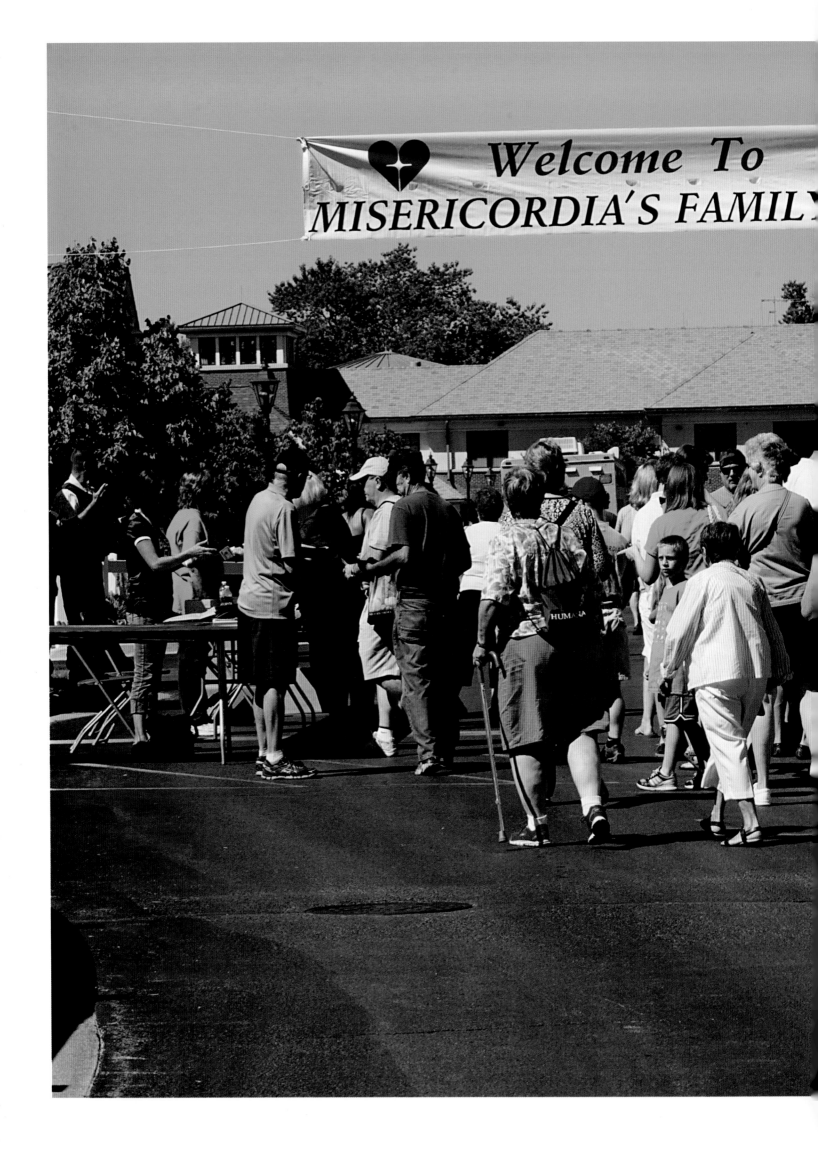

Misericordia

Misericordia

On any given day at Misericordia Heart of Mercy, more than 600 children and adults with intellectual and developmental disabilities are busy at work – traversing the 31-acre campus and the city of Chicago getting to various employment opportunities, taking continuing education classes, exercising at the on-campus health and fitness center, creating works of art in the HeART Studio Workshops, singing and dancing in performance groups, and so much more.

Its mission – *to support children and adults with intellectual and developmental disabilities who choose our community by providing the highest quality residential, training, and employment services. Misericordia provides the full continuum of care designed to meet each person's changing needs and maximize his or her independence, self-determination, interpersonal relationships, and engagement in the community within an environment that fosters each person's spirituality, dignity, respect, and quality of life* – is a call to action for 1,000 dedicated staff members, families, community networks, and tens of thousands of volunteers every year.

Misericordia – which means Heart of Mercy in Latin – has become synonymous with excellent care, and it is a model for others worldwide in providing residential options and programs so those with intellectual and developmental disabilities can live lives that are as fulfilled, meaningful, and as independent as possible.

Misericordia is unique from other providers in the field because it provides a full continuum of care and network of services for individuals from diverse racial, religious, and socioeconomic backgrounds, with disabilities ranging from mild to profound. With hundreds of families on its waiting list, Misericordia continues to grow to meet the evolving needs – and to anticipate the future needs – of its residents and the larger community.

Founded in 1921 as a maternity hospital, Misericordia has changed over the years to meet unmet needs and has learned to do three things very well – it provides exceptional programs for its residents, gives peace of mind to residents' families, and shares its mission with supporters across the country.

The Misericordia Development Office

Misericordia

Dear Friends,

When Misericordia Heart of Mercy Center opened its doors in 1976 to 39 children with developmental disabilities, we were unsure of how its story would unfold. Throughout the years, we have continued to grow and develop – always to meet an unmet need.

And today, thanks to the dedication of countless supporters who believe in our mission, Misericordia is home to more than 600 children and adults with developmental disabilities. It provides a full continuum of residential care, life-giving programs that meet the individual needs of each resident, and an extensive outreach program for more than 150 families in the community with children living at home.

I have had the great privilege of being the Executive Director of Misericordia during this time. When I reflect on our journey alongside friends and families who are caring for their most vulnerable member, I realize the community that has become Misericordia is a community that manifests God's love in action. It is a welcoming place of joy, compassion and generosity of spirit.

The best way to tell the story of Misericordia is to visit our campus. But for those who are unable to do so, this unique photo collection offers a snapshot into the daily lives of those who call Misericordia home. At Misericordia, we look upon each one of our children and adults as a person with individual needs, feelings, aspirations, limitations, and gifts. Each one is unique, a gift to us today, a loving and loved person made by God with a purpose in life – no matter how wrapped in mystery that purpose is.

We believe, we accept, we love each person, and we are a better people because they have touched our lives.

Sincerely,

Sister Rosemary Connelly, RSM
Misericordia Heart of Mercy
Executive Director

Misericordia

One of the first places I visited after my installation as Archbishop of Chicago was Misericordia Heart of Mercy. Meeting the residents, staff, and volunteers was a memorable experience. The beautiful campus is outstanding; however, it is the life-enhancing opportunities for all those involved with Misericordia that left a lasting impression.

Excellent, loving care is the hallmark of Misericordia. Yet, what makes this extraordinary place unique is that those associated with Misericordia embody not only compassionate dedication to creating a better world for people with disabilities, they acknowledge and embrace the ethic of solidarity. During my visit, it was evident that residents, staff, and volunteers mutually benefit from the solidarity cultivated at Misericordia and among those who comprise the larger Misericordia Family.

We owe a profound debt of gratitude as well to Sister Rosemary Connelly, RSM, for her faith-filled leadership, visionary advocacy, and lifelong service on behalf of people with disabilities. Finally, thank you to Misericordia's dedicated administrators and staff for their commitment and support of the residents, mission, and programs of Misericordia. May God bless you.

Most Reverend Blase J. Cupich
Archbishop of Chicago

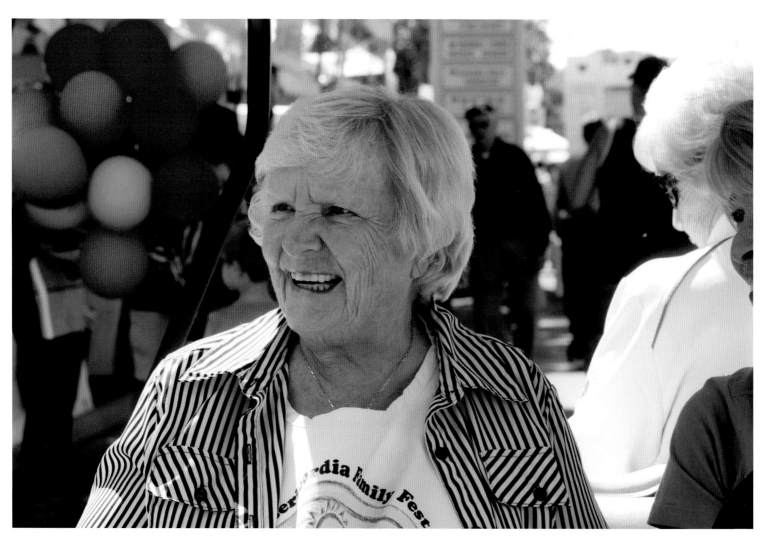

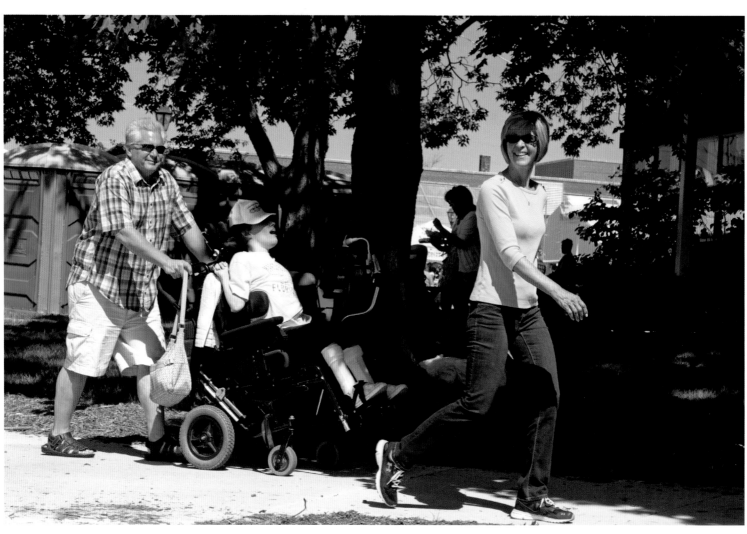

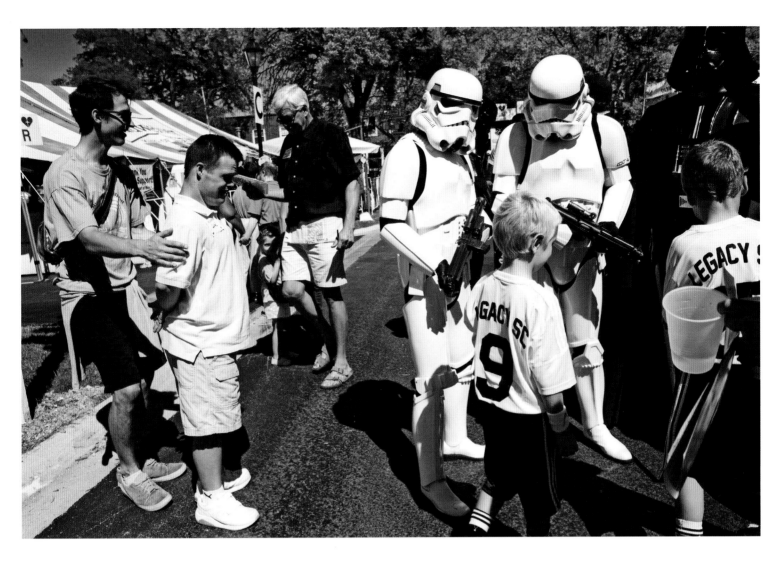
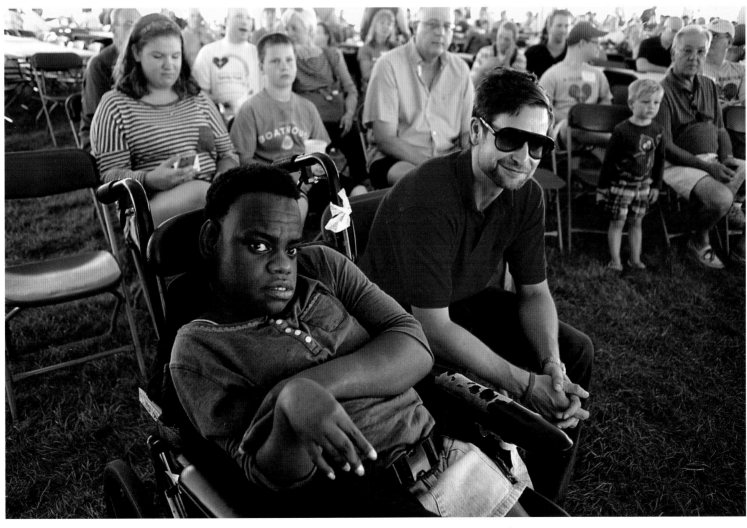

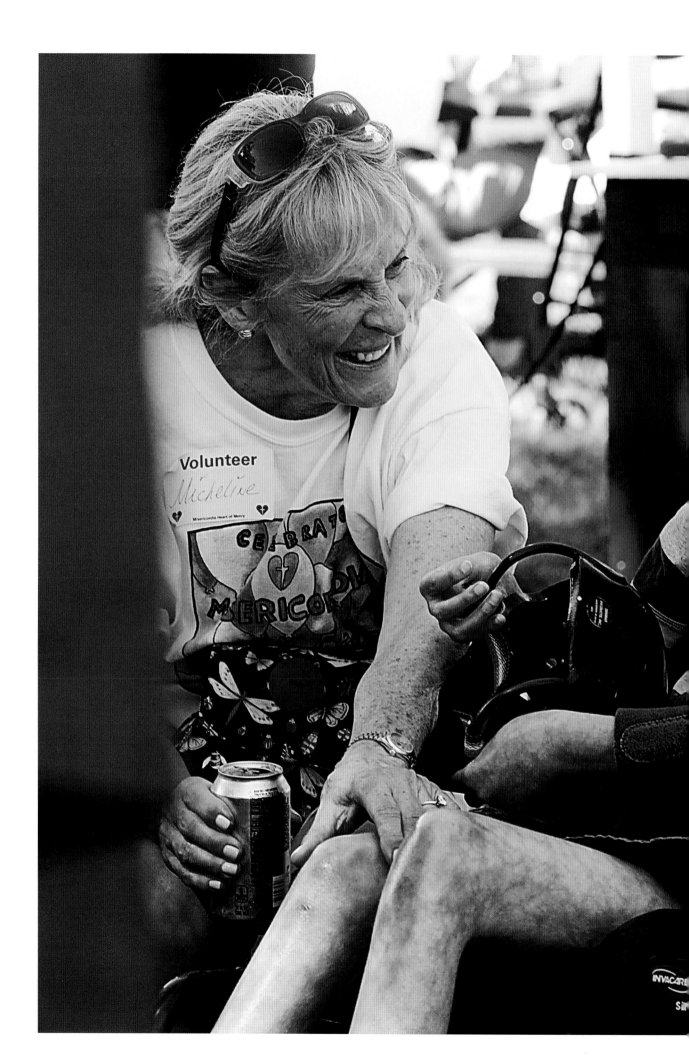

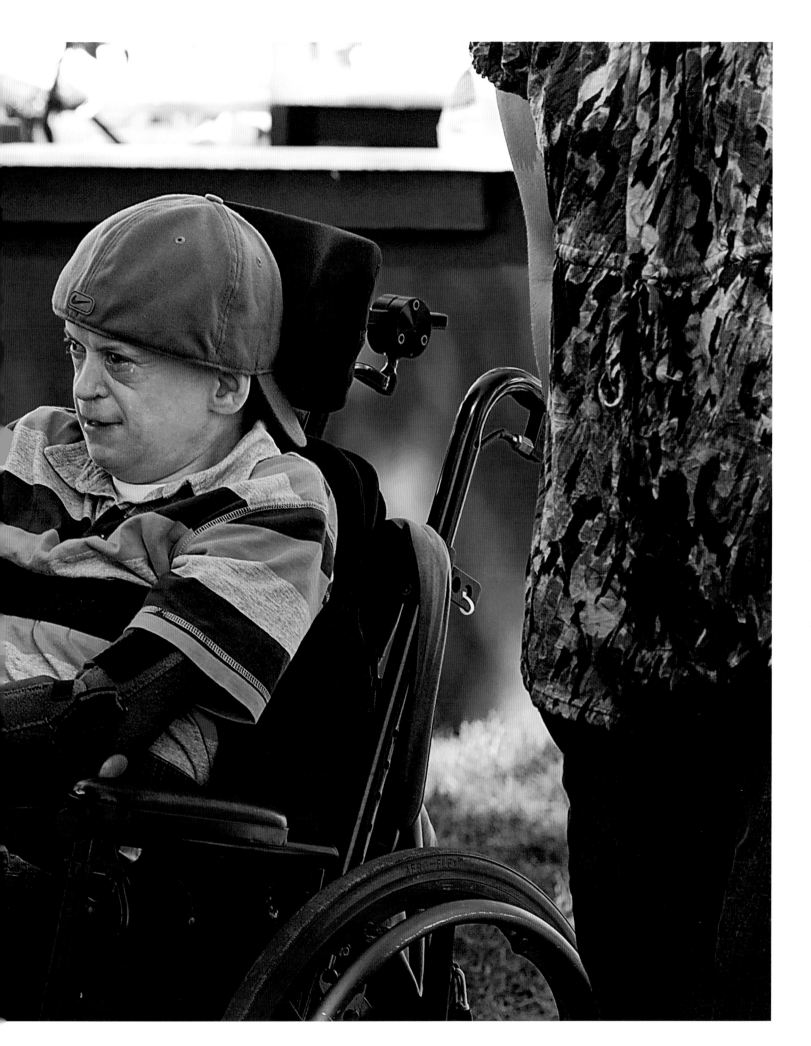

It has been a privilege to have been a small part of the Misericordia community these past 25 years. I initially came to Misericordia for a start, but realized quickly that I had no desire to leave anytime soon, after experiencing the goodness that surrounds this special place every single day. They say our residents are blessed, and I know this to be true, but all who are involved with Misericordia, including our amazing staff, dedicated volunteers, and generous friends, would say that they too are equally blessed to be a part of the Misericordia family. The future is bright because we do not walk this journey alone, and we thank the Lord for all of our friends who are making a difference here at Misericordia.

Kevin Connelly
Misericordia Heart of Mercy
Assistant Executive Director

Work Opportunities

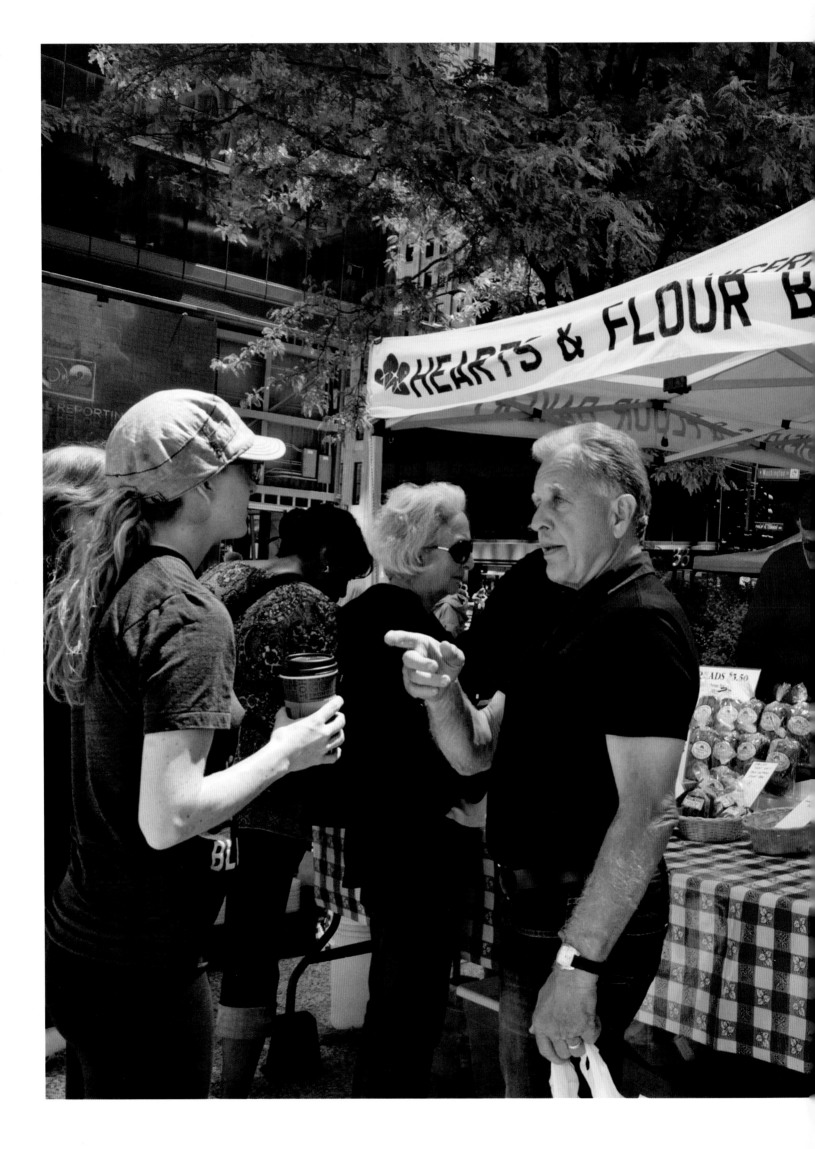

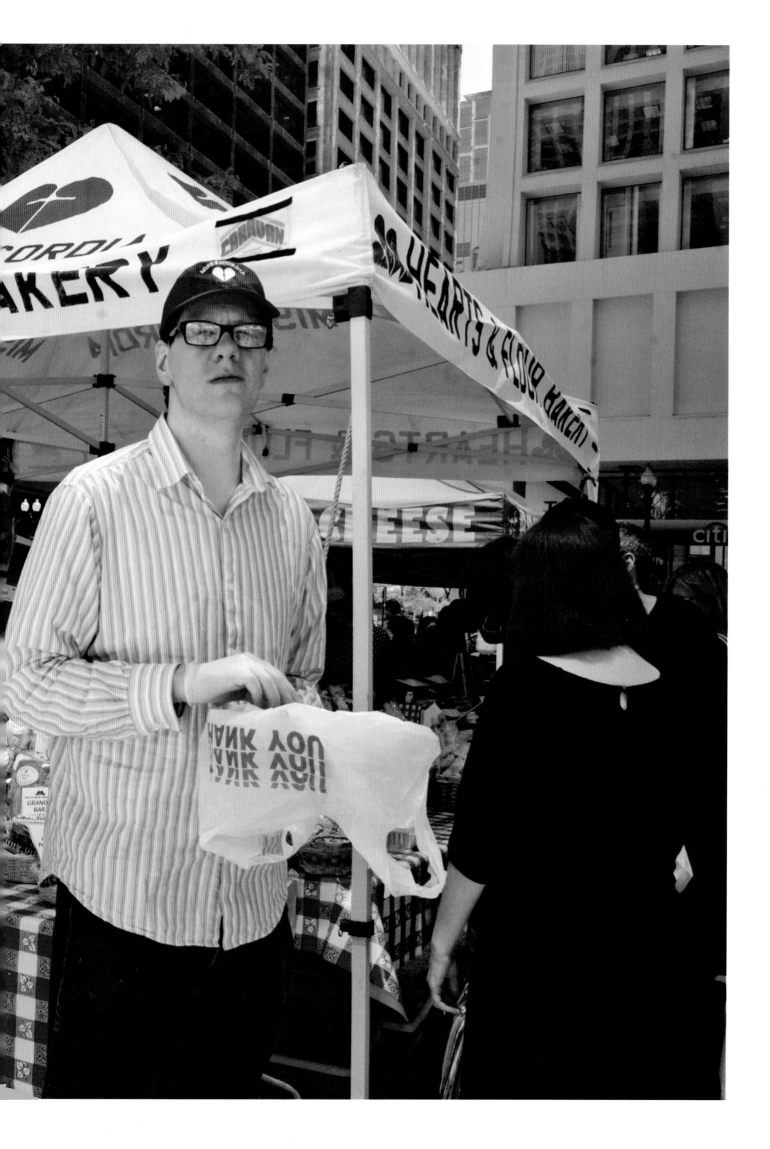

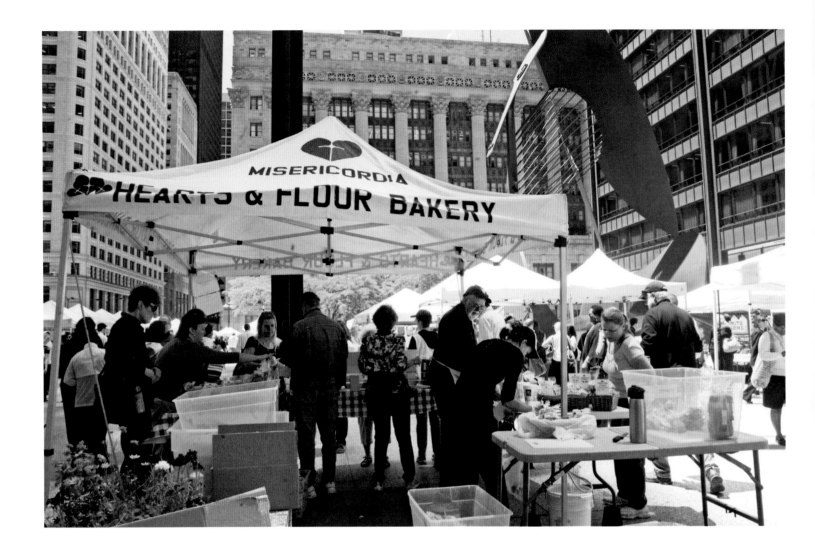

With deep roots in the city of Chicago, Misericordia has provided comprehensive support services for those in need over the last 95 years. Misericordia's dedication to expanded opportunity and innovative support for individuals with developmental disabilities, their focus on maximizing a person's potential, and the opportunity for meaningful volunteer opportunities, has positively impacted countless individuals in the Chicagoland community. My late grandparents, Mayor Richard J. Daley and Eleanor "Sis" Daley, first became involved with Misericordia at the maternity hospital location on 47th Street in the late 1960s. Since then, the Daleys have remained active and committed to Misericordia's mission, including my aunts Mary Carol Vanecko and Patricia Martino, who are both proud members of the Misericordia Women's Board. We are very fortunate to call Sister Rosemary and the entire Misericordia community part of the family.

Maura Daley

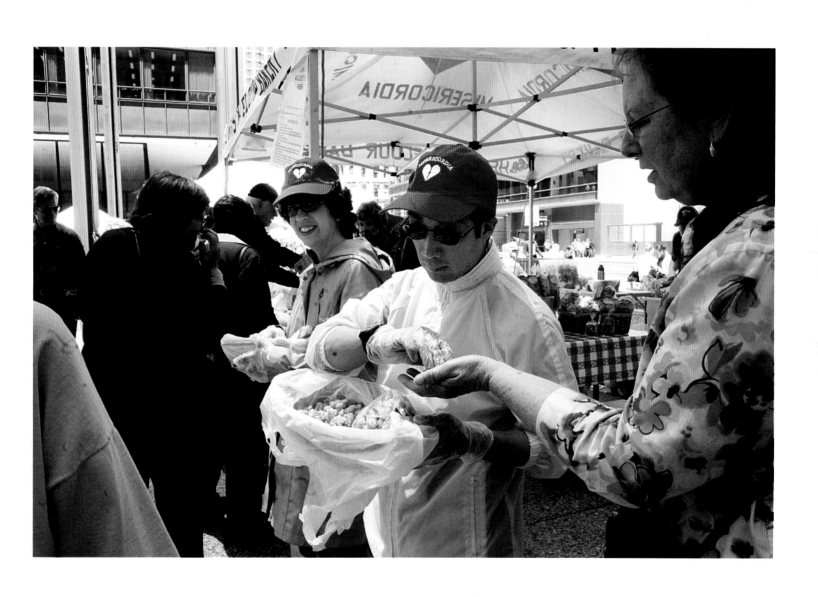

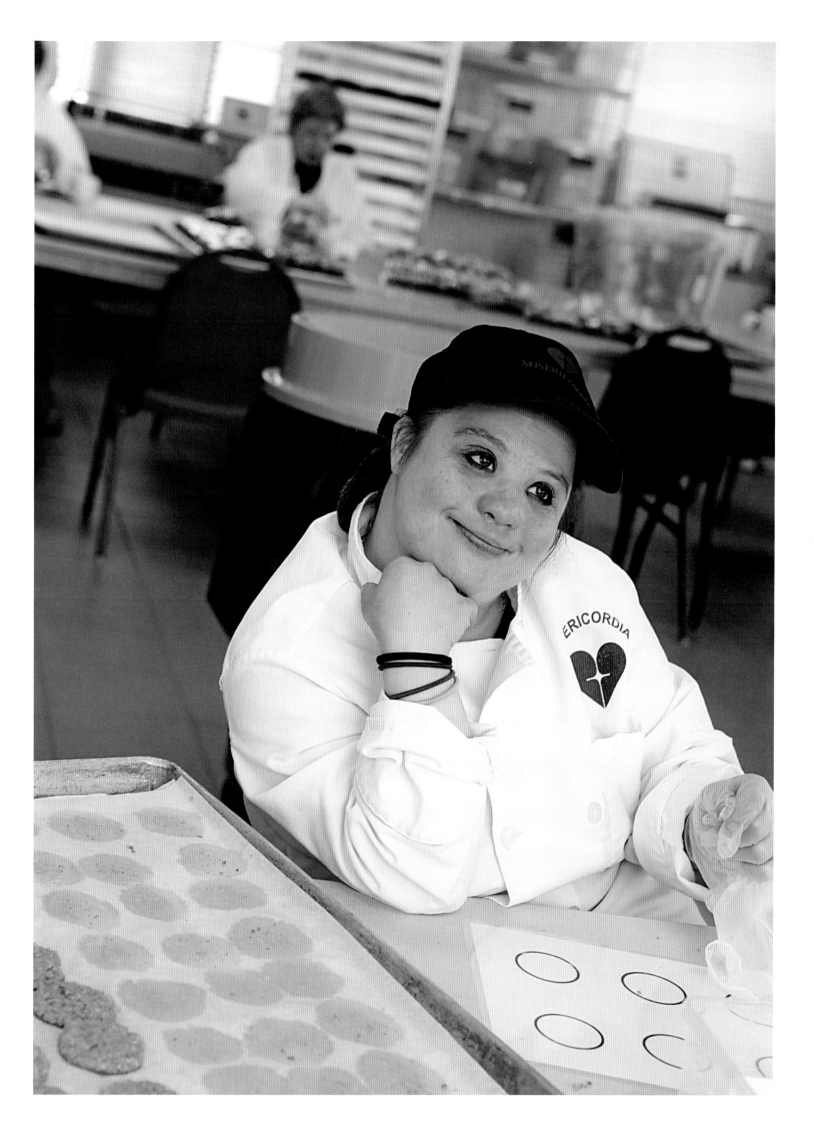

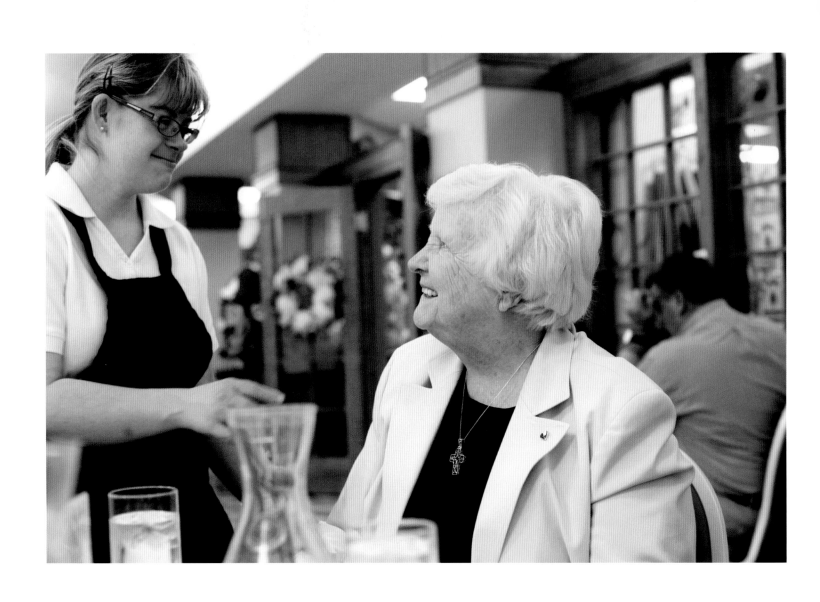

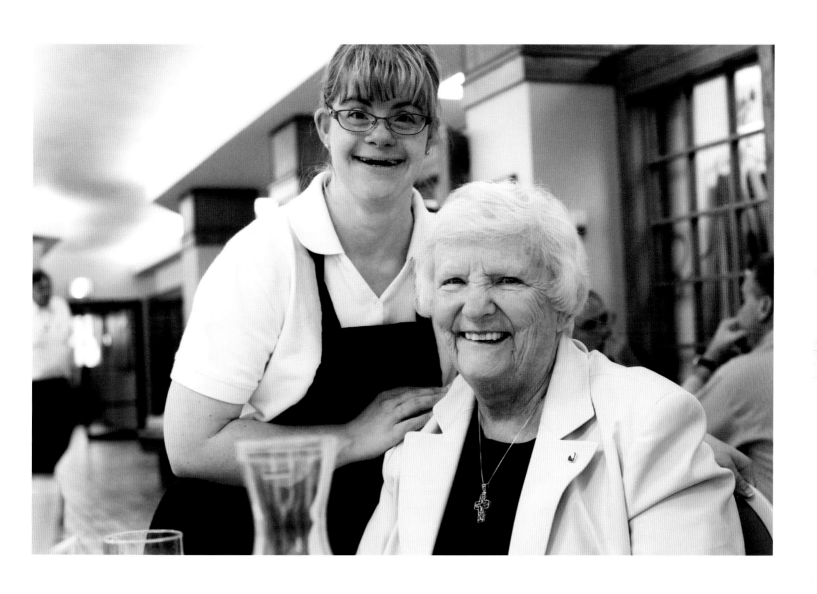

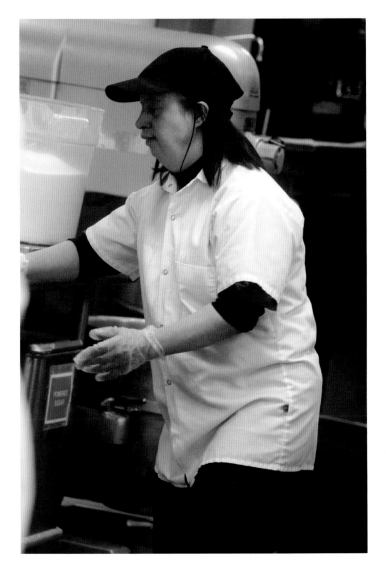

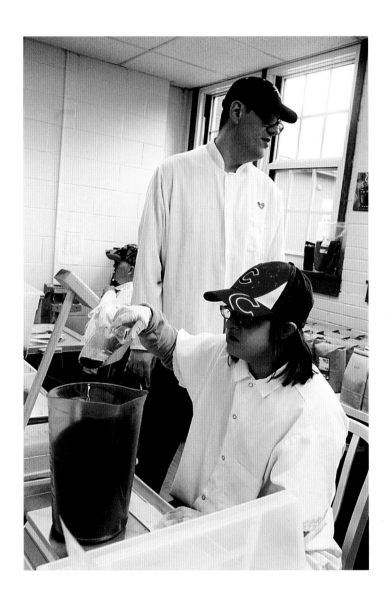

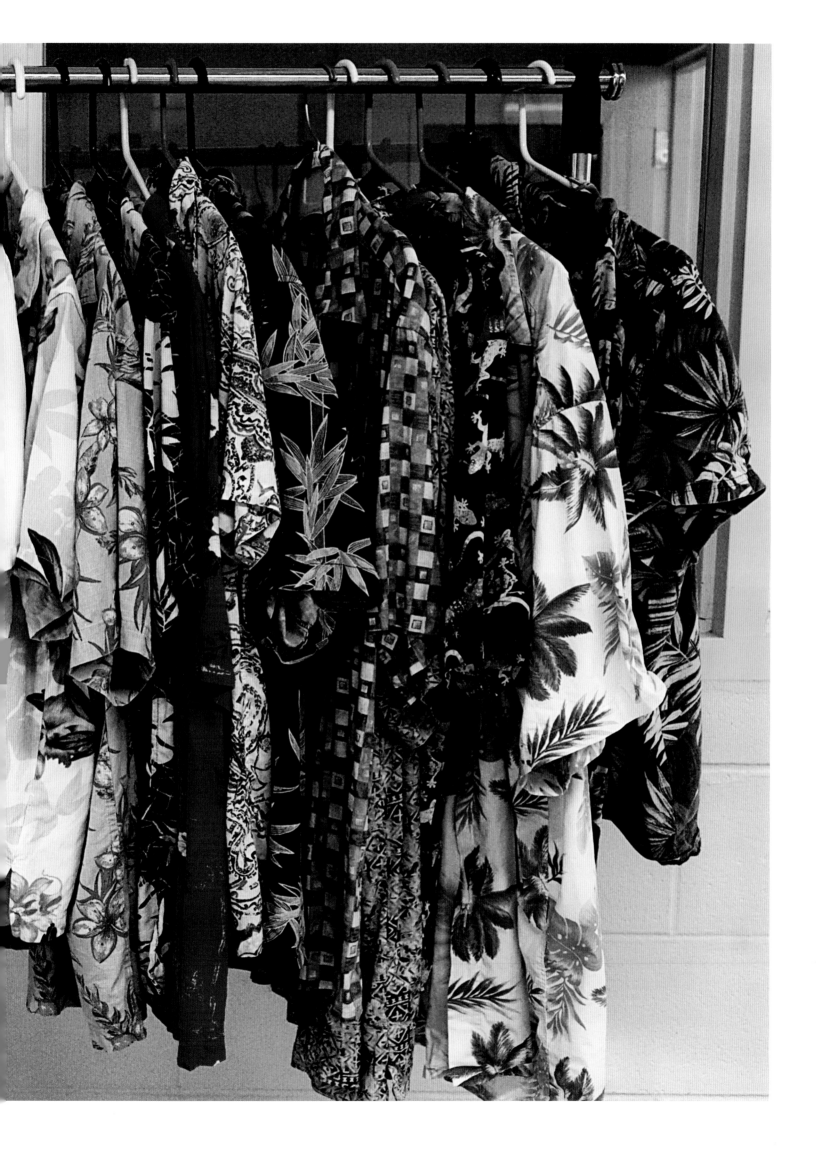

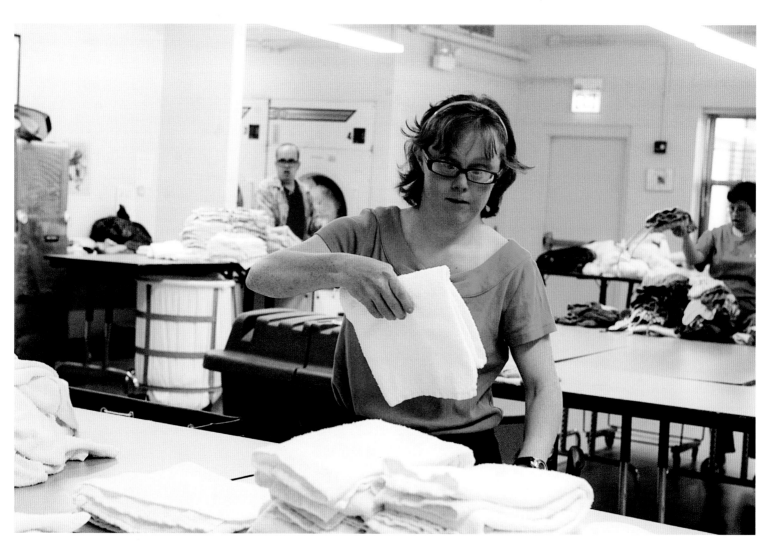
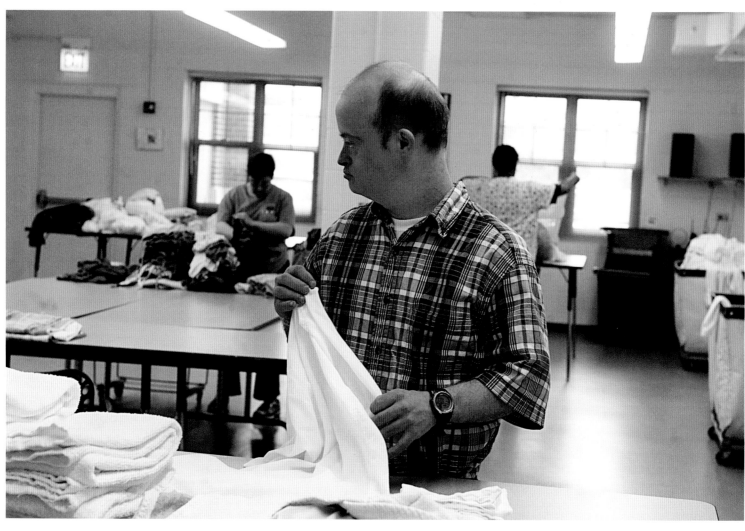

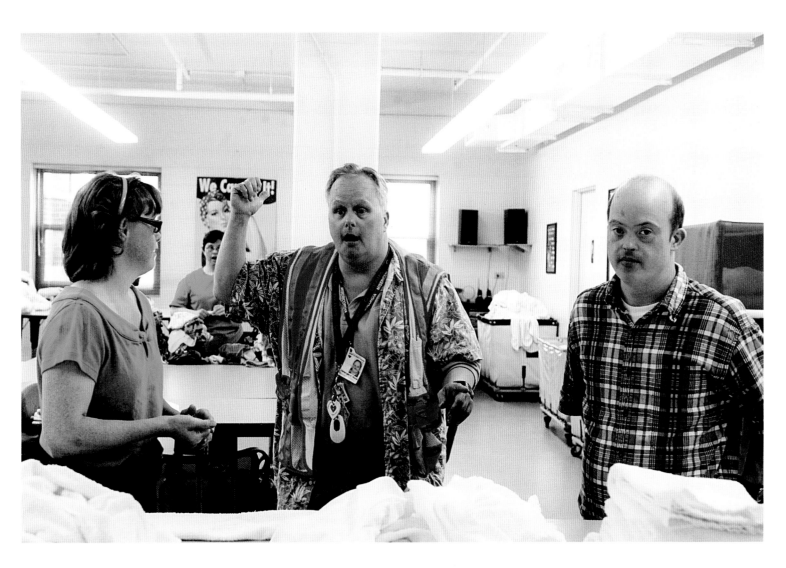

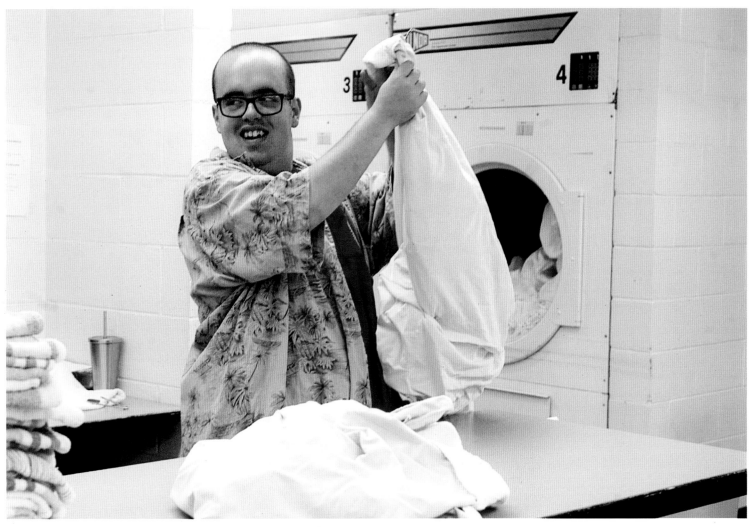

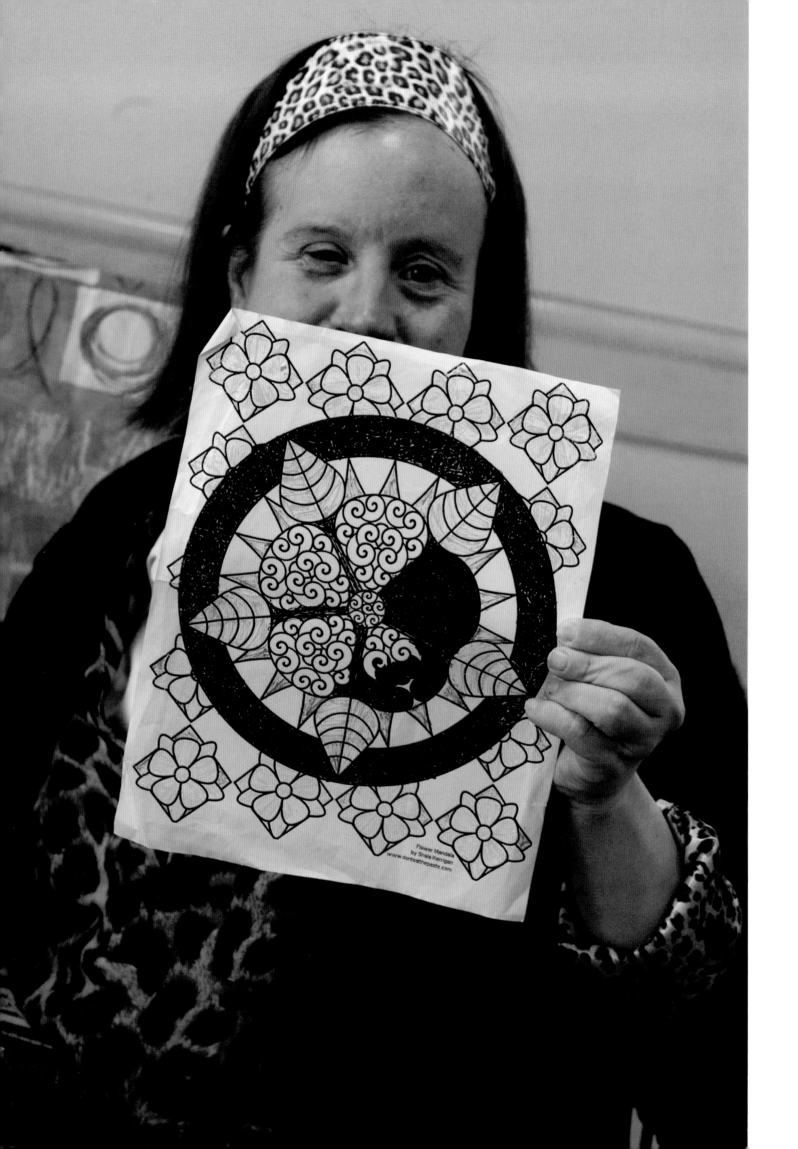

Flower Mandala
by Shala Kerrigan
www.donteatthepaste.com

Creativity, Art

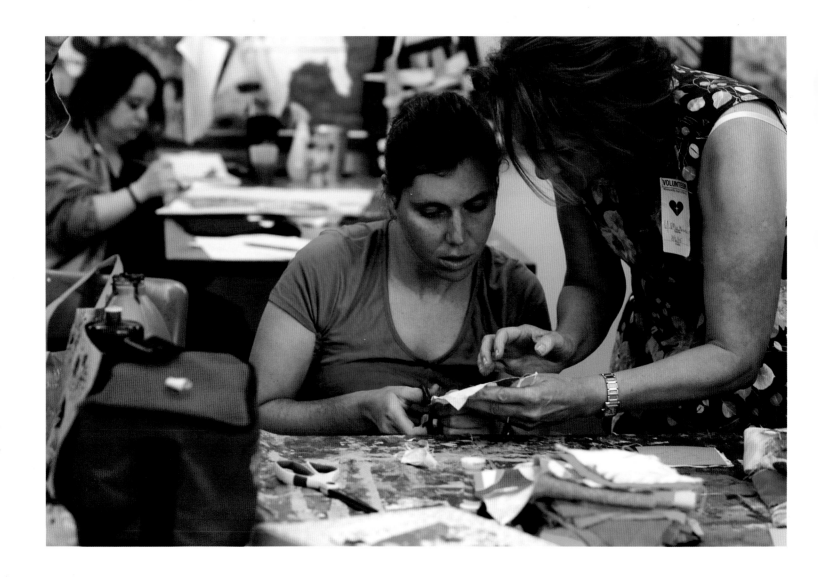

Misericordia has made all the difference for our
Lauren, with friendships and fulfillment she had
never known. We have watched her blossom into
a happy and more independent young woman,
enjoying a life that once seemed out of reach. And
that has changed our lives, too.

Susan and David Axelrod
Misericordia Parents

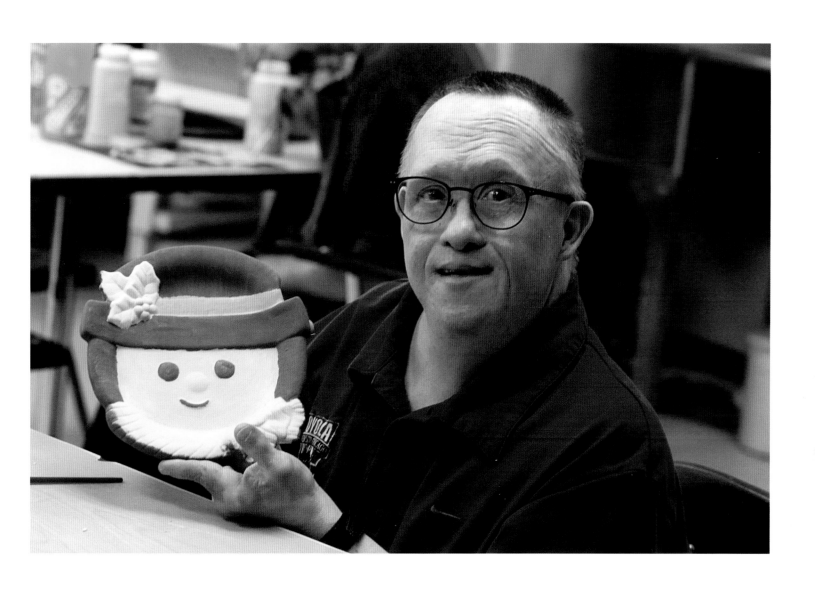

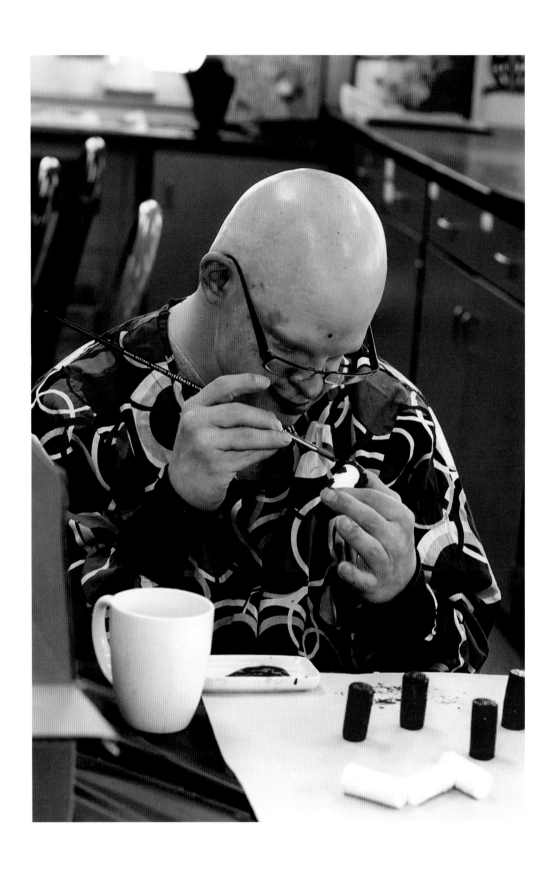

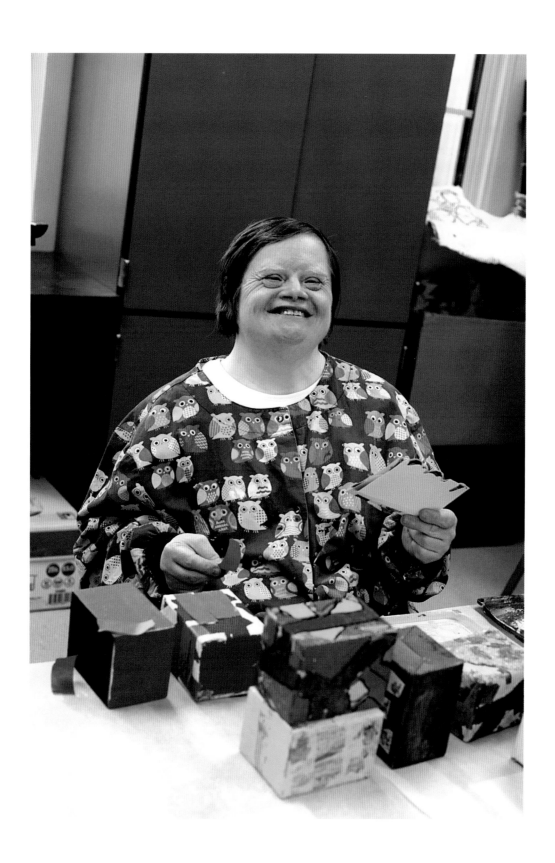

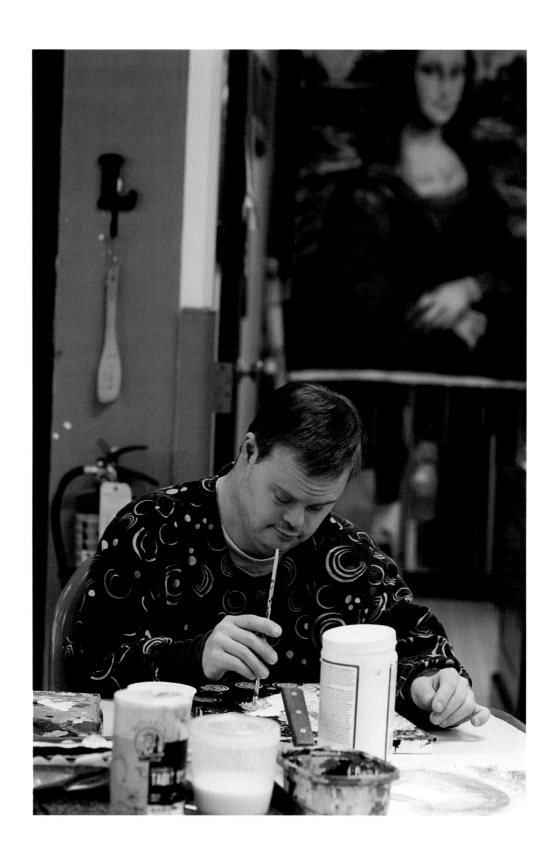

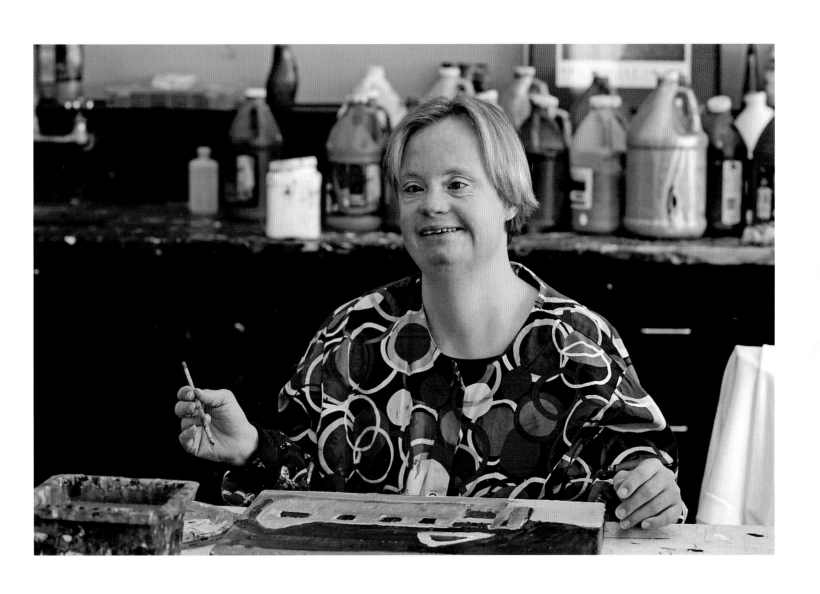

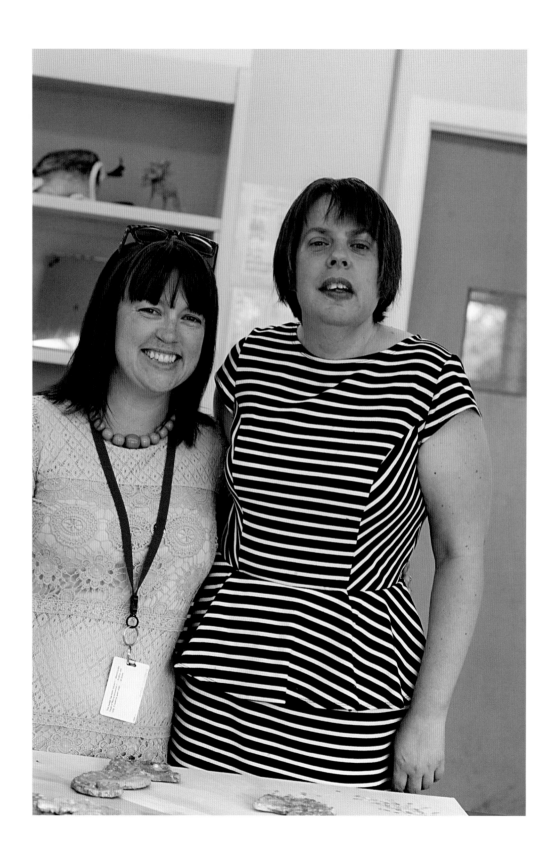

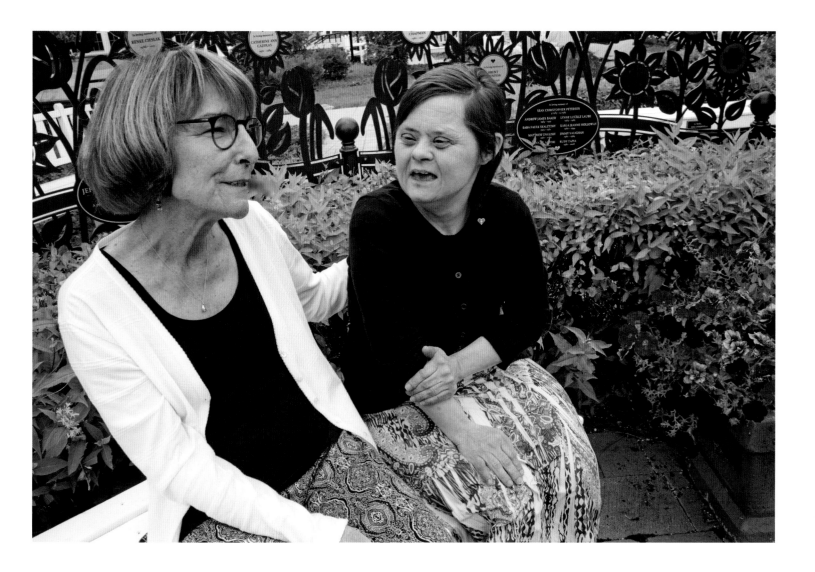

I have been a part of the Misericordia family for almost forty years. Every day the residents make me smile, laugh, and sometimes cry. They are truly happy and they have the best self-image of anyone I know! I feel blessed to have a very strong connection with our parents and siblings. I remember their joy when telling them that we have a place for their child and supporting them through that process. I have had many discussions with families about their child's progress, their concerns and resolving issues with them.

I have been at the bedside with them as their family member returns home to God, sharing both tears and joyful memories. Our families are grateful for the care and love their family member receives at Misericordia. Misericordia enables them to have peace of mind which is a true gift for them.

Mary Pat O'Brien
Misericordia Heart of Mercy
Assistant Executive Director

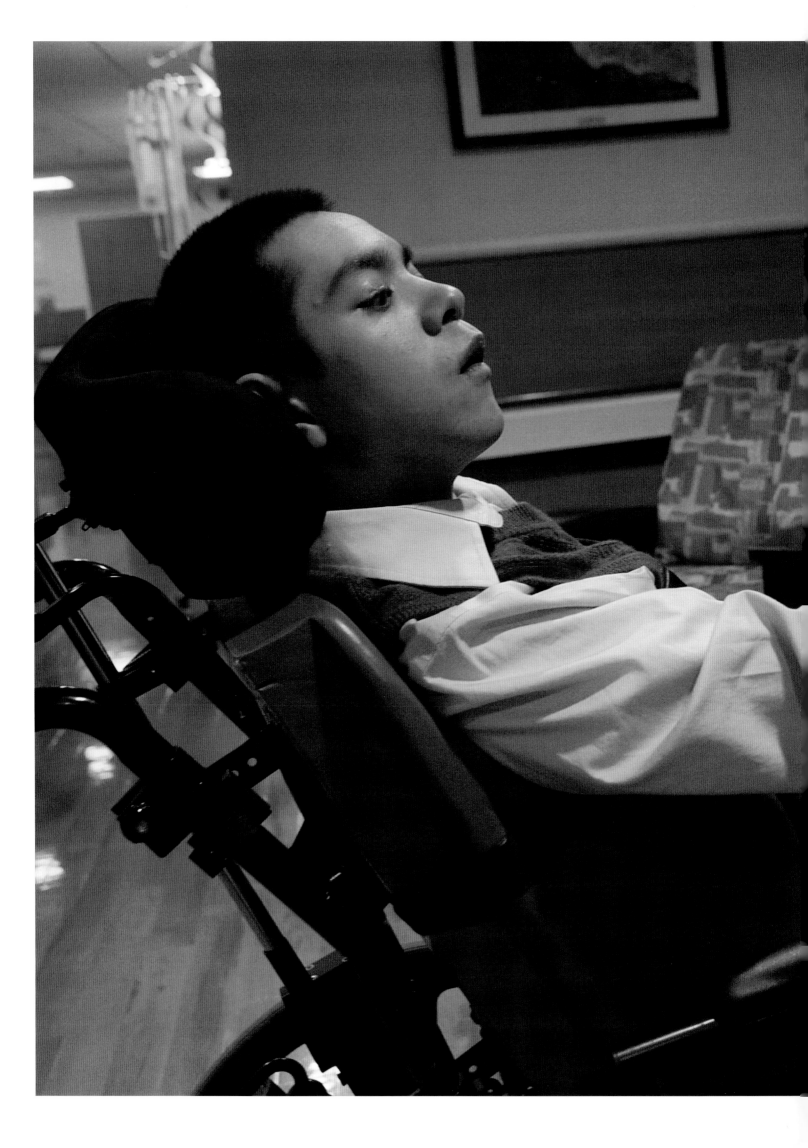

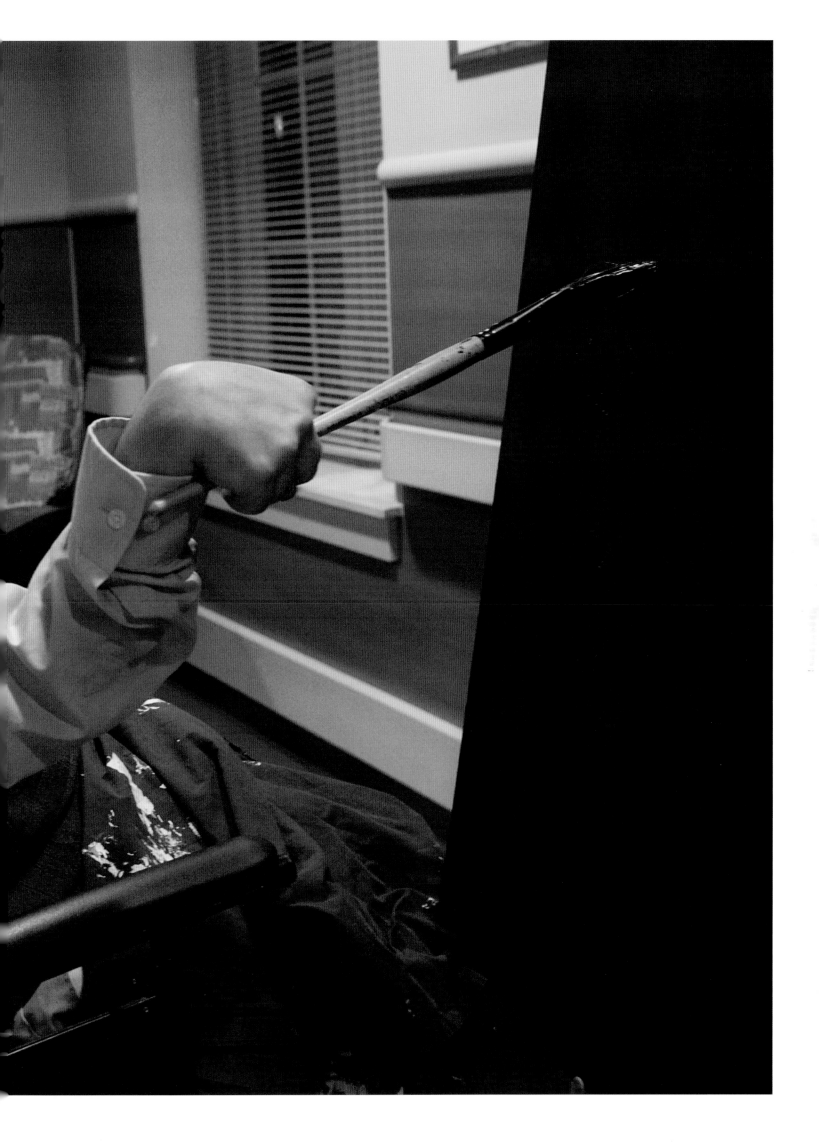

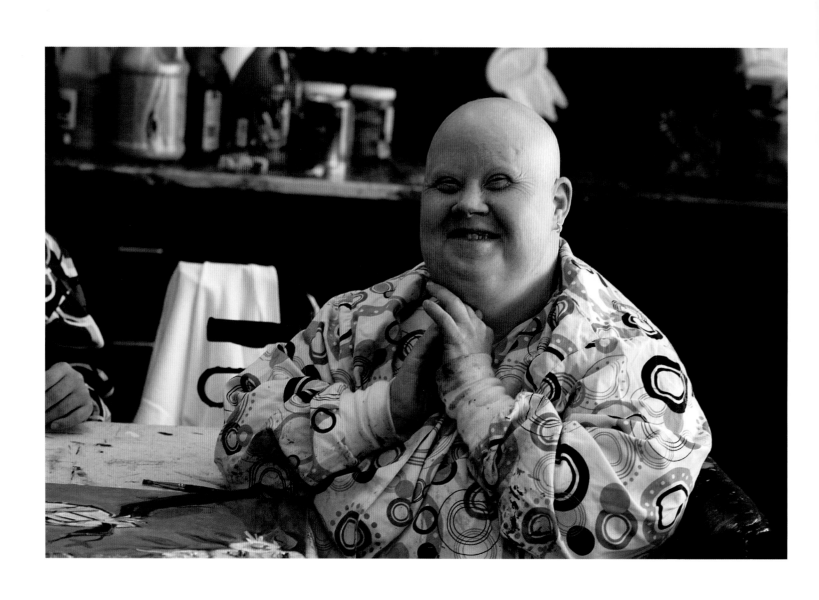

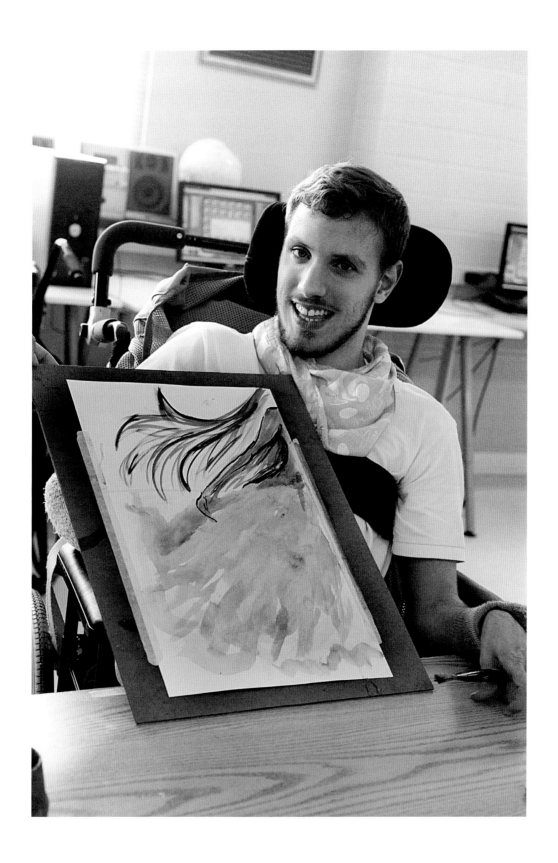

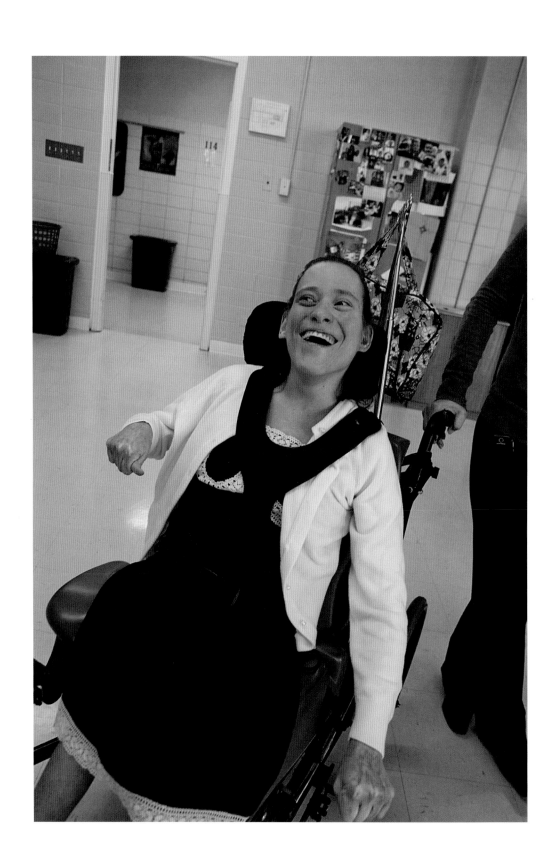

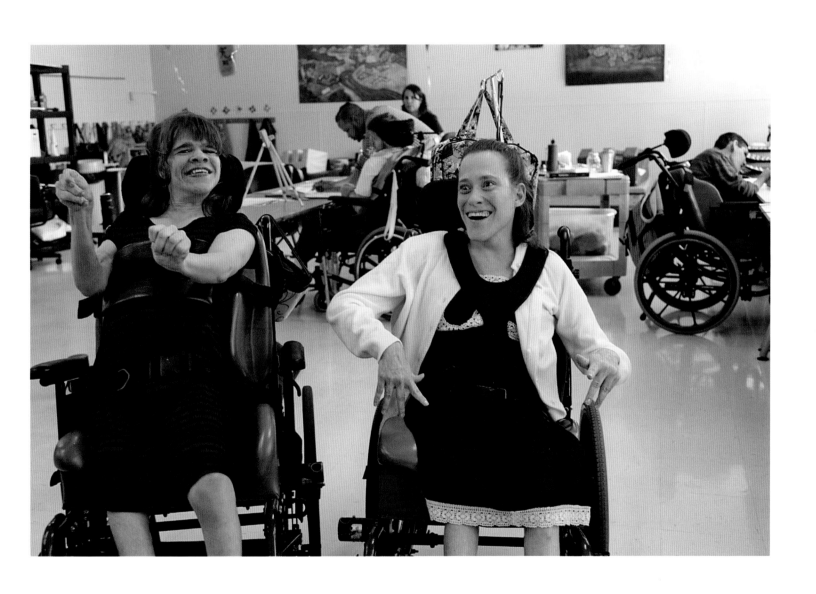

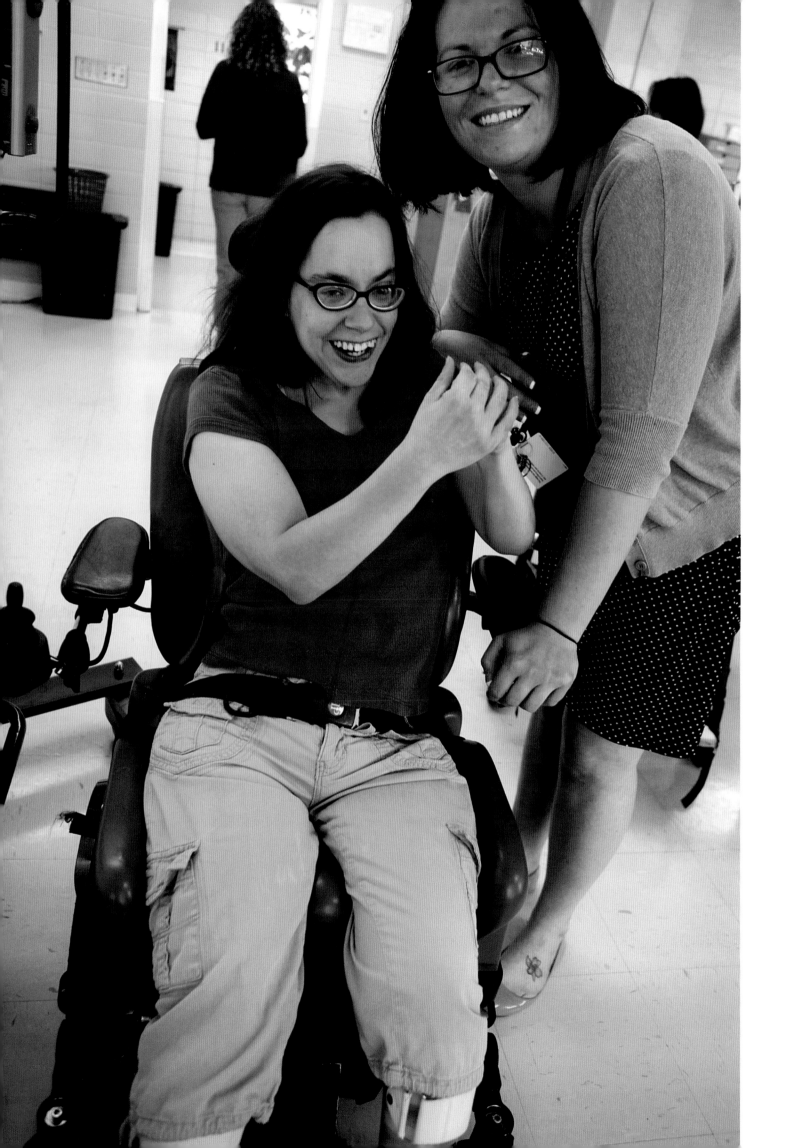

Technology

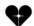

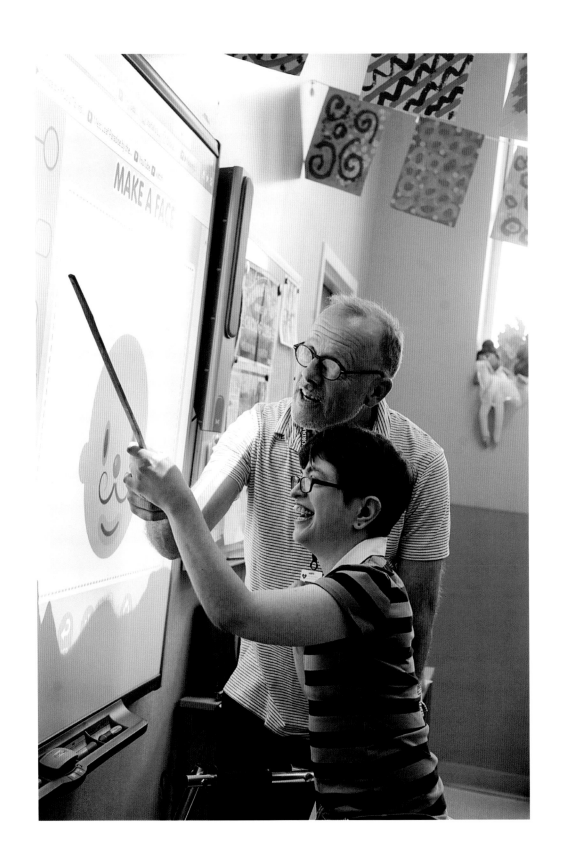

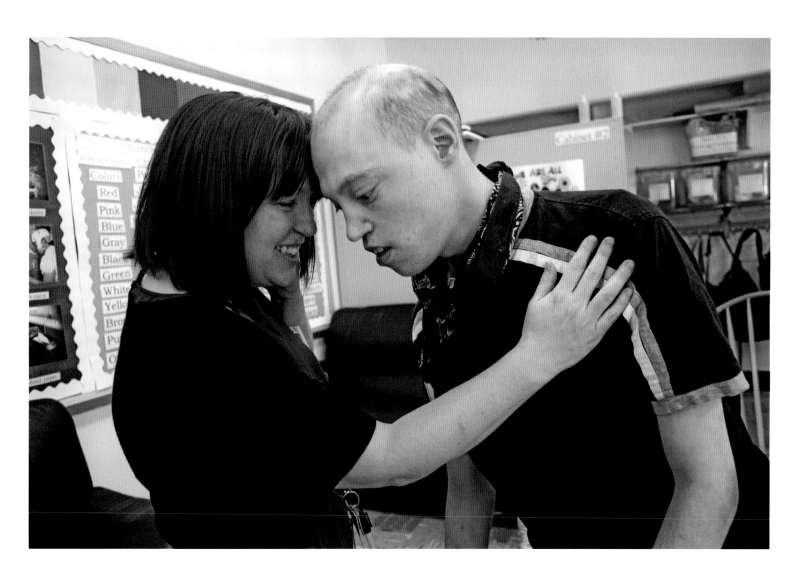

When our son, Gideon, was a little boy, he was drawn to the sights and sounds of other children. But he had no language to speak to them. And instinctively, they knew he was different. For little kids, that's scary. But at Misericordia, Gideon is welcomed by a community that understands his unspoken language. It embraces him, celebrates him. Misericordia is a loving home and a gift to Gideon and to our grateful family.

Carol Marin
Misericordia Parent,
Journalist

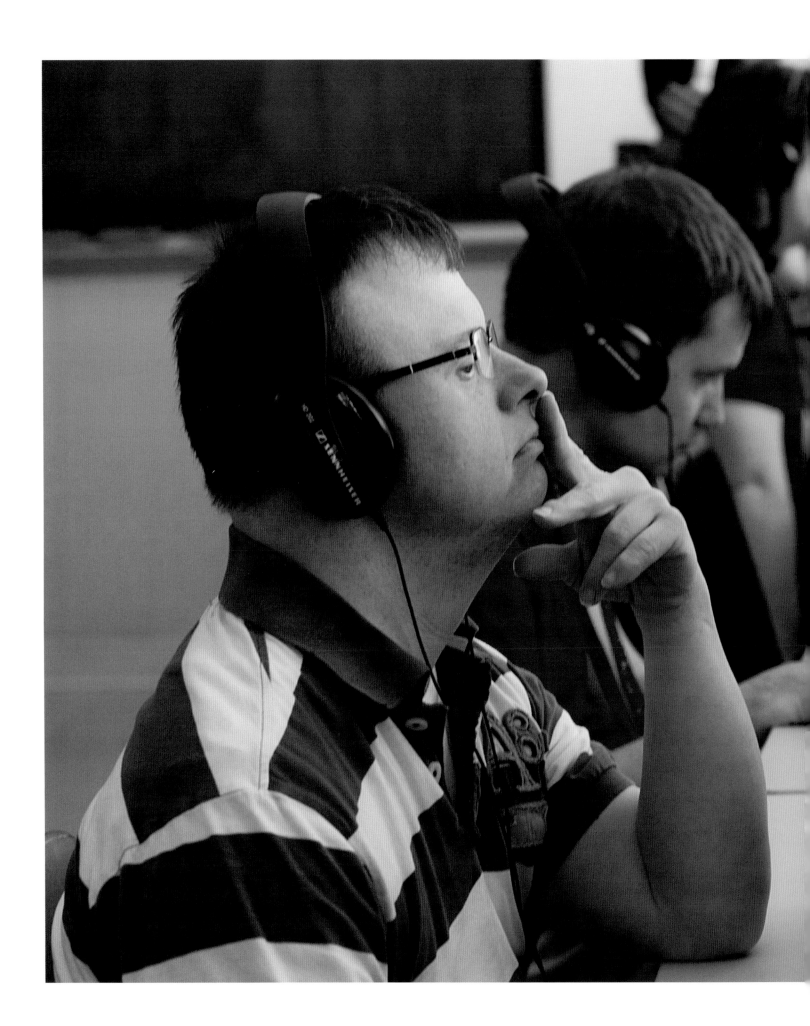

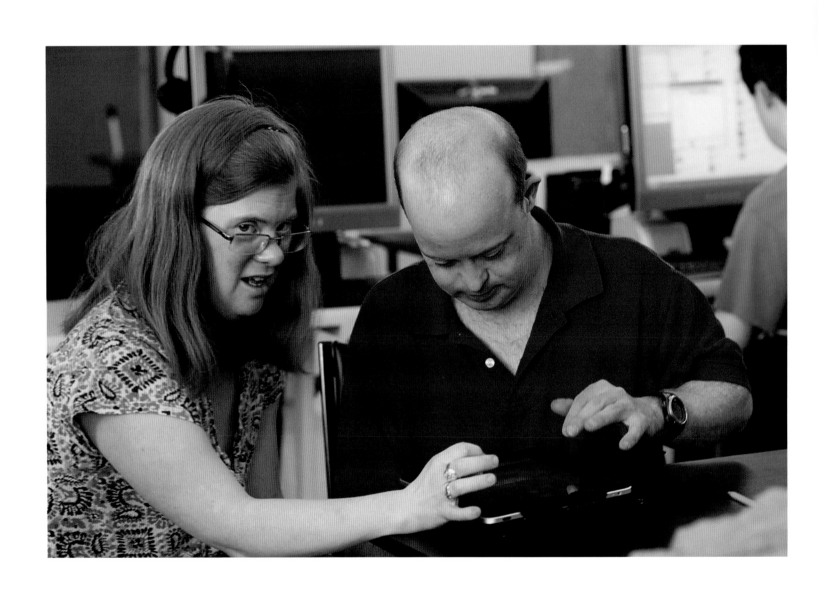

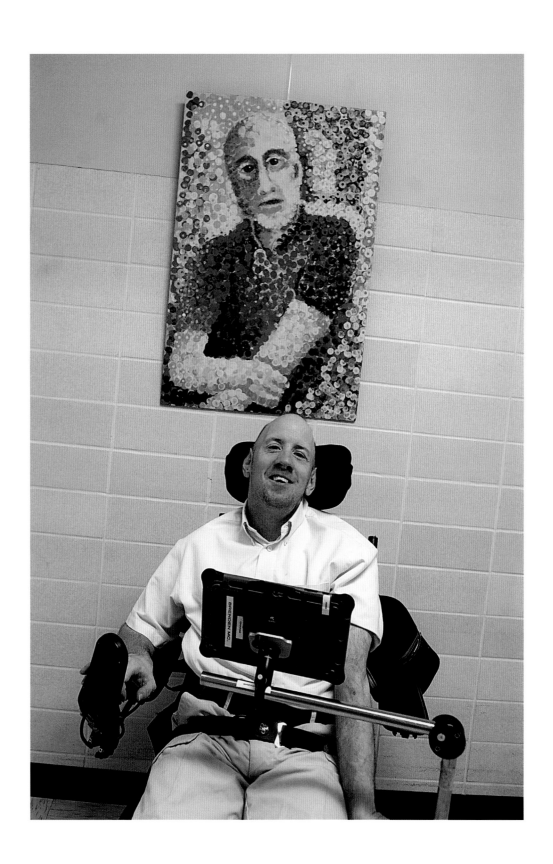

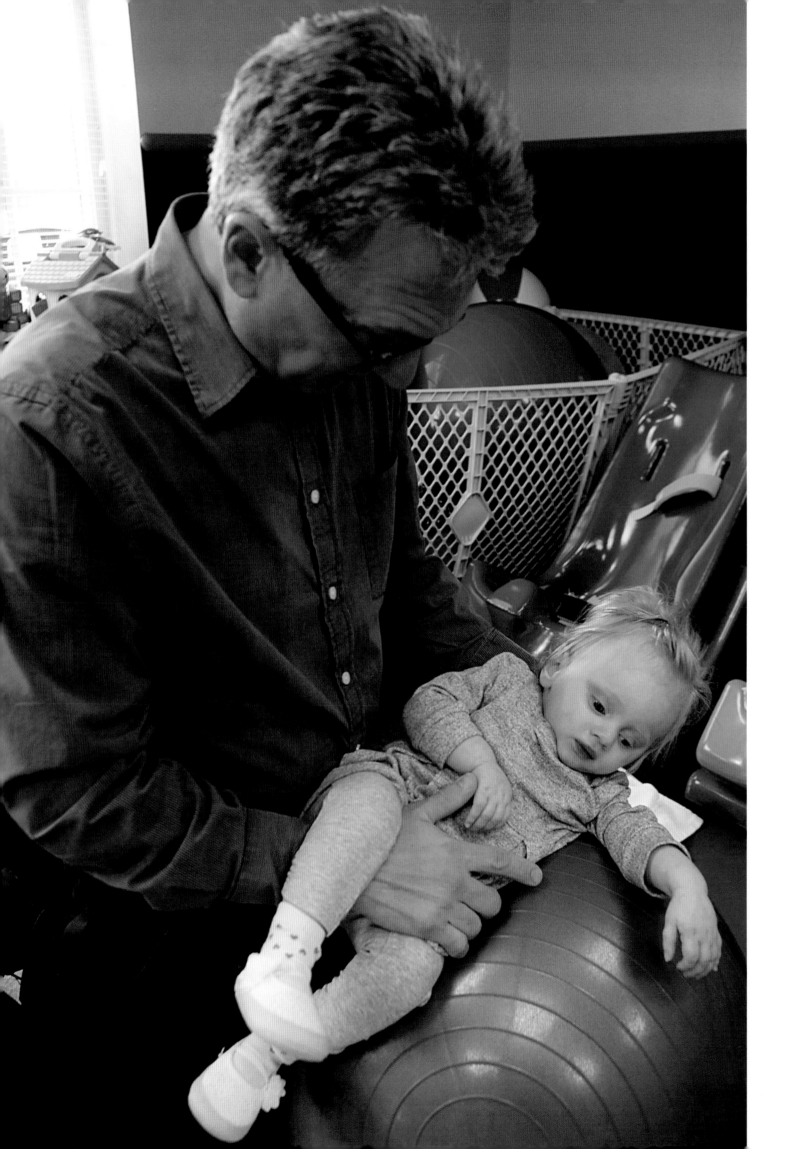

PART 4

Children

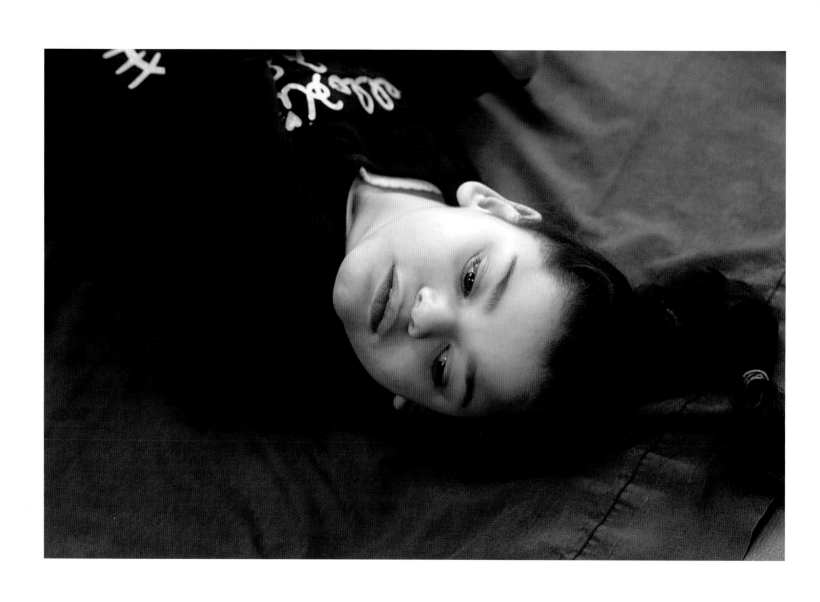

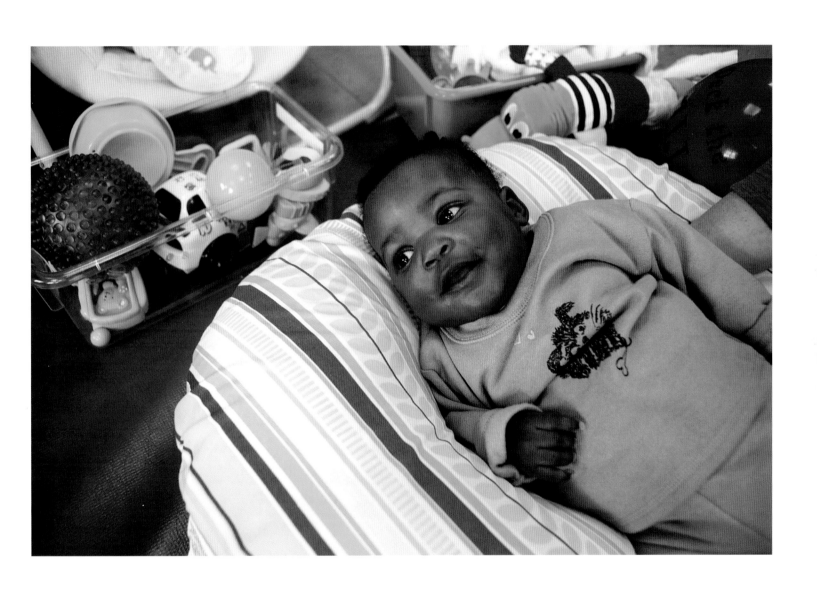

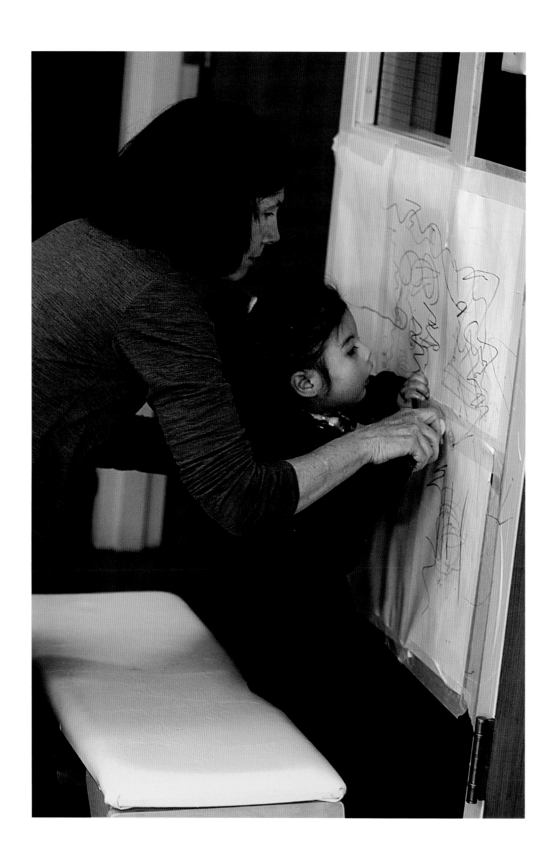

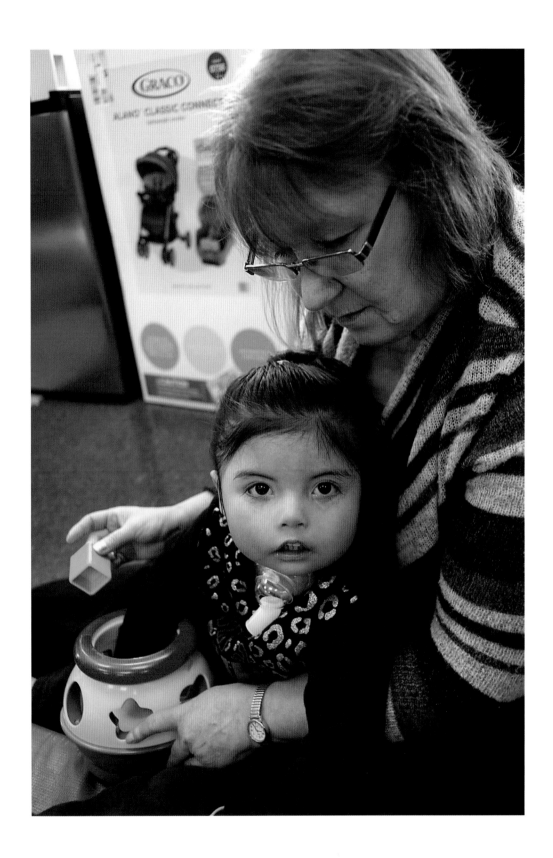

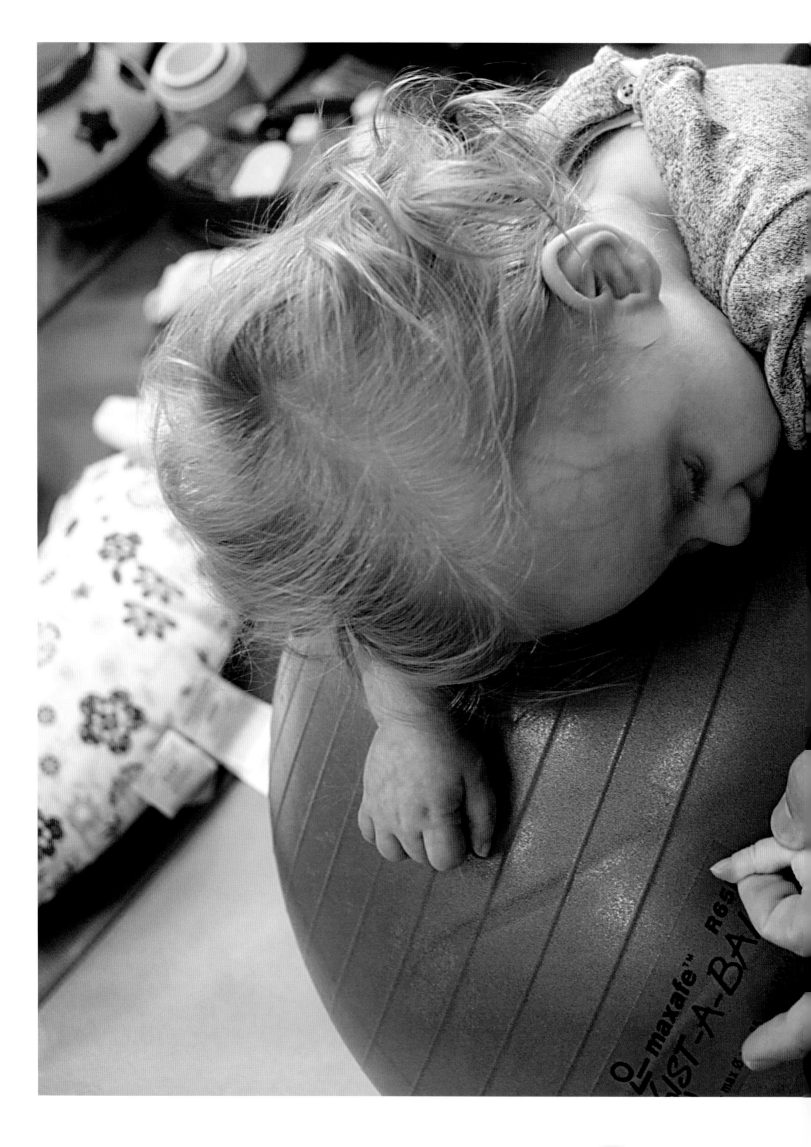

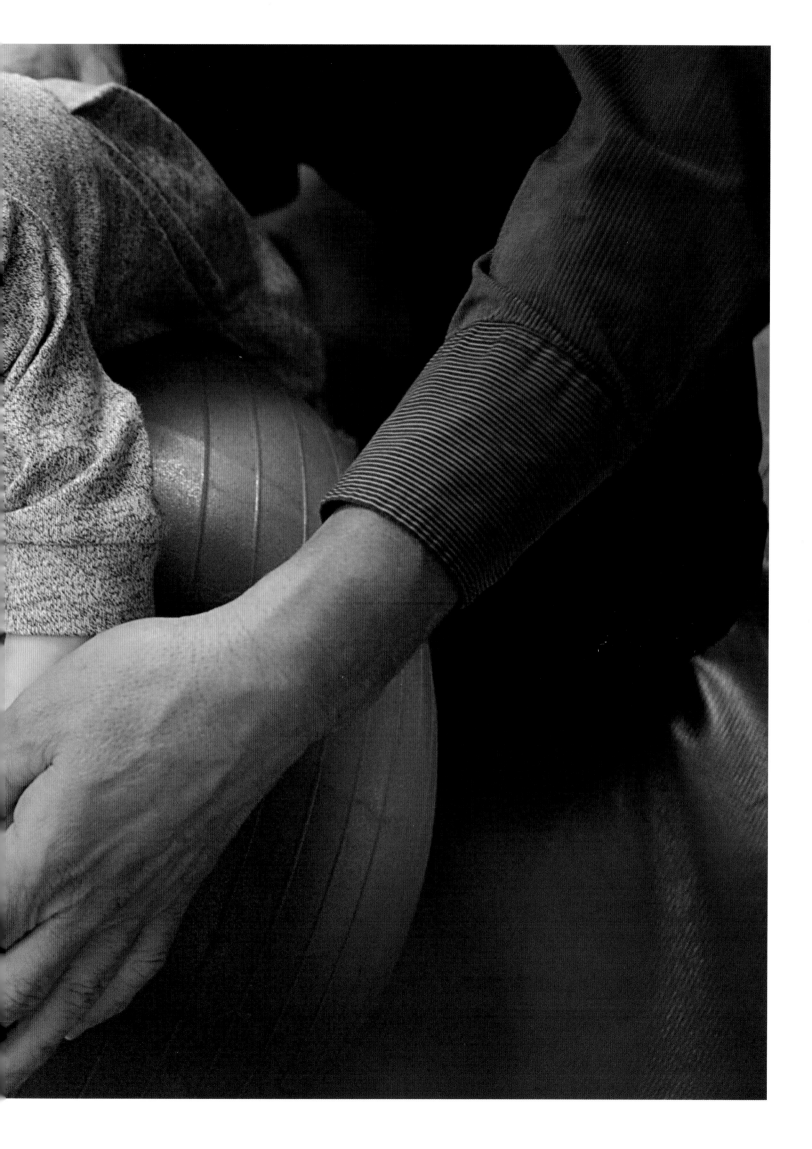

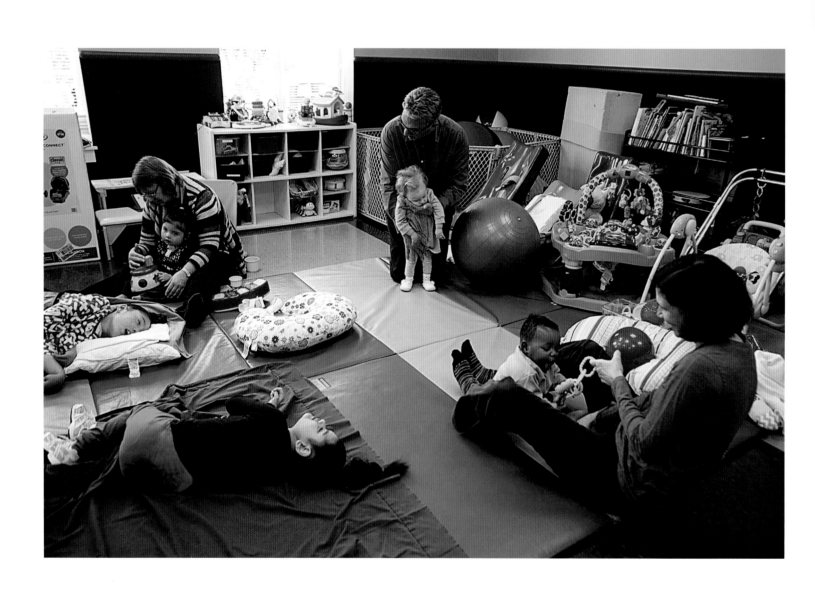

My experience over these past 25 years is one of blessing. Every time I am at Misericordia I see love in the way the residents are cared for and how they care for each other. Whenever I am there, I always feel blest by the residents, Sr. Rosemary, and all the staff who create a true home. I believe all of us that have been a part of the mission of Misericordia feel deeply honored to be a part of this wonderful mission and are so grateful for the vision and leadership of Sr. Rosemary and her wonderful team.

Reverend Monsignor Michael M. Boland
President and CEO of Catholic Charities
of the Archdiocese of Chicago

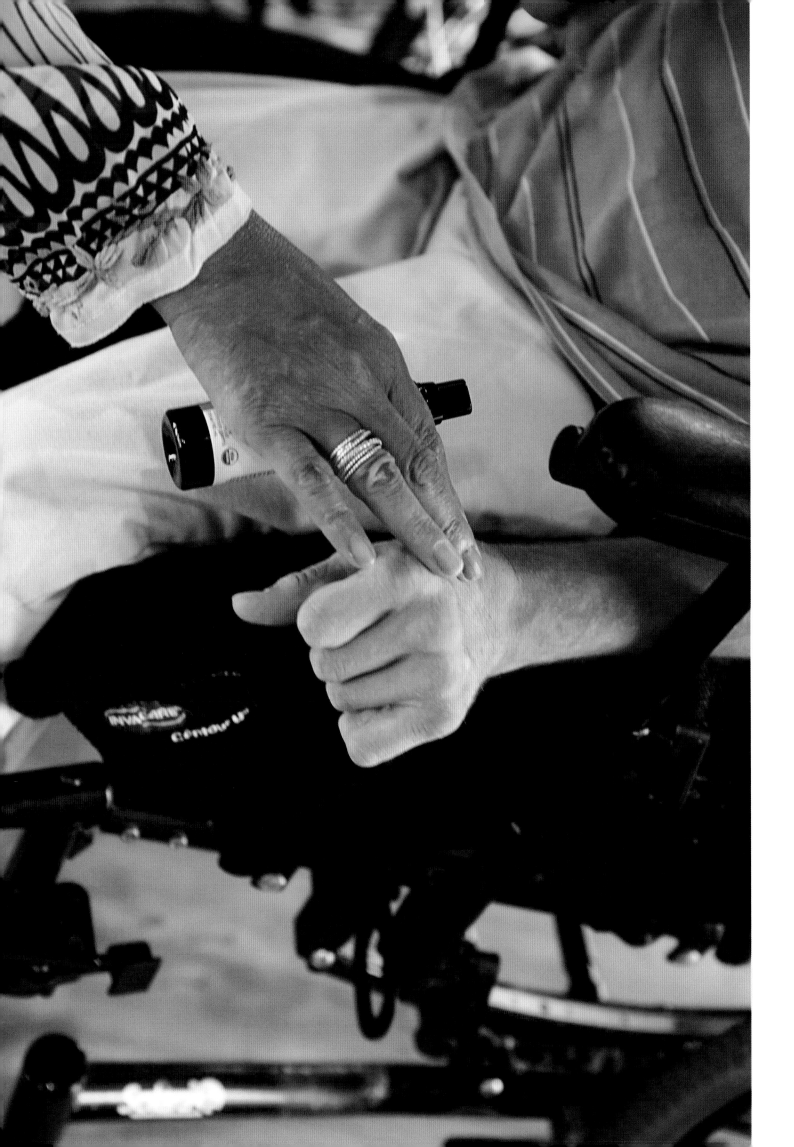

Sensory Perception

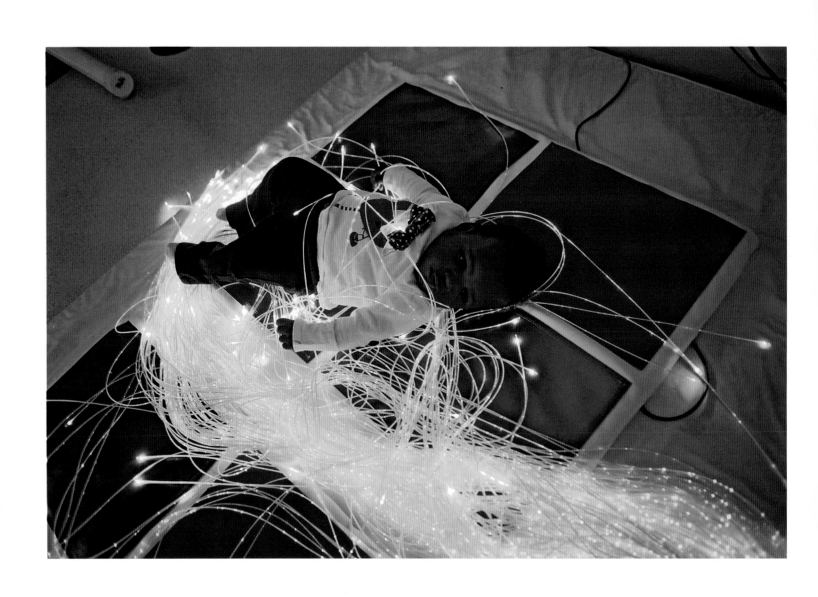

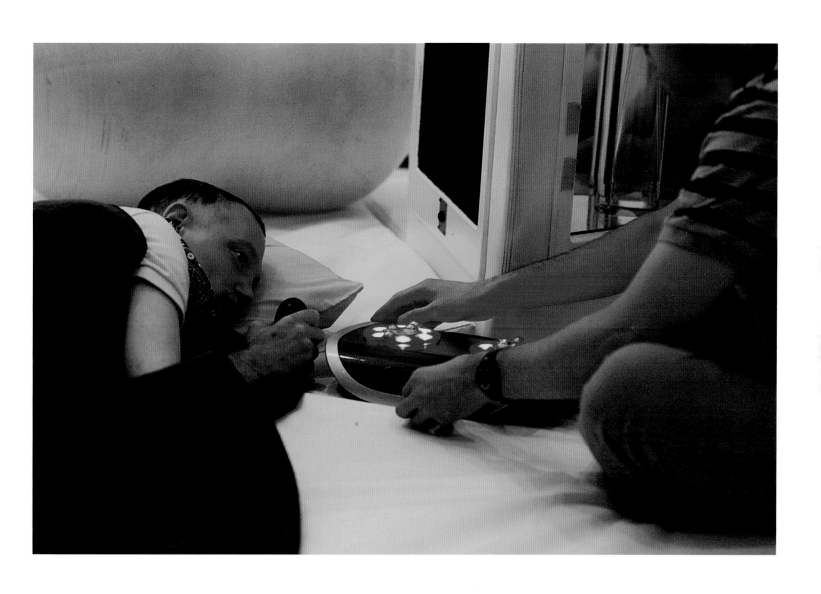

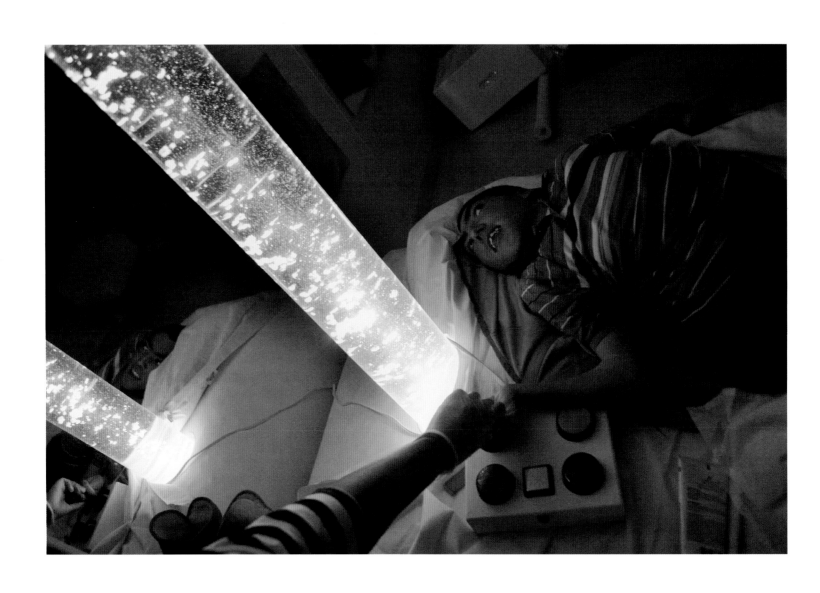

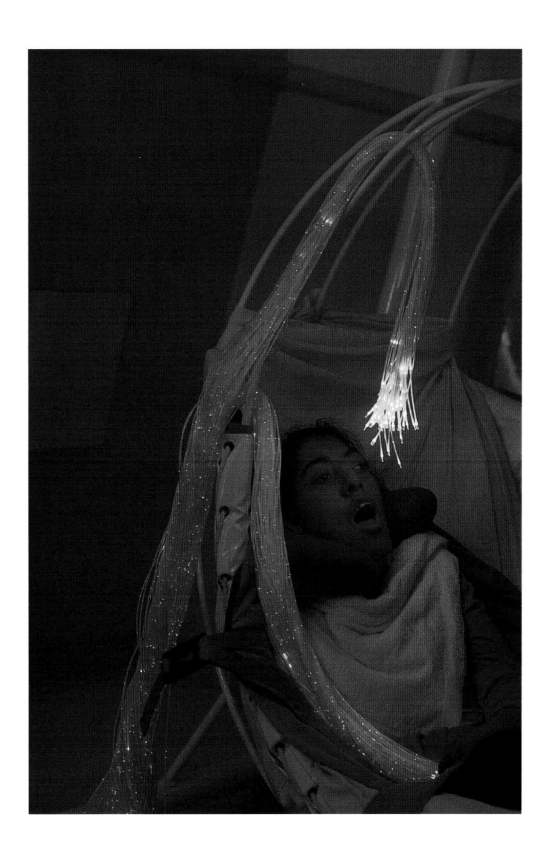

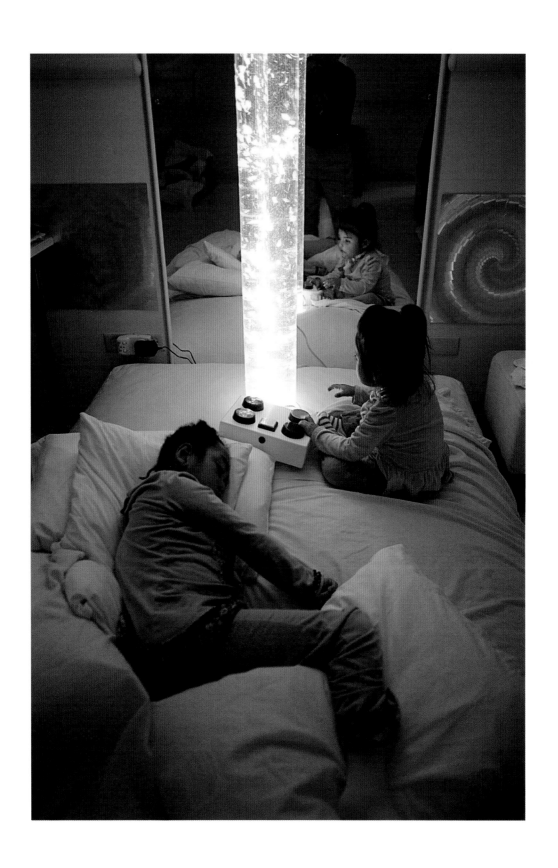

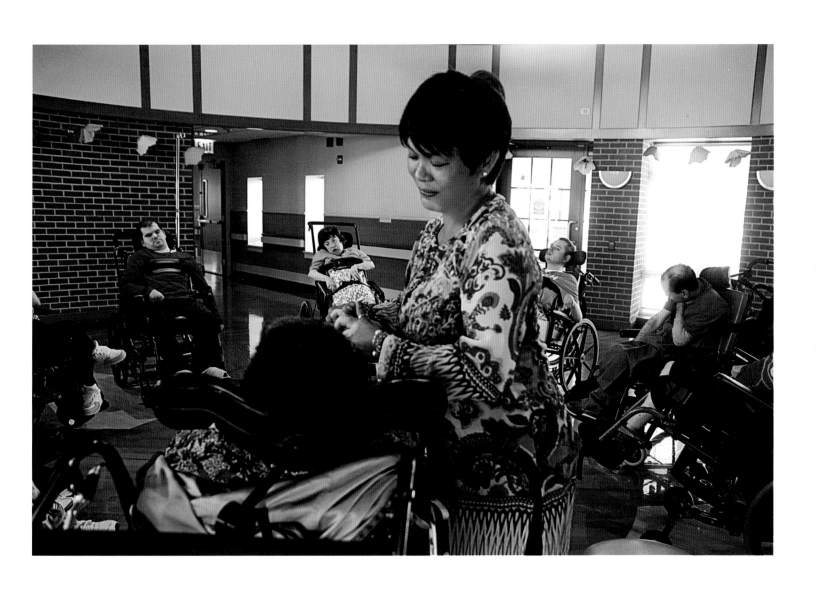

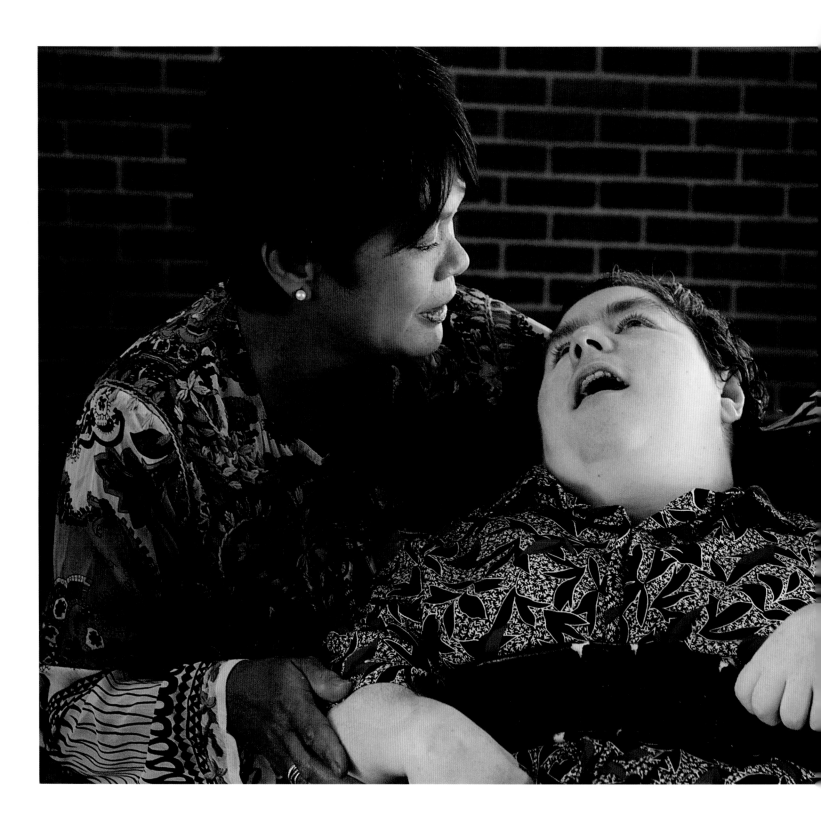

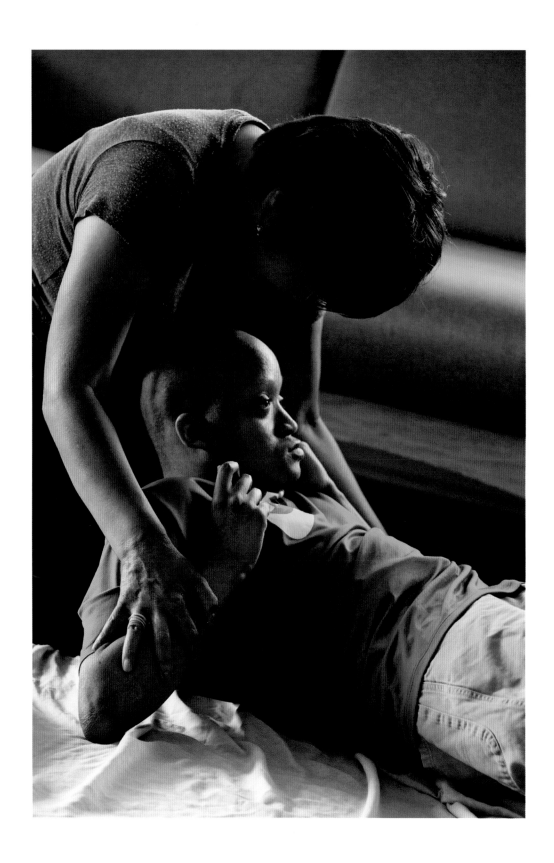

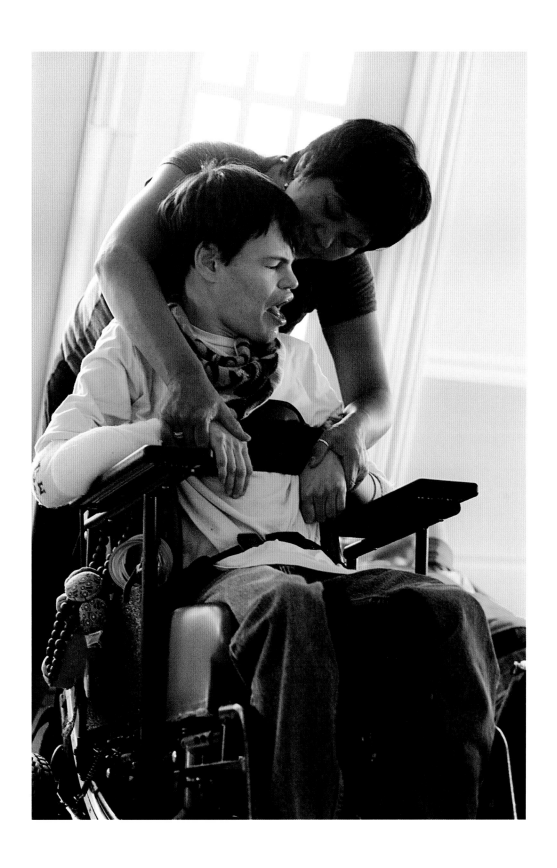

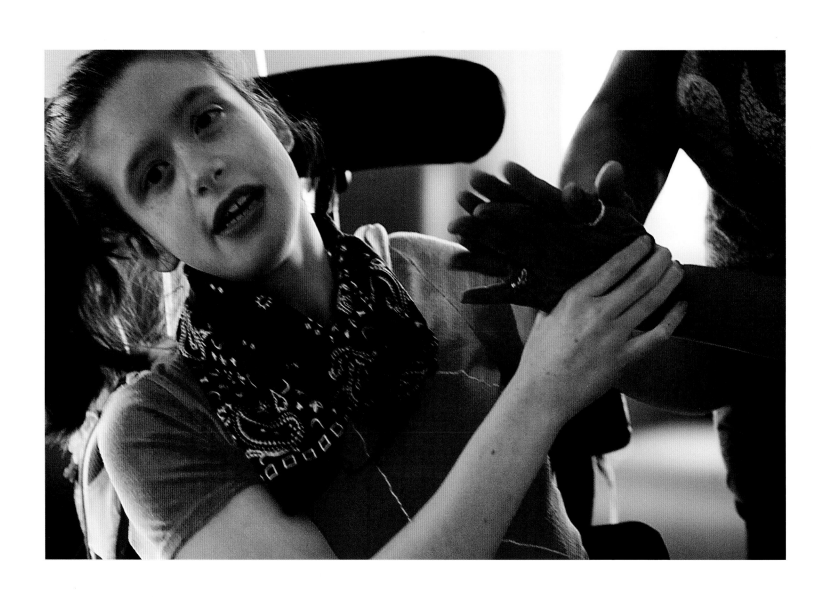

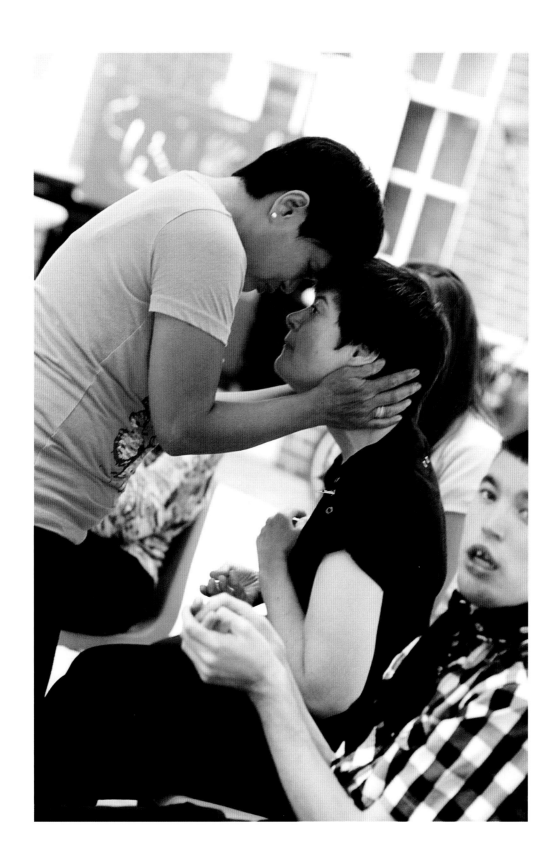

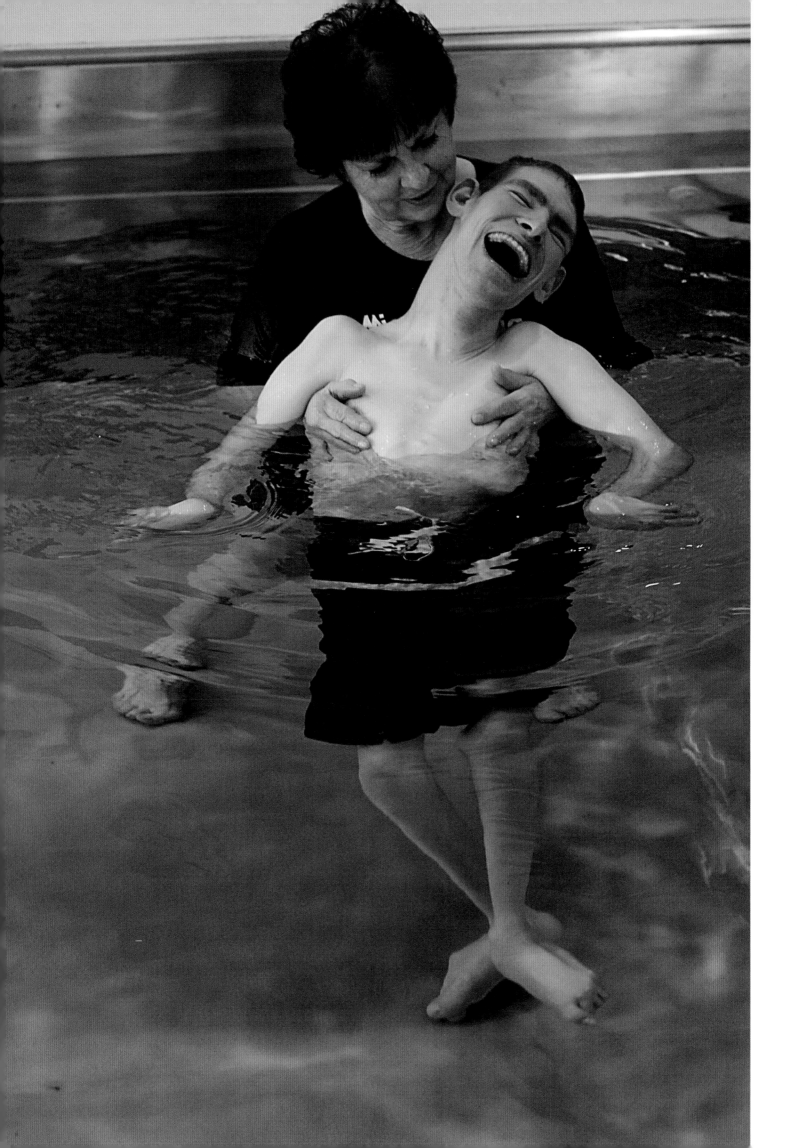

Water Therapy and Athletics

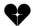

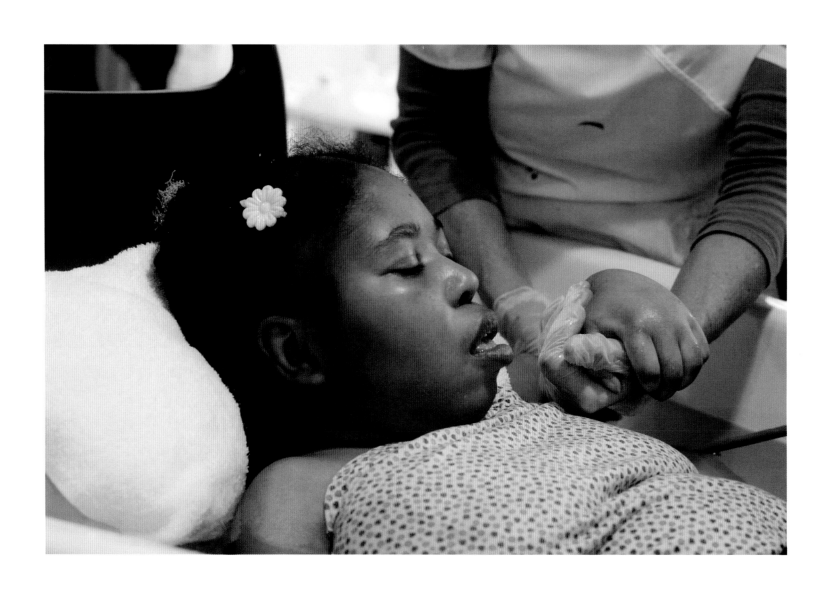

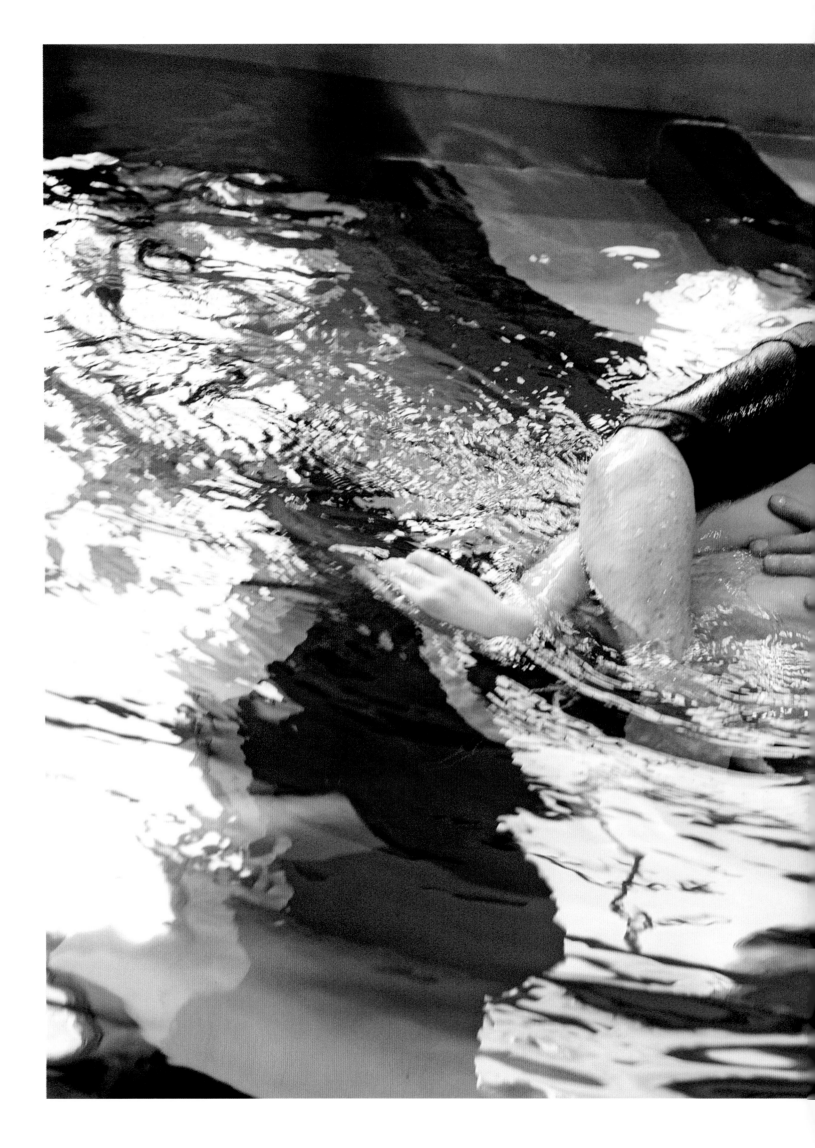

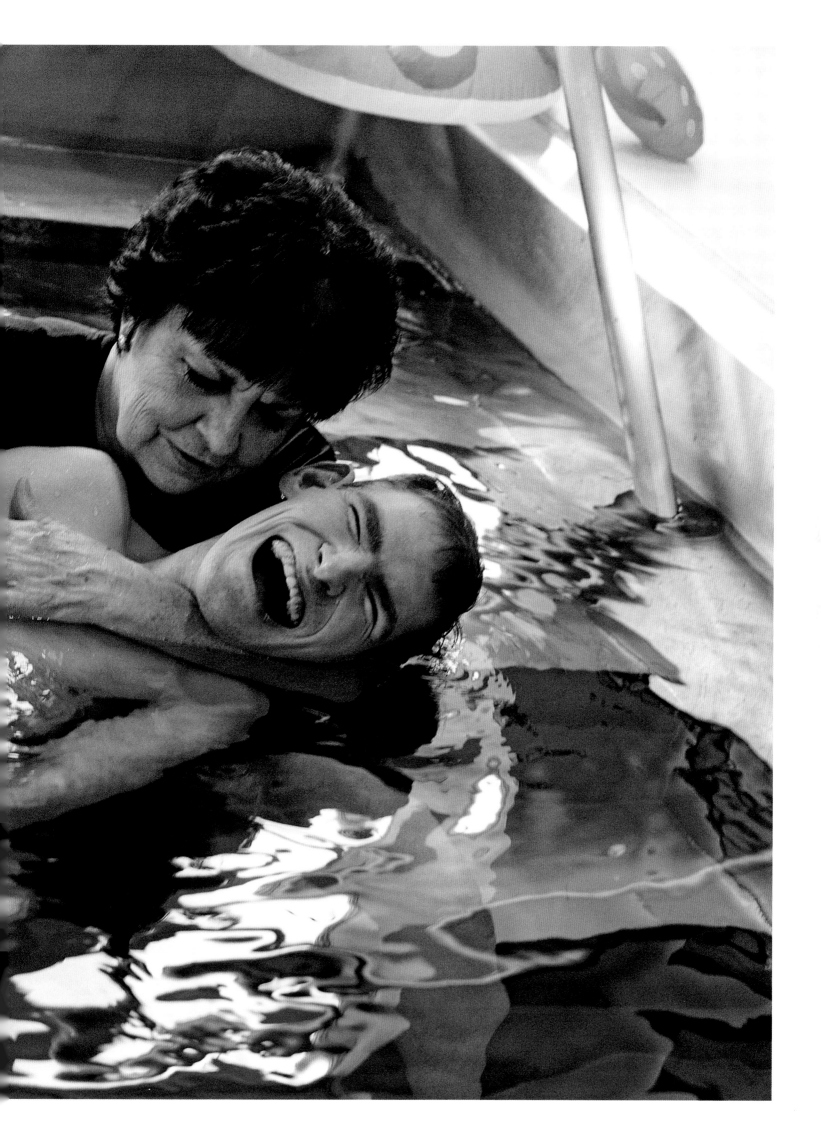

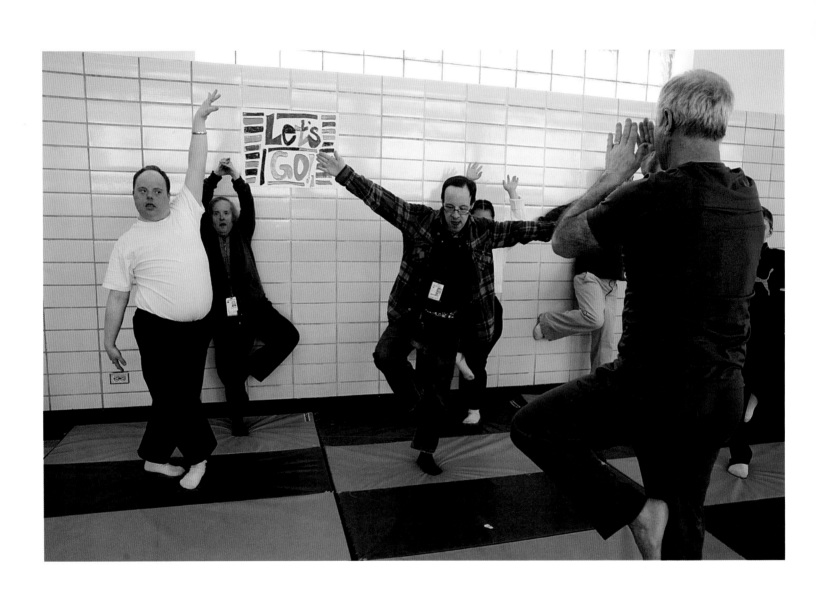

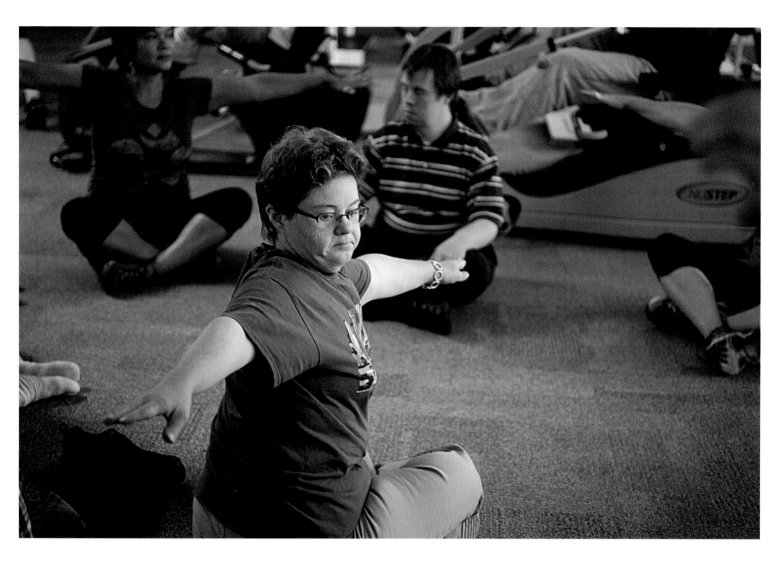

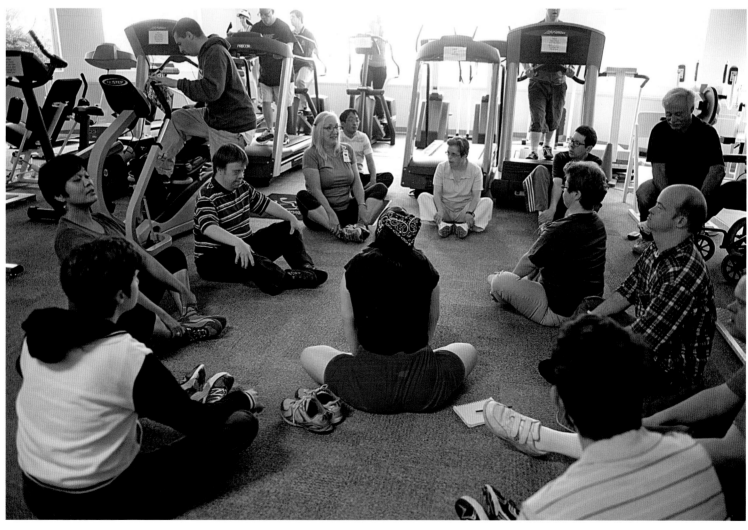

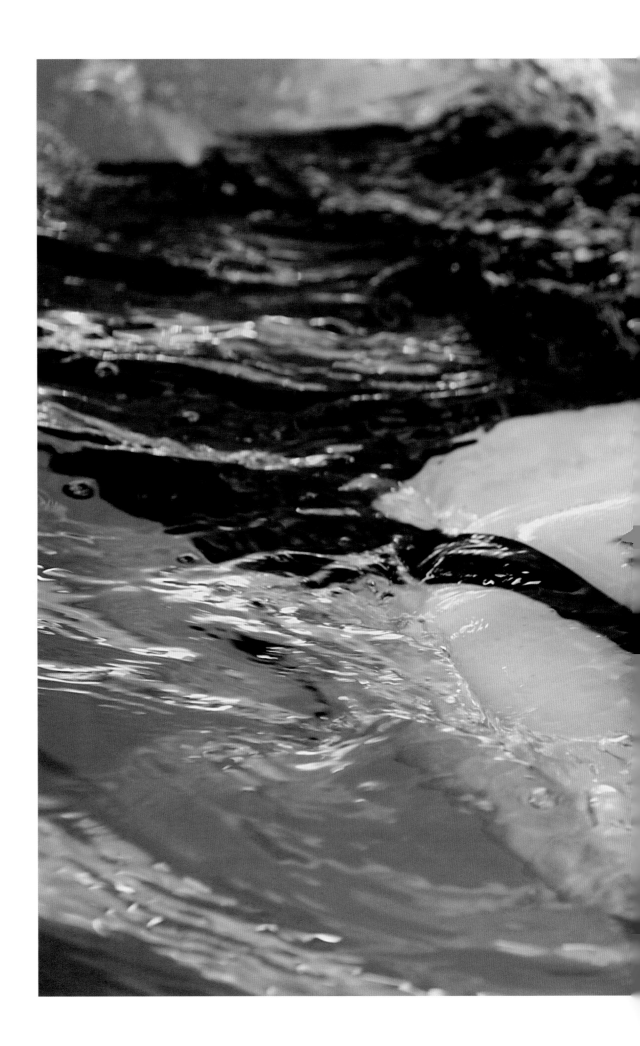

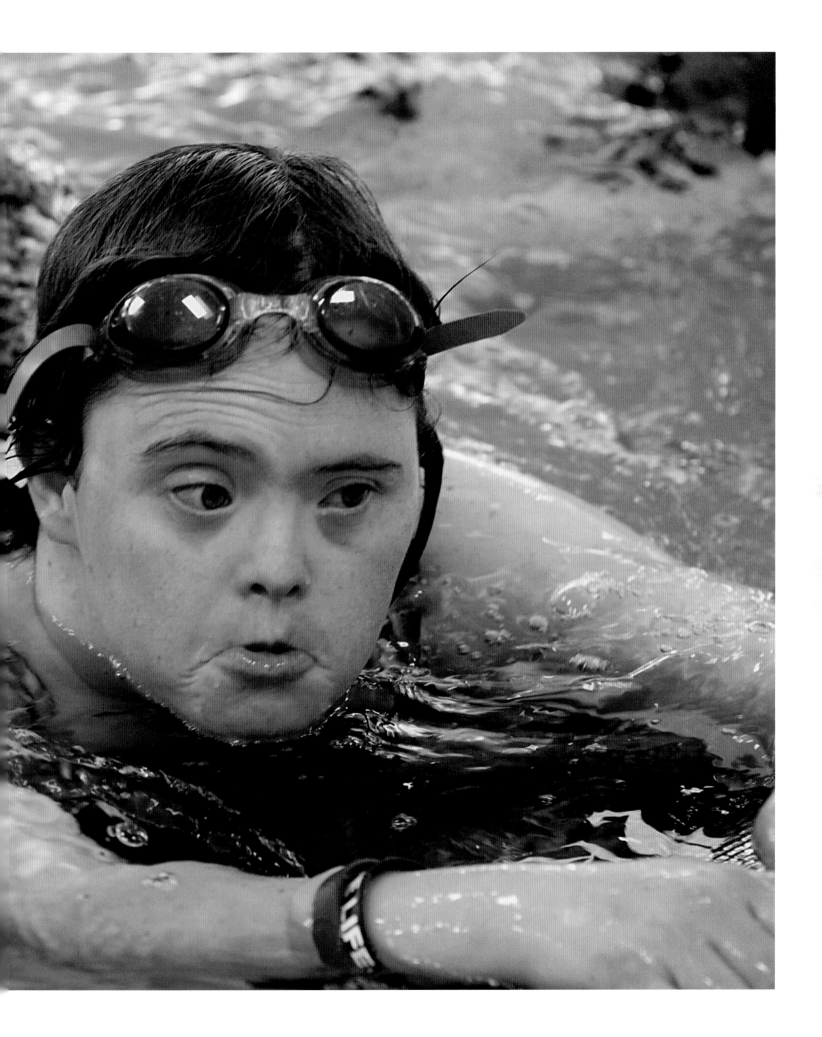

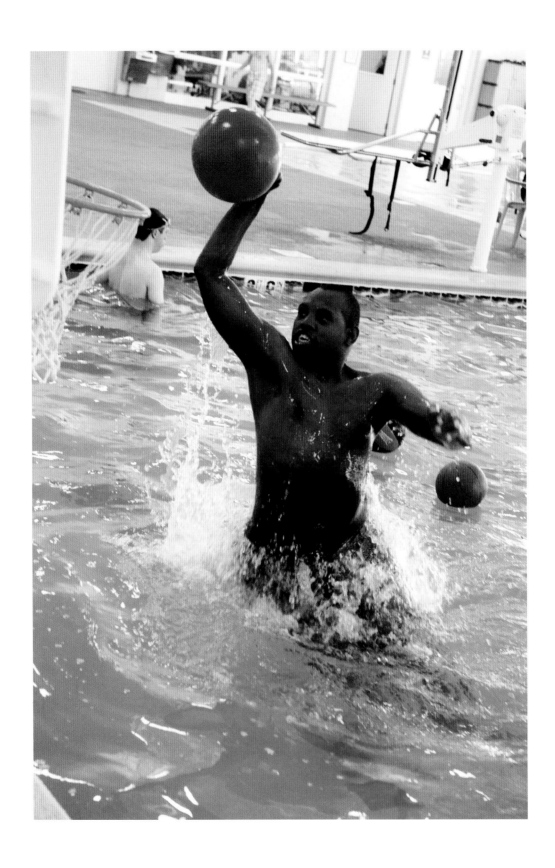

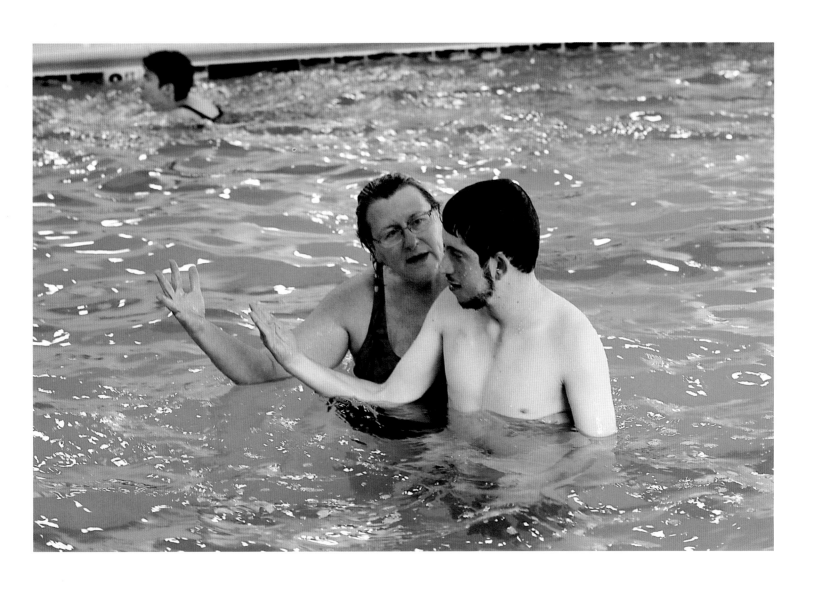

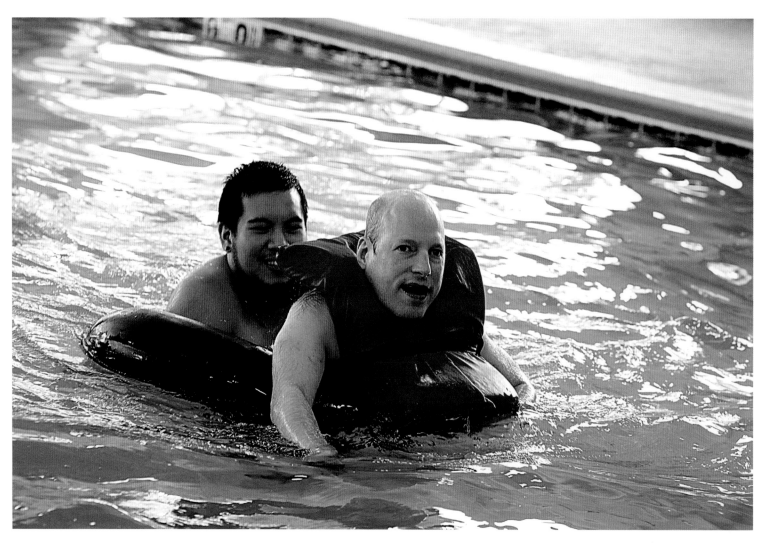

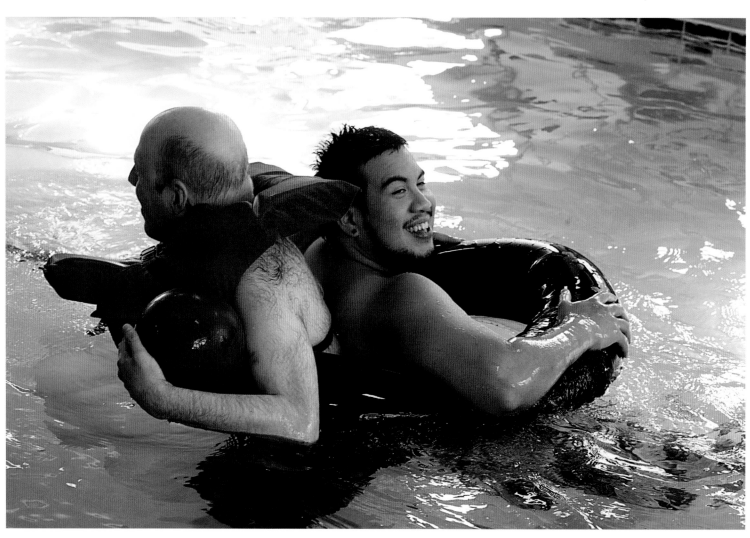

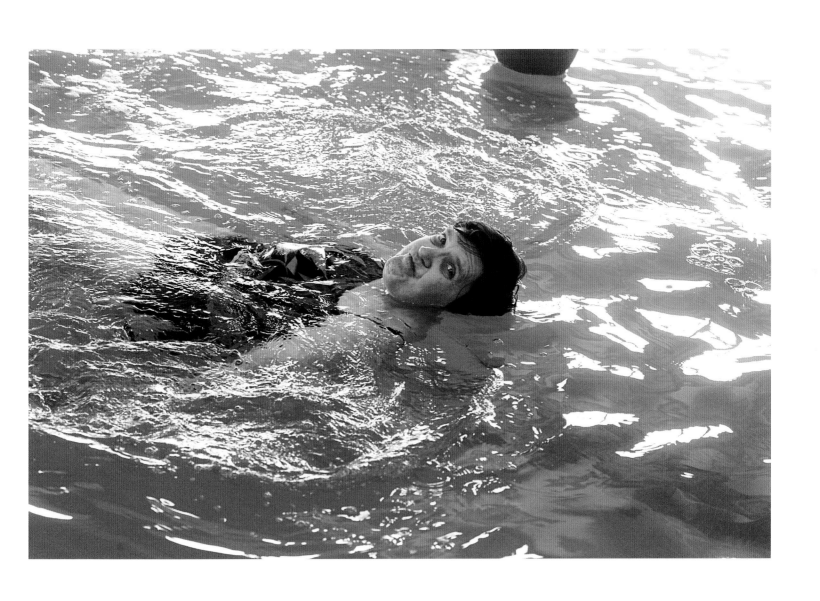

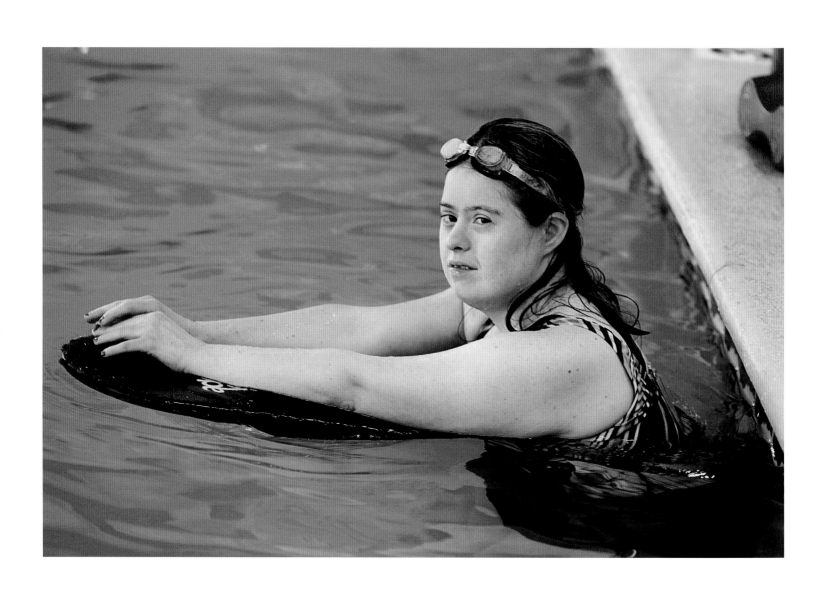

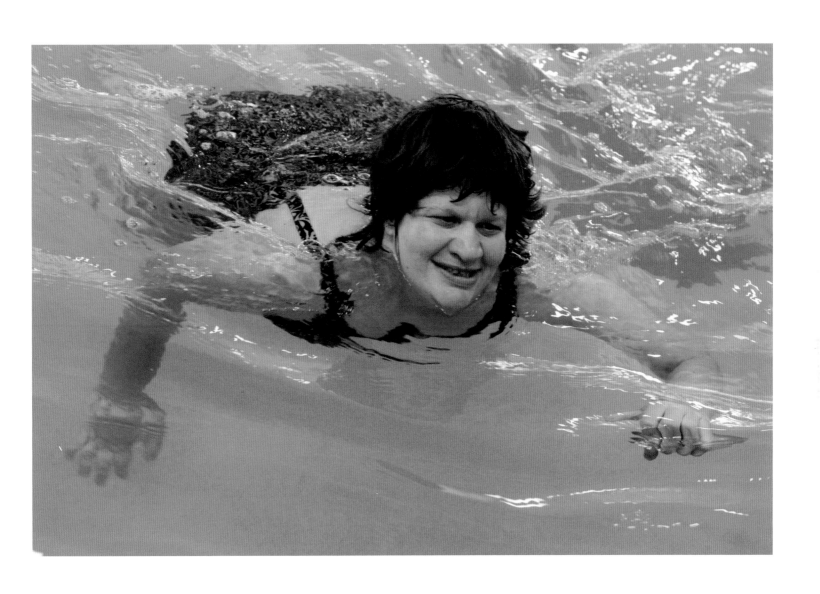

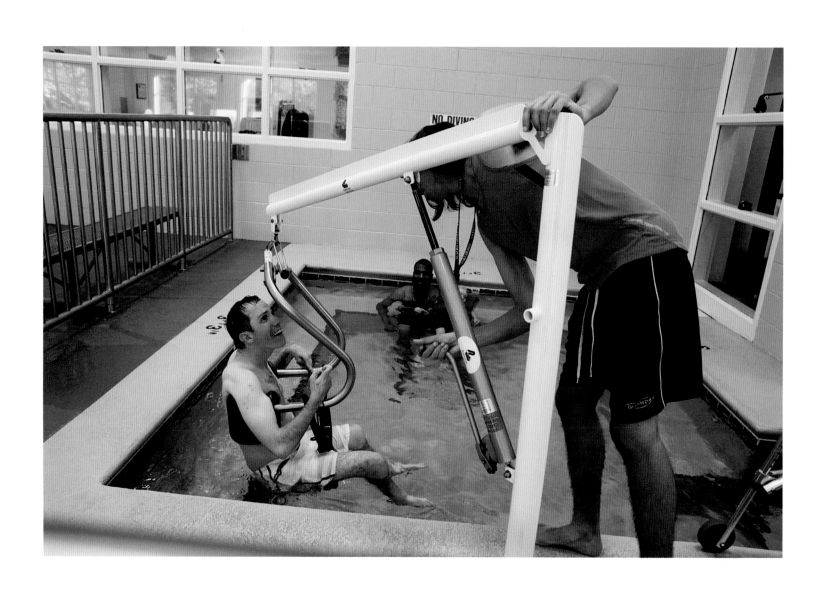

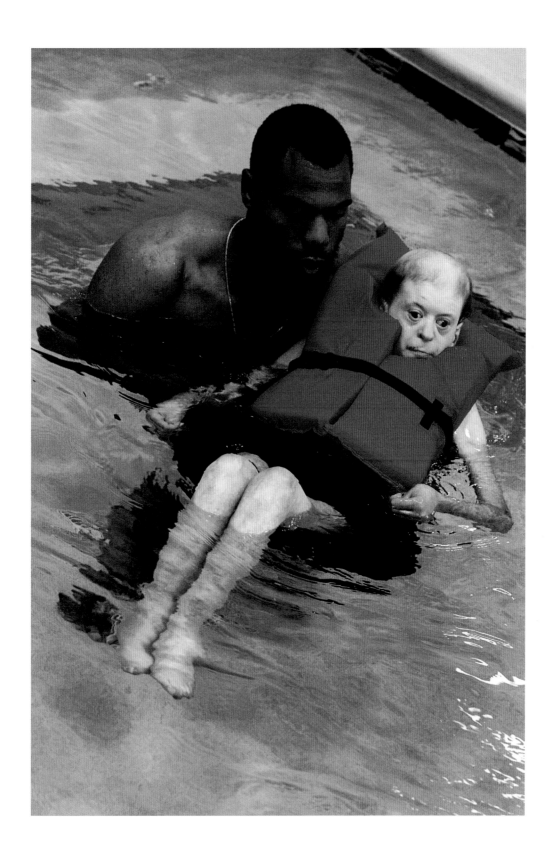

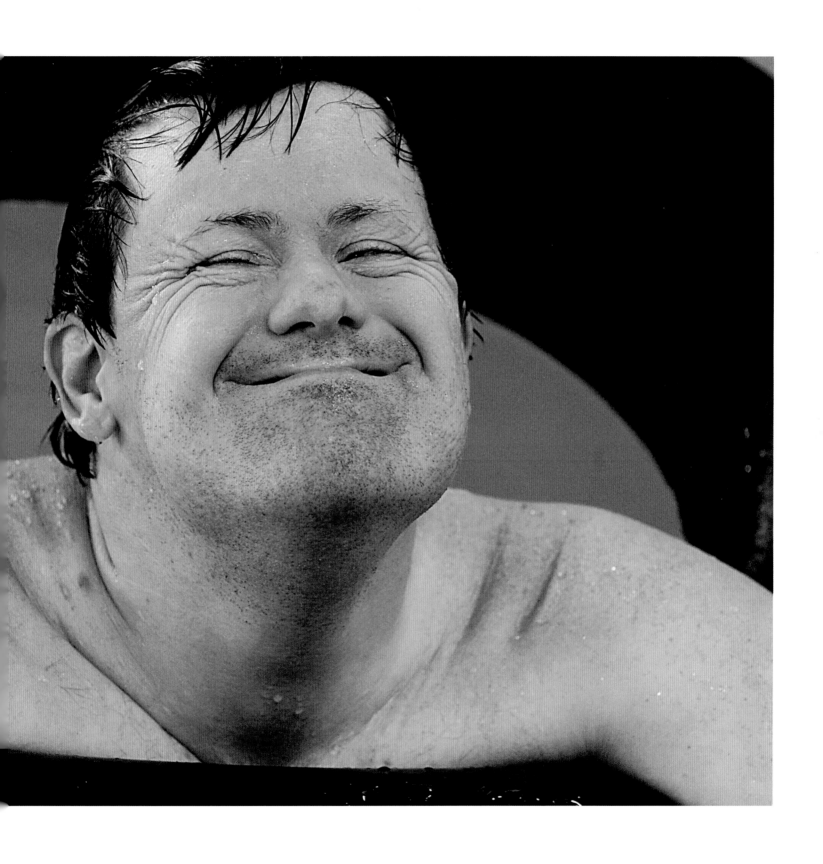

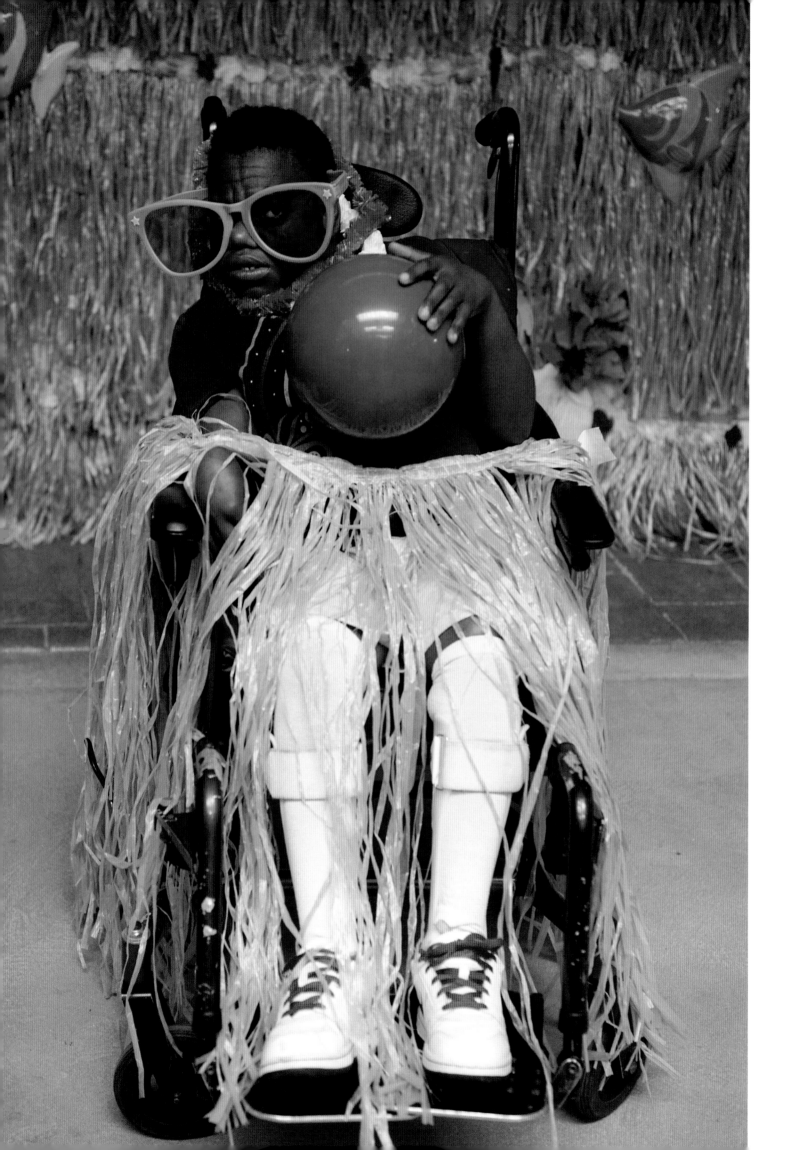

Outings / Off Campus

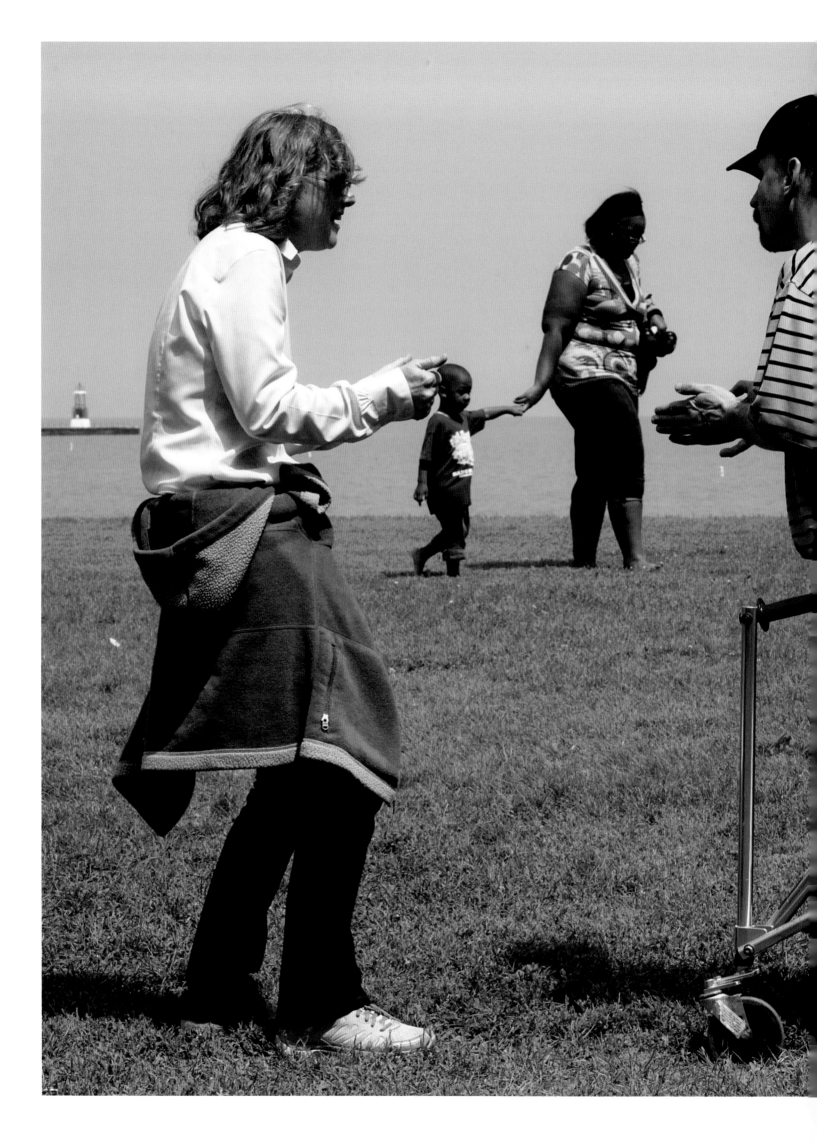

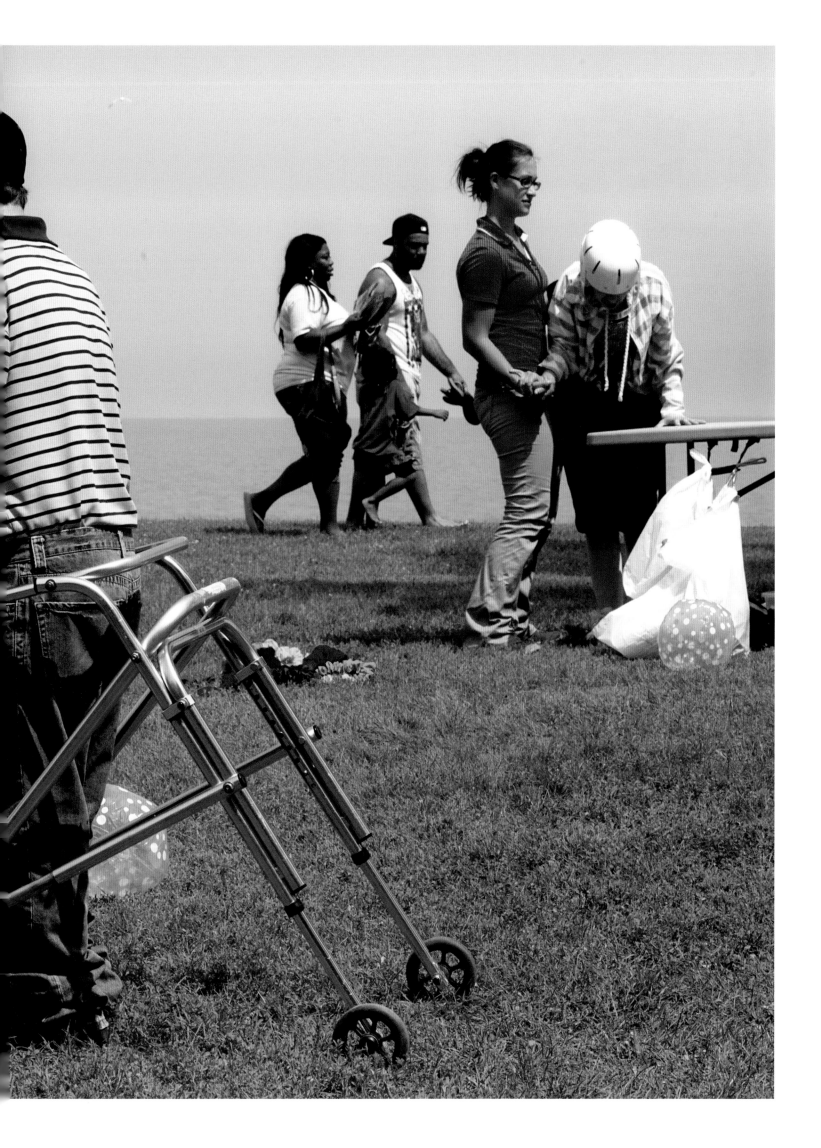

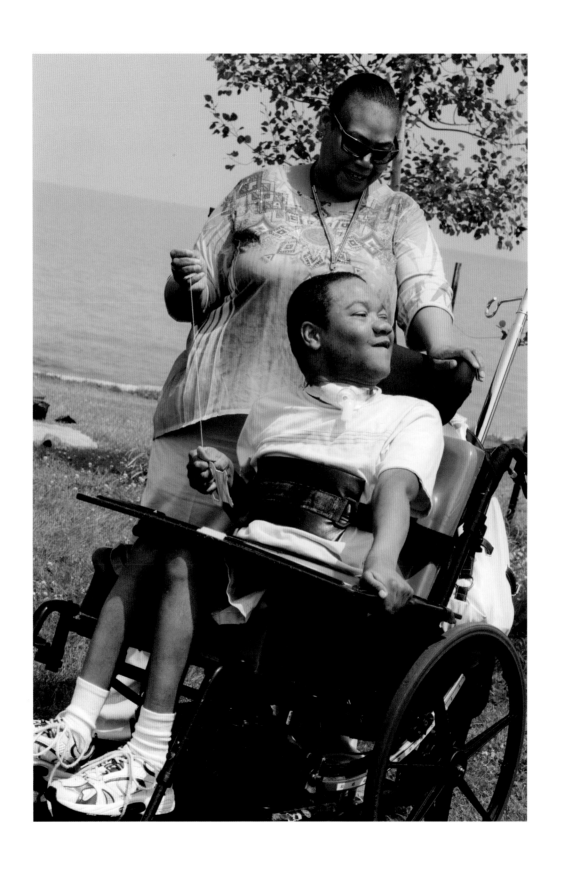

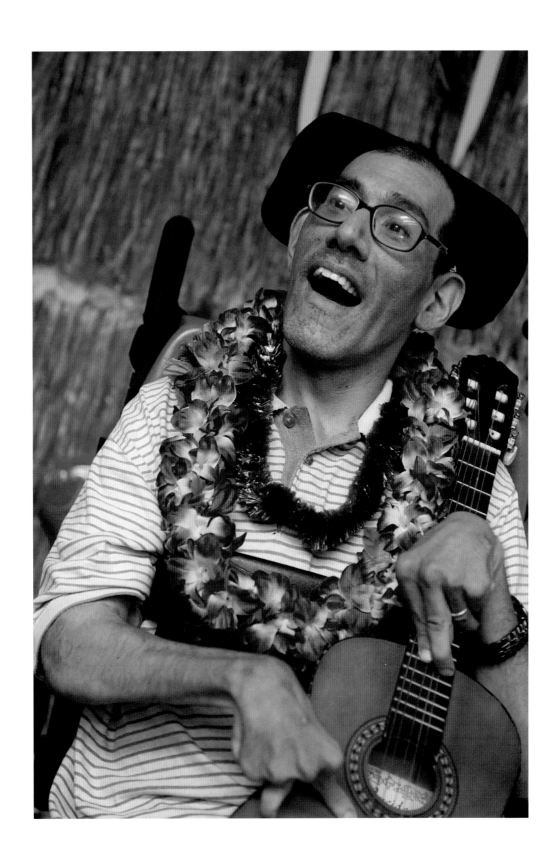

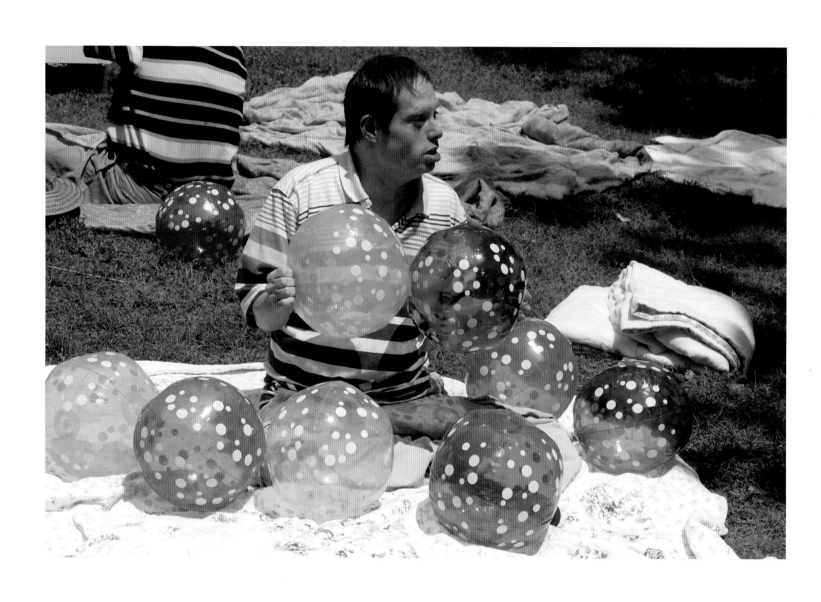

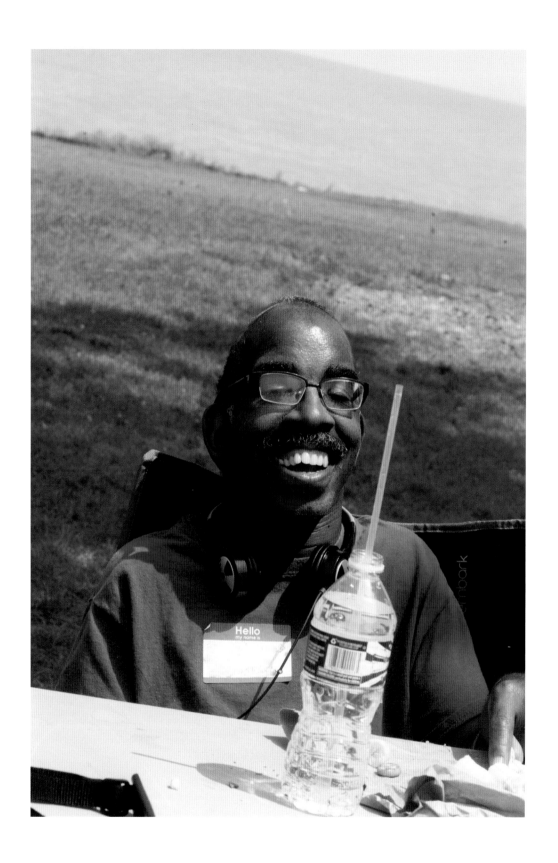

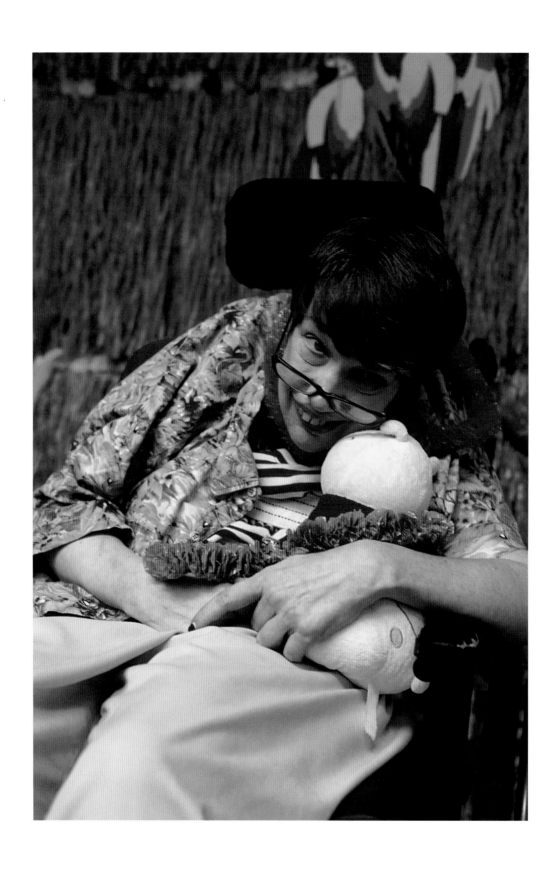

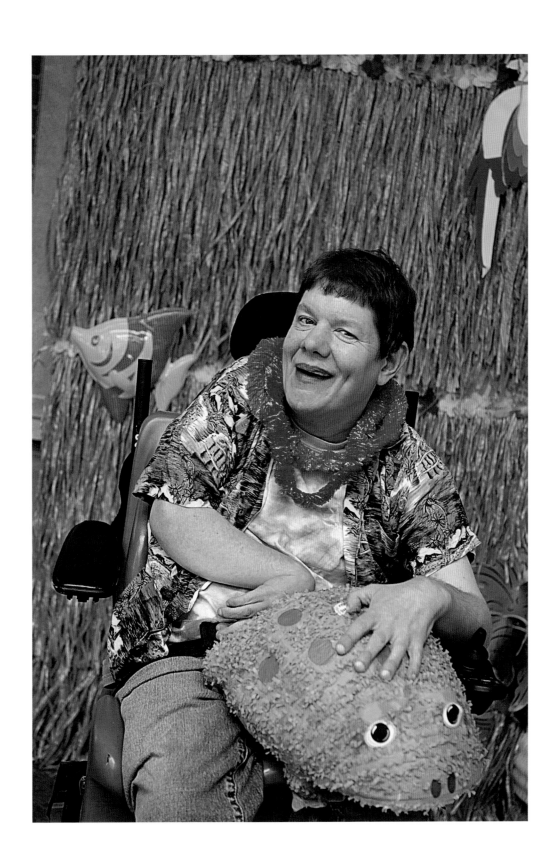

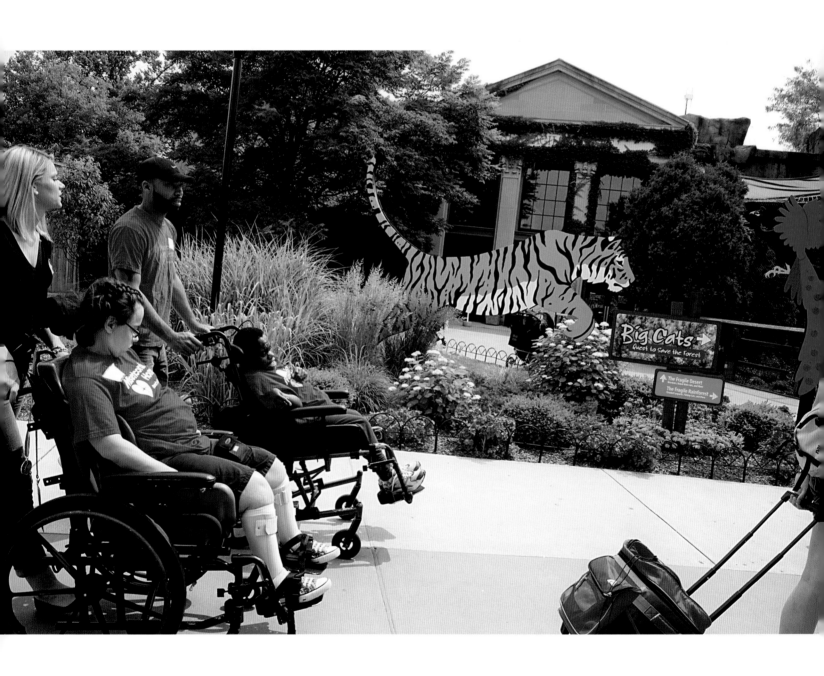

Brookfield ZOO

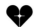

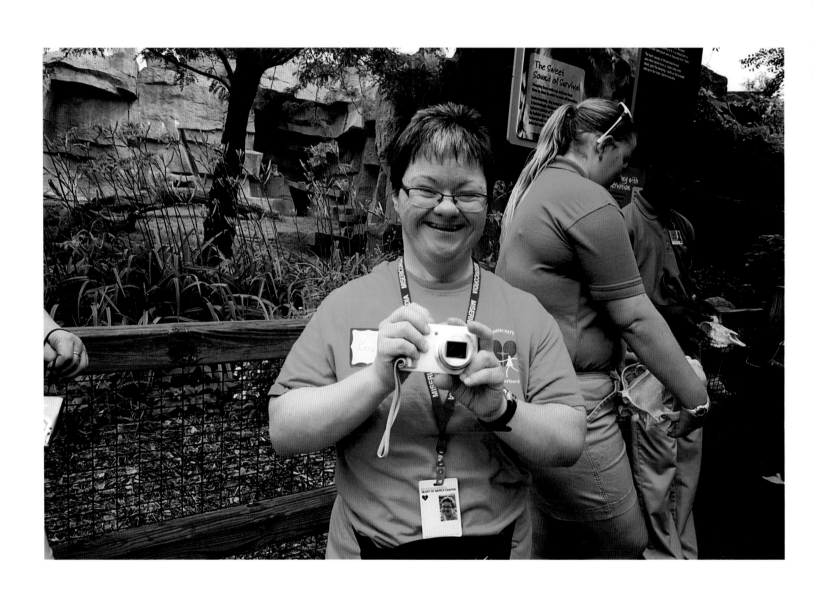

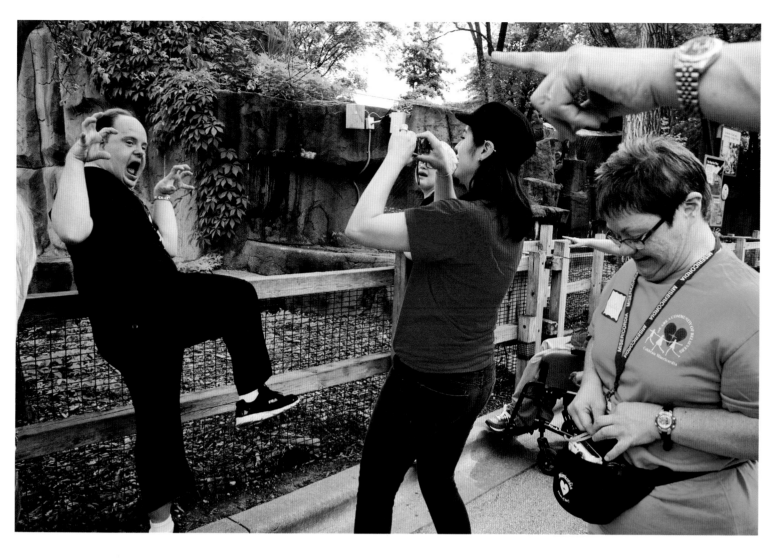

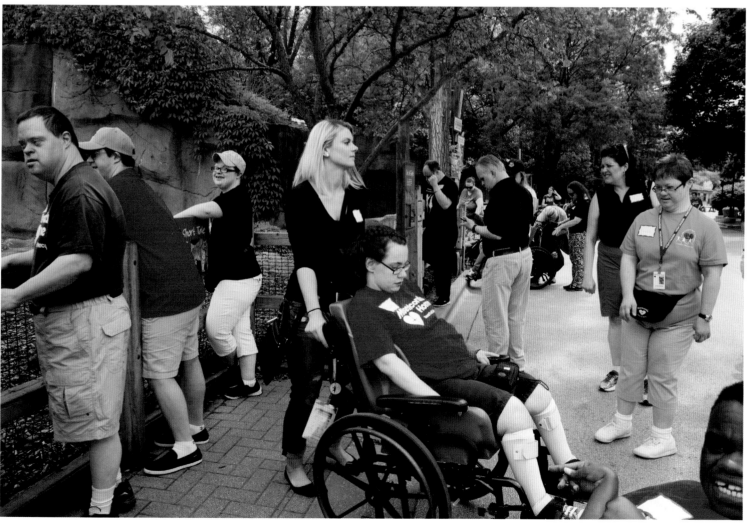

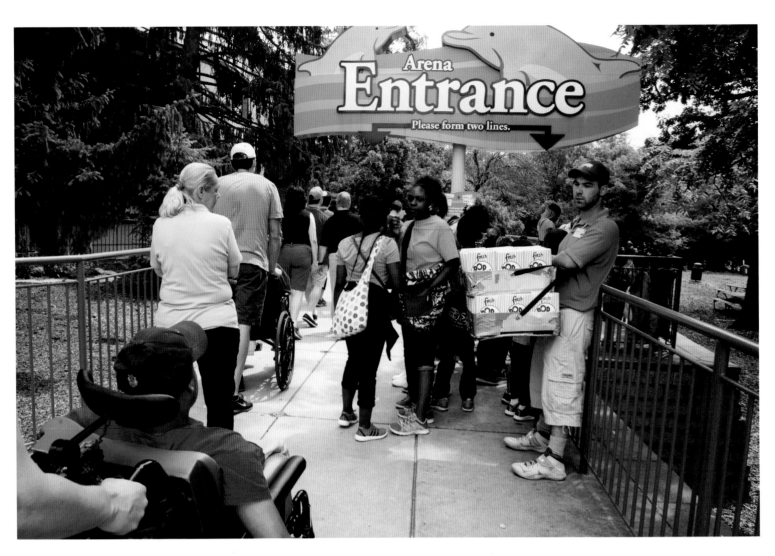

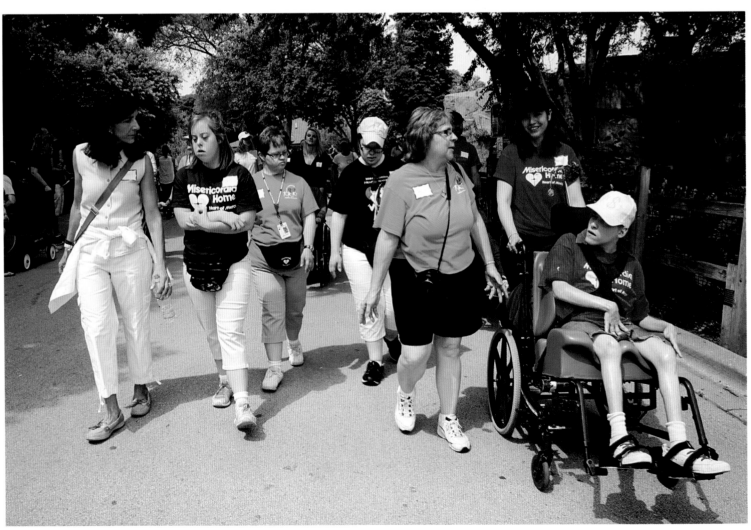

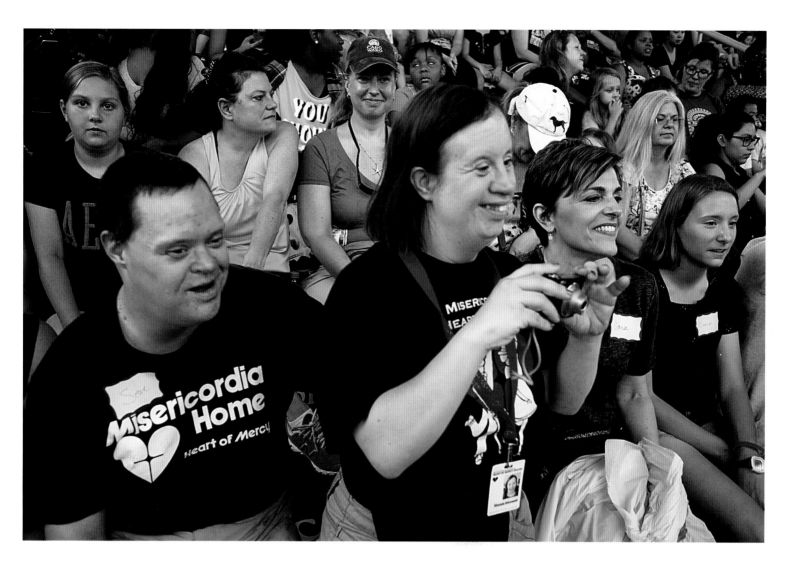

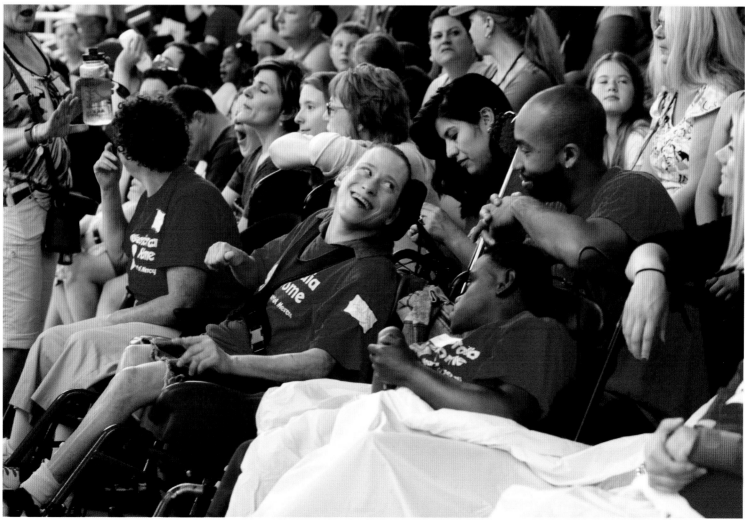

US Cellular Field

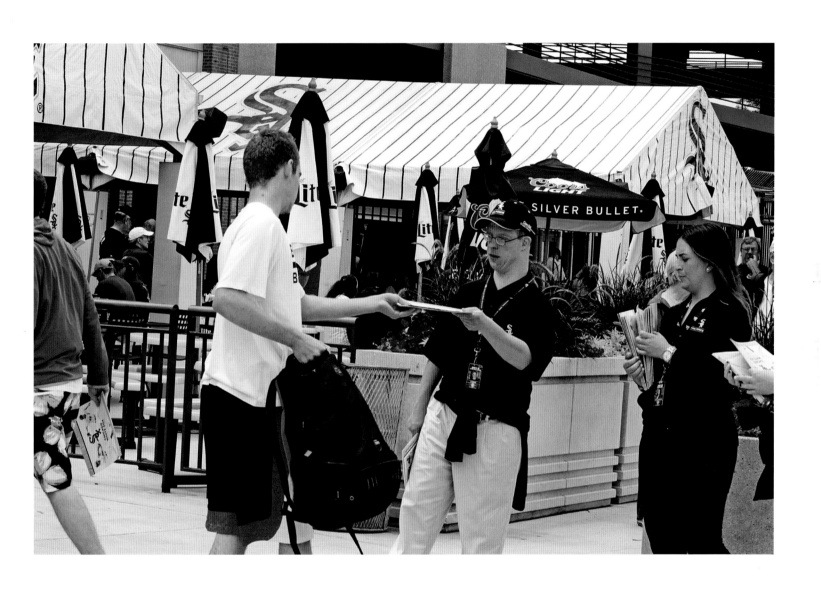

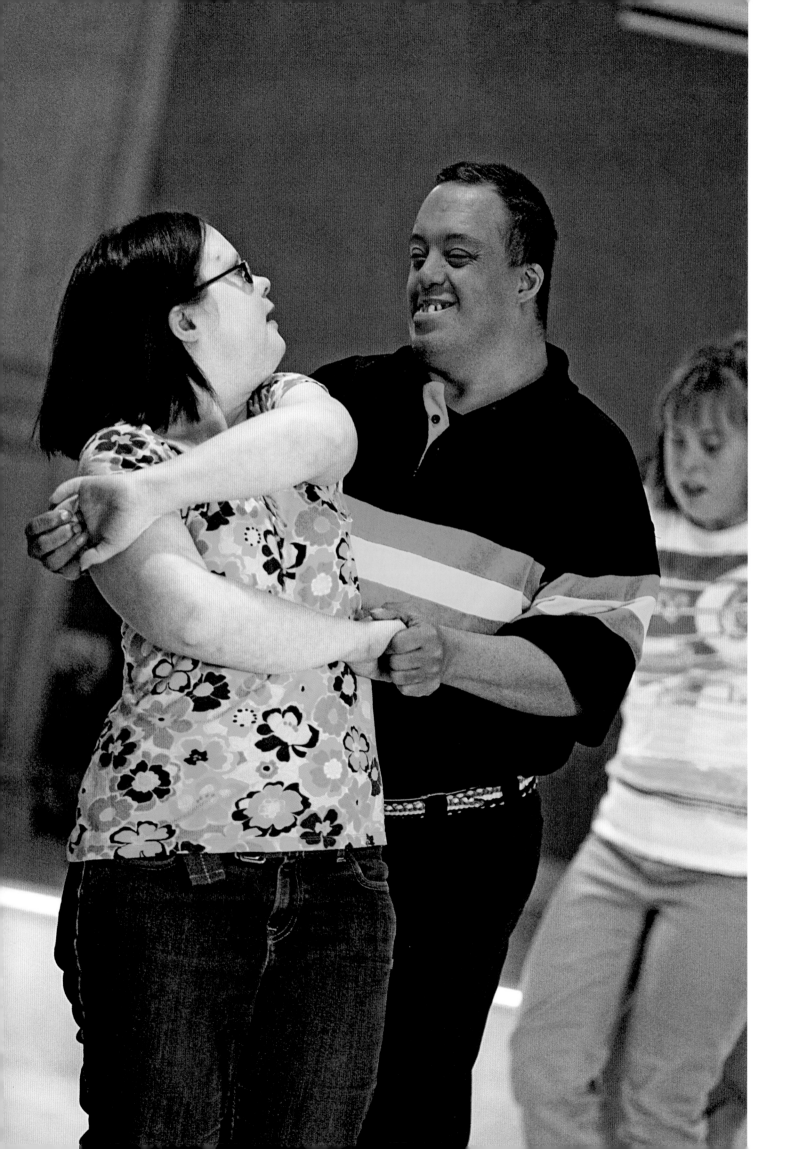

Music and Dance

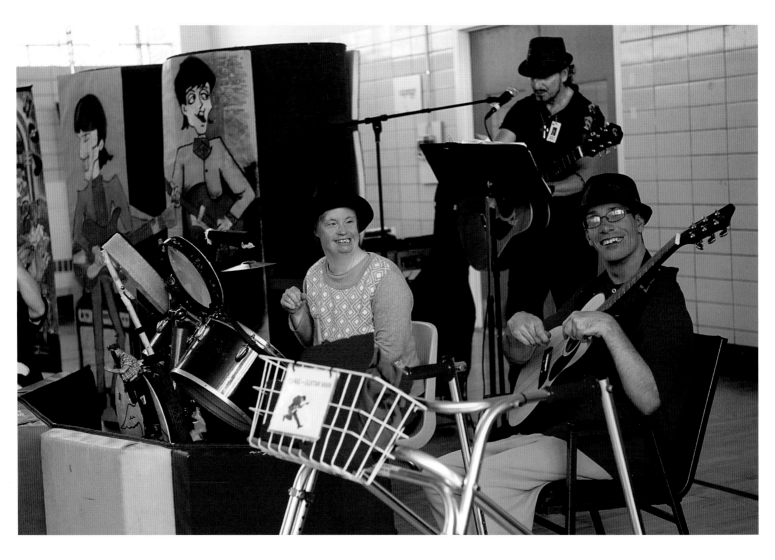

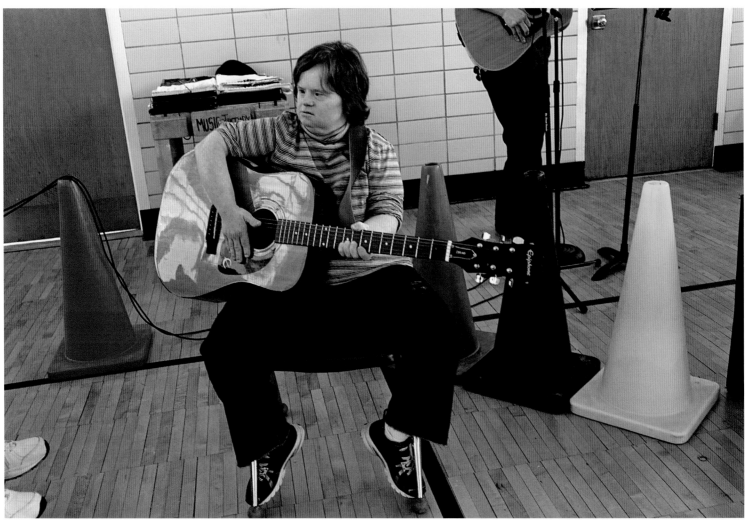

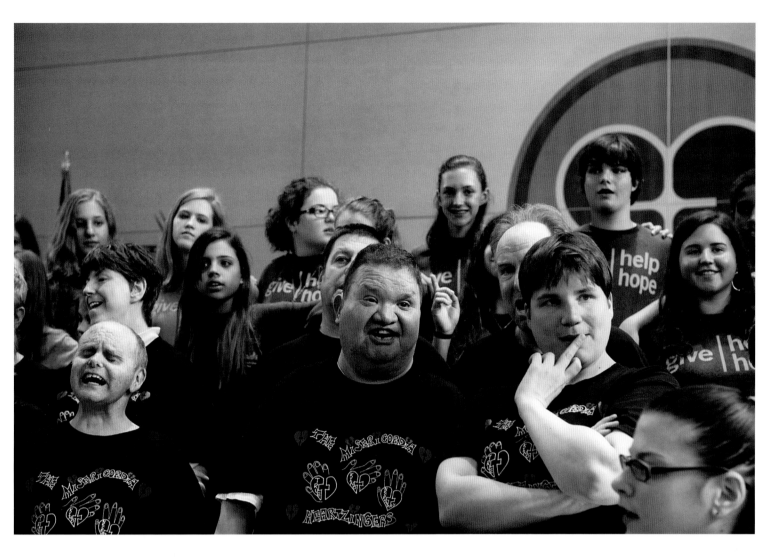

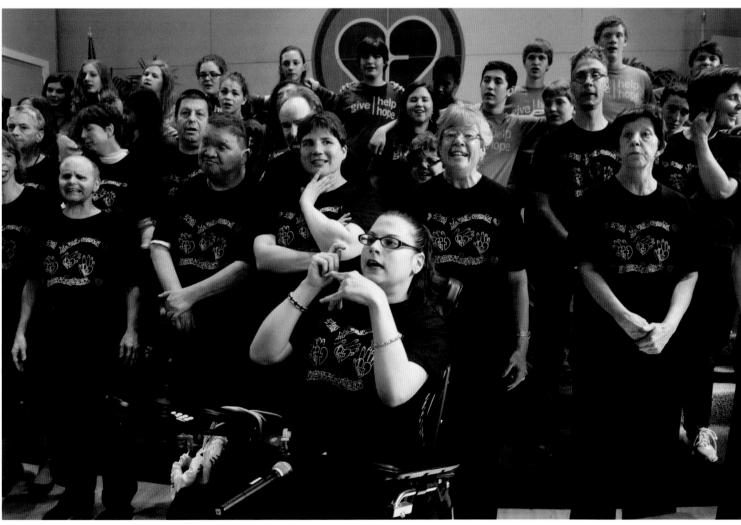

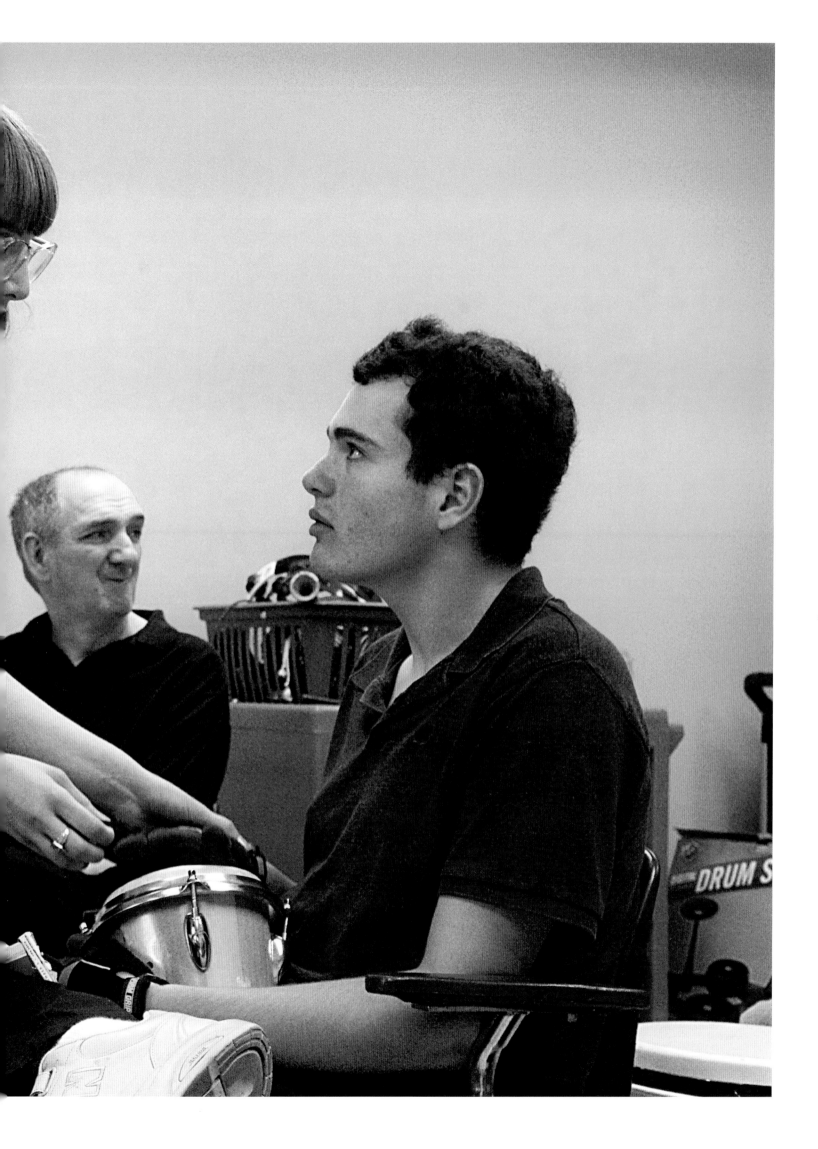

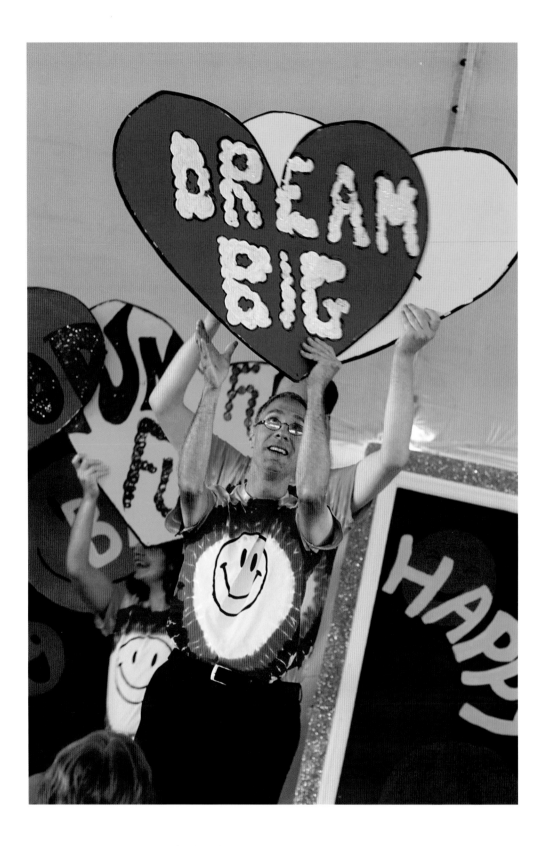

Believe it or not, all the players in the locker room on a daily basis try to emulate the spirit, the emotion, the heart, and the love that you guys all have here at Misericordia. And, I think that is a huge reason we've been champions more than once. So, it is fair to say that you guys have a huge part in winning this trophy again and we thank you.

Jonathan Toews
Captain, Chicago Blackhawks

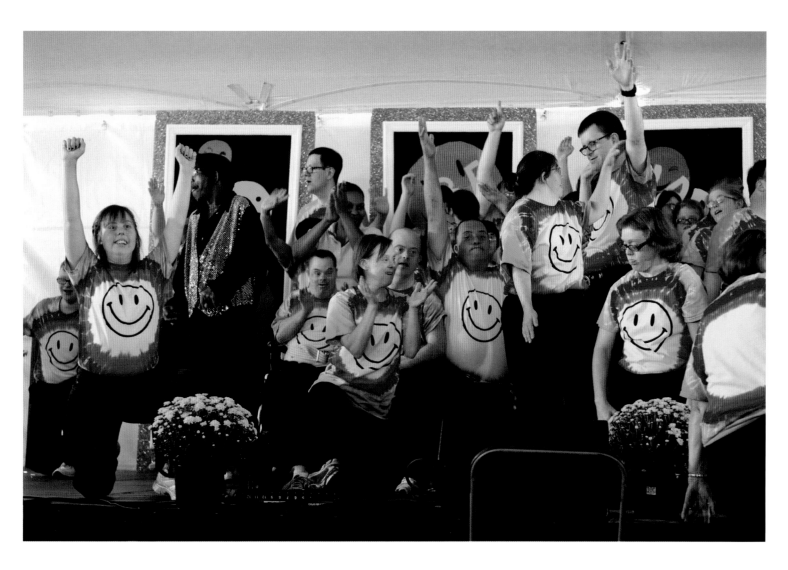

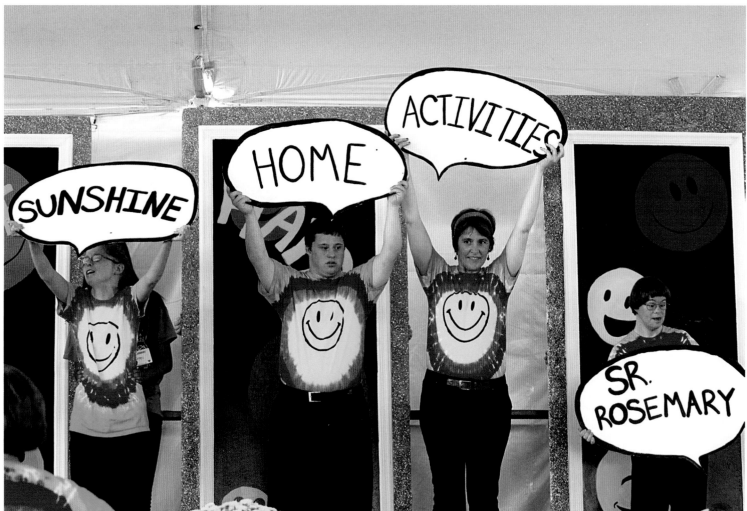

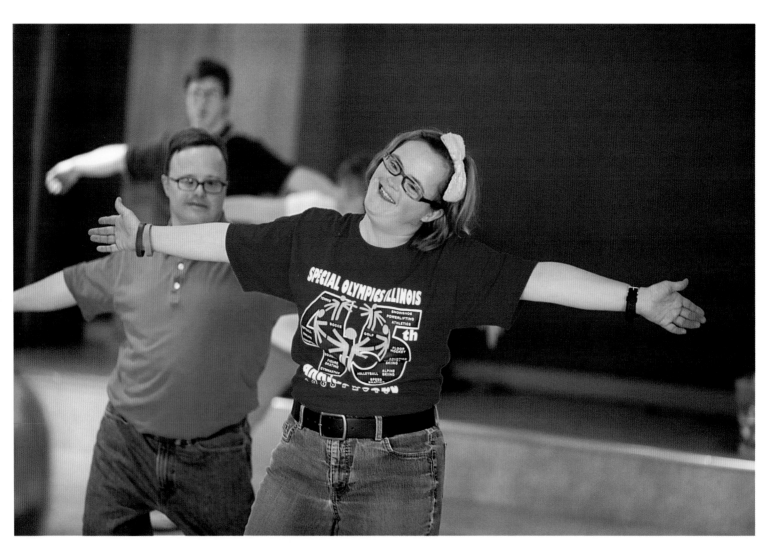
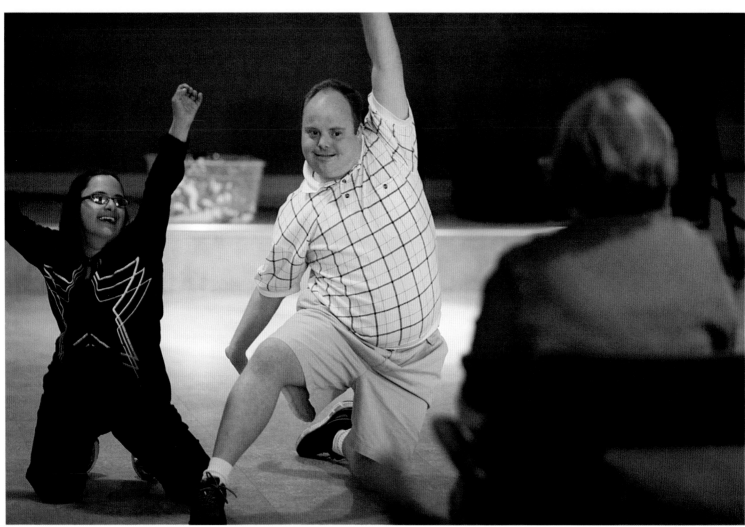

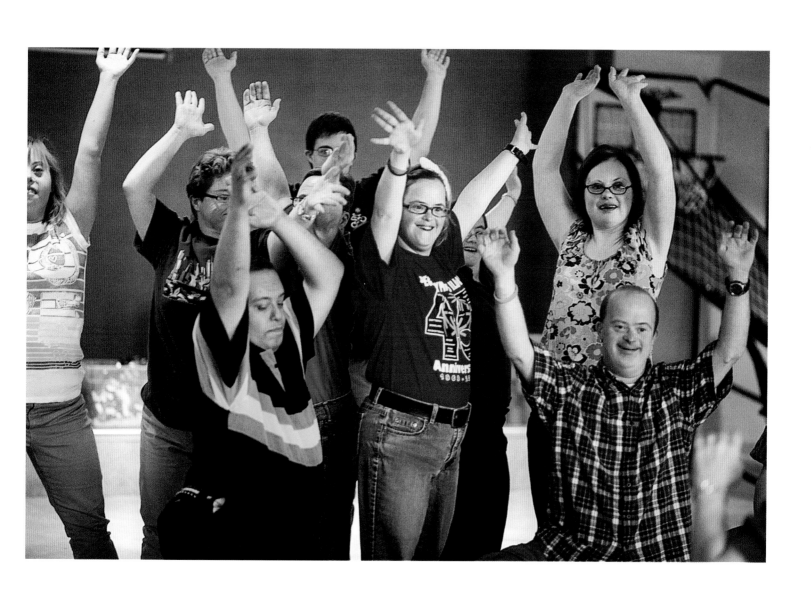

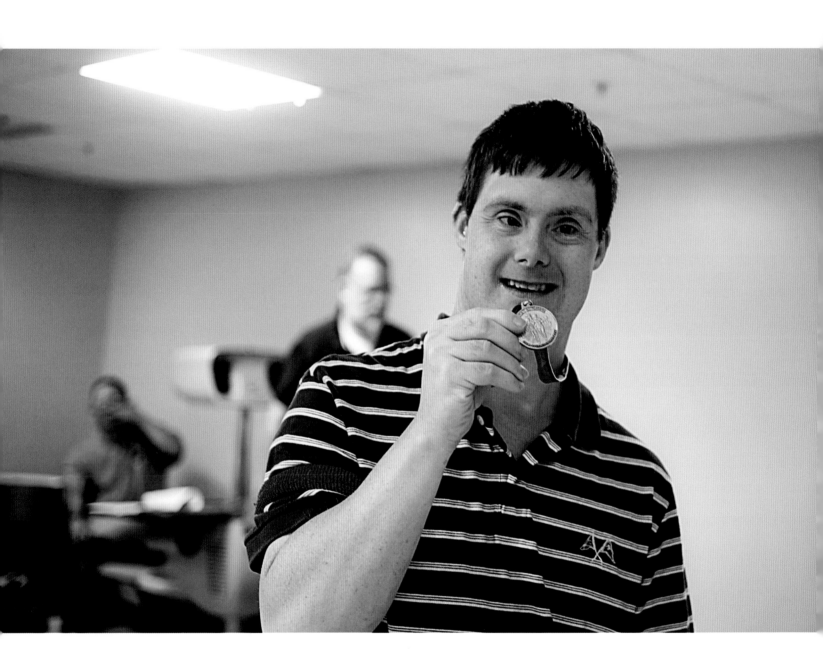

Activities and Sports

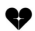

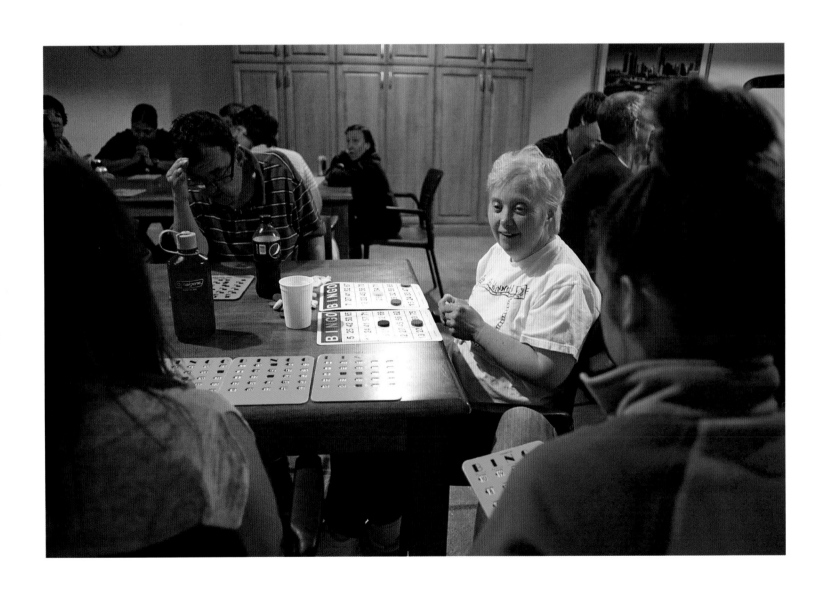

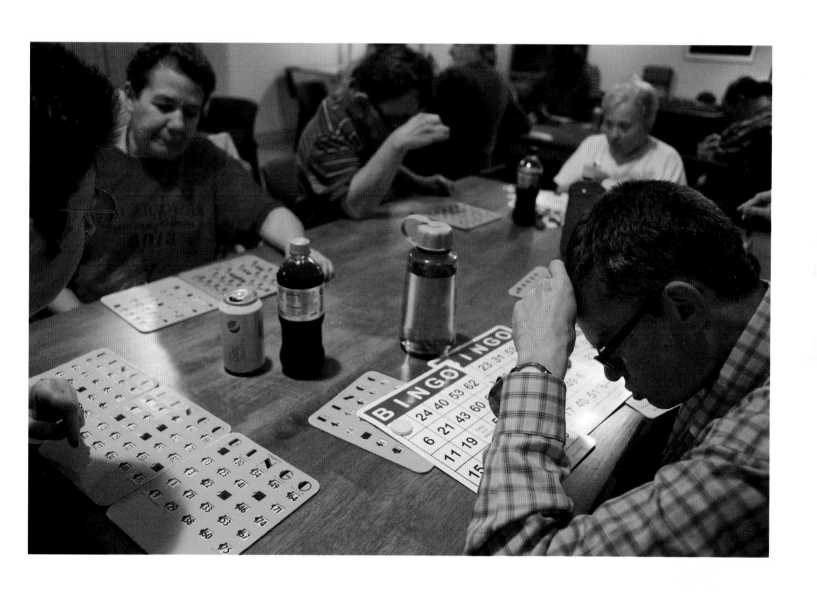

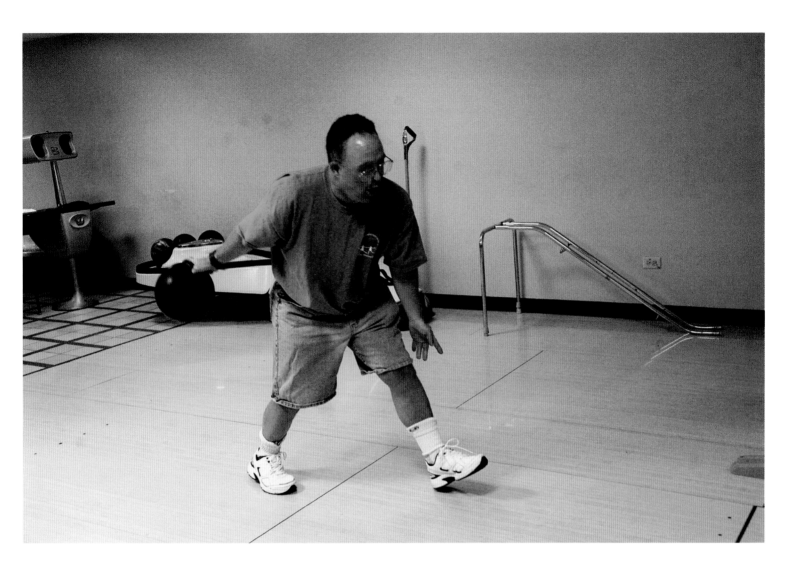

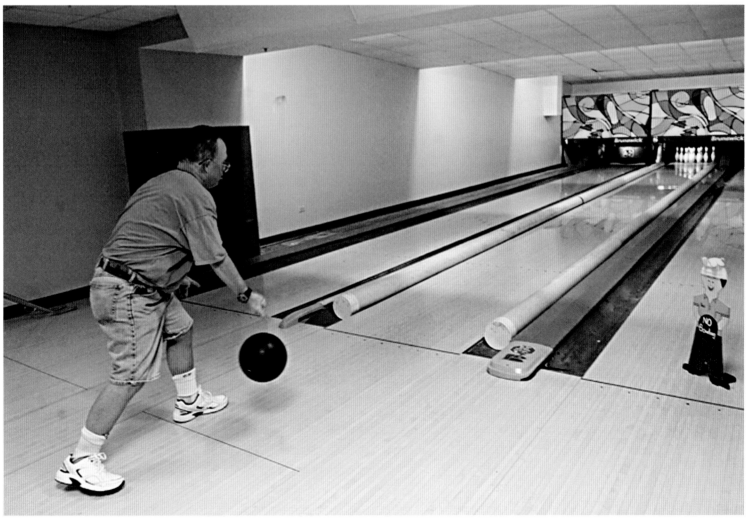

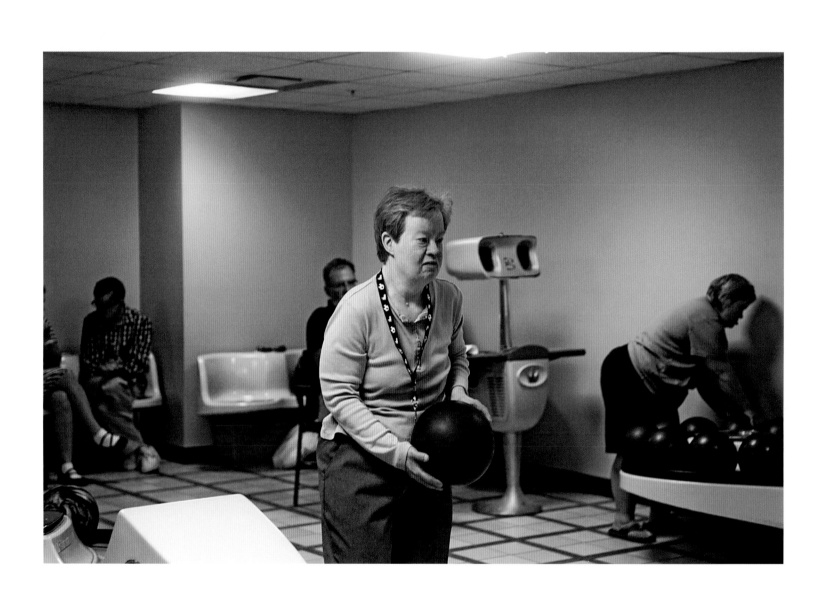

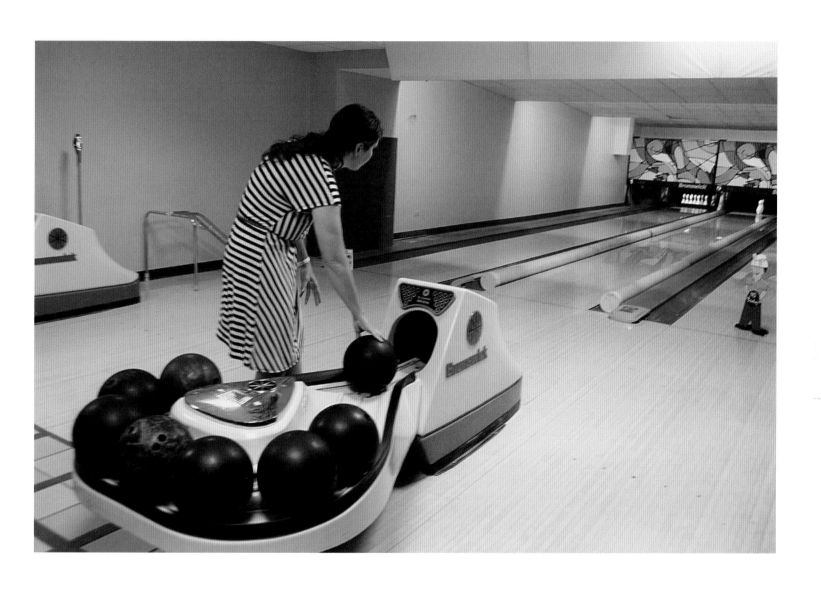

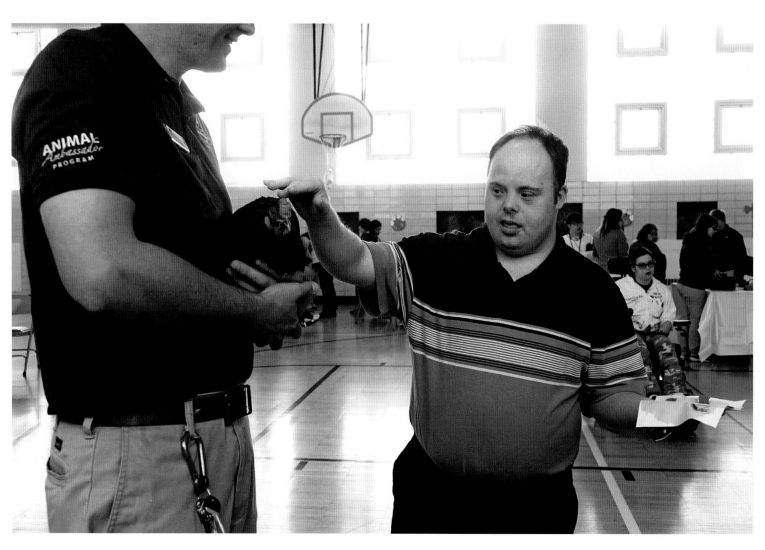

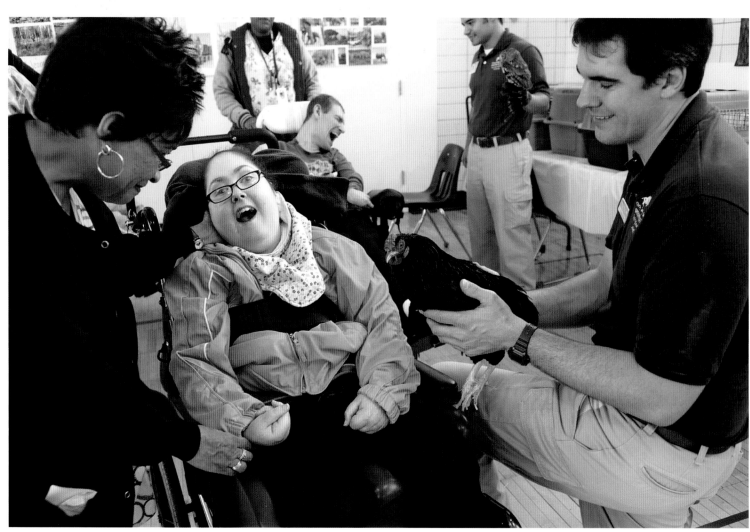

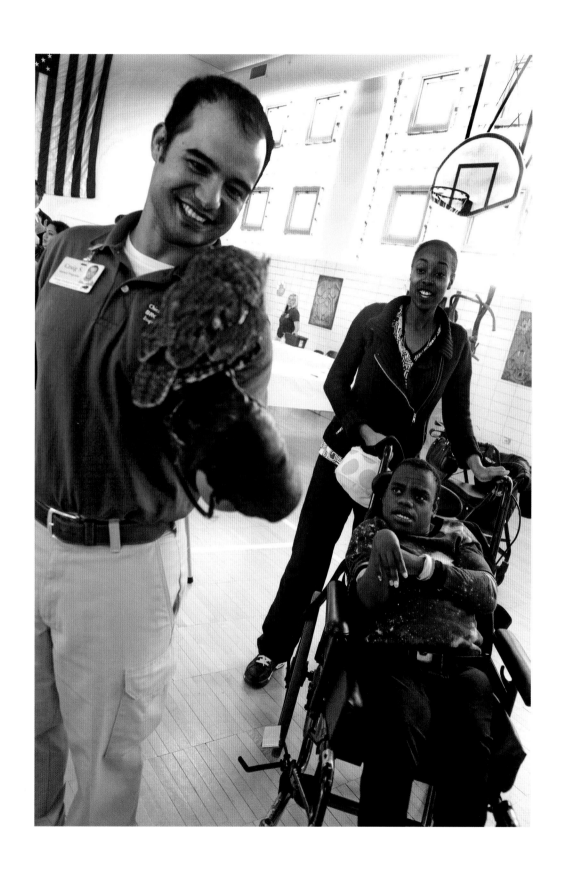

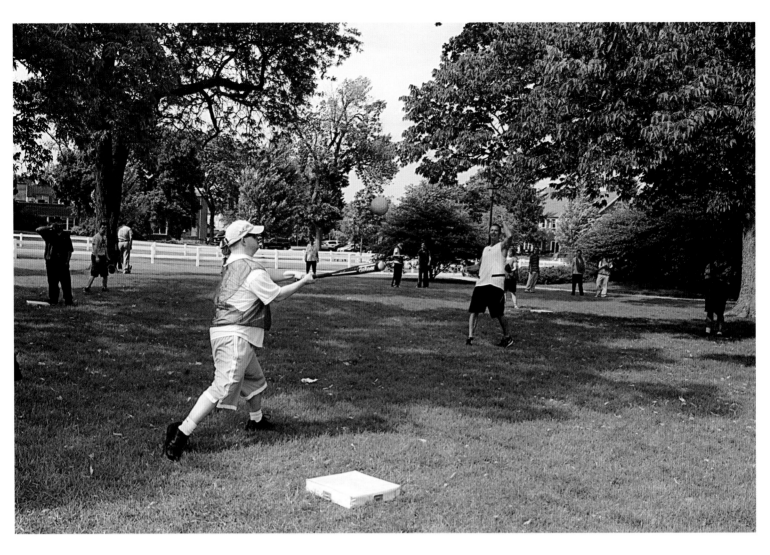

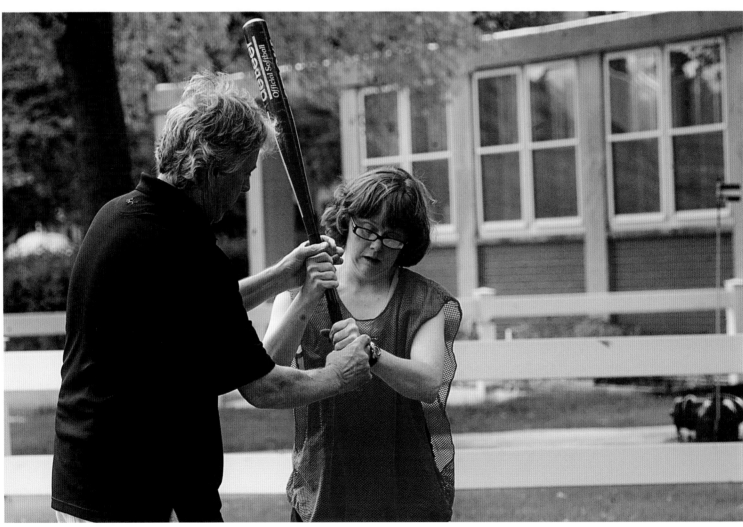

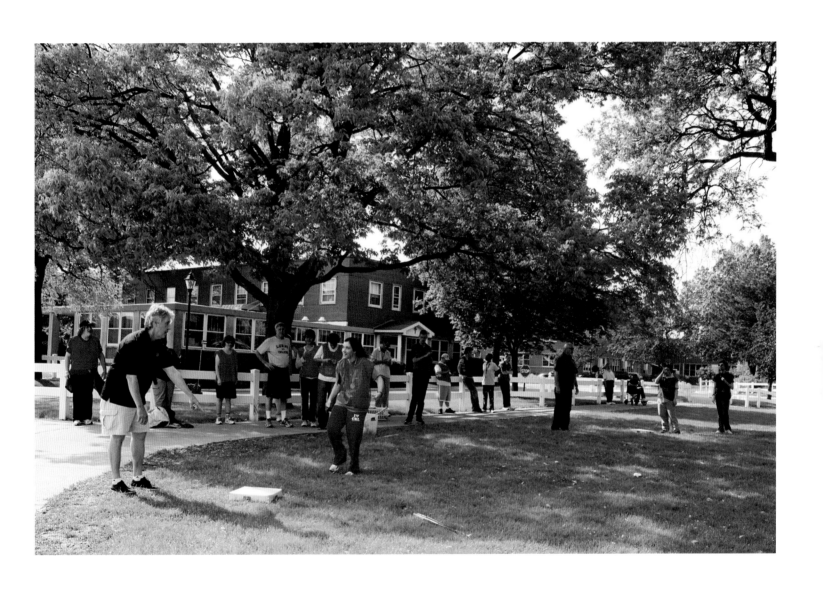

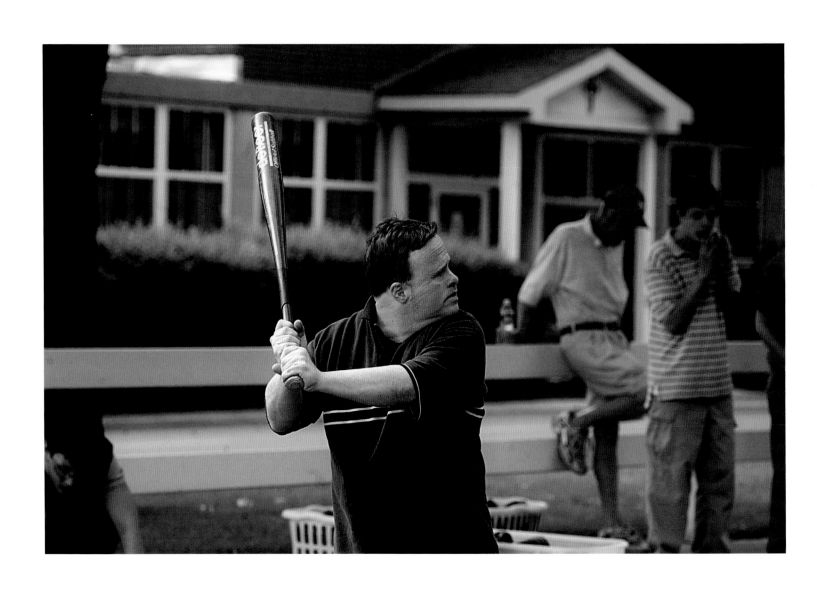

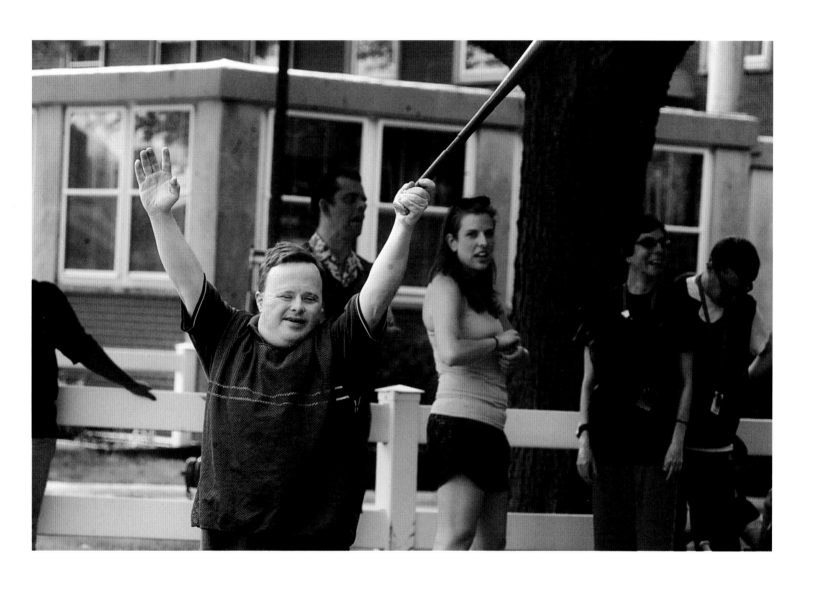

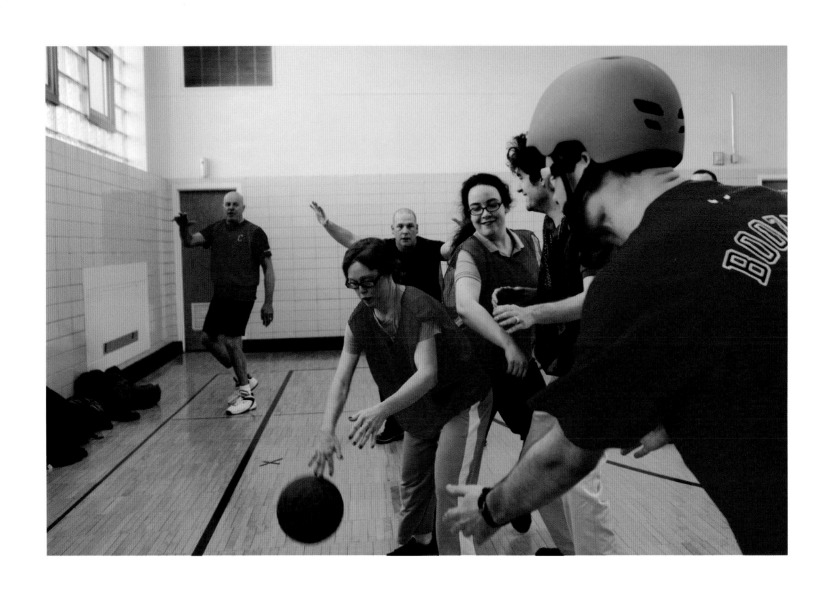

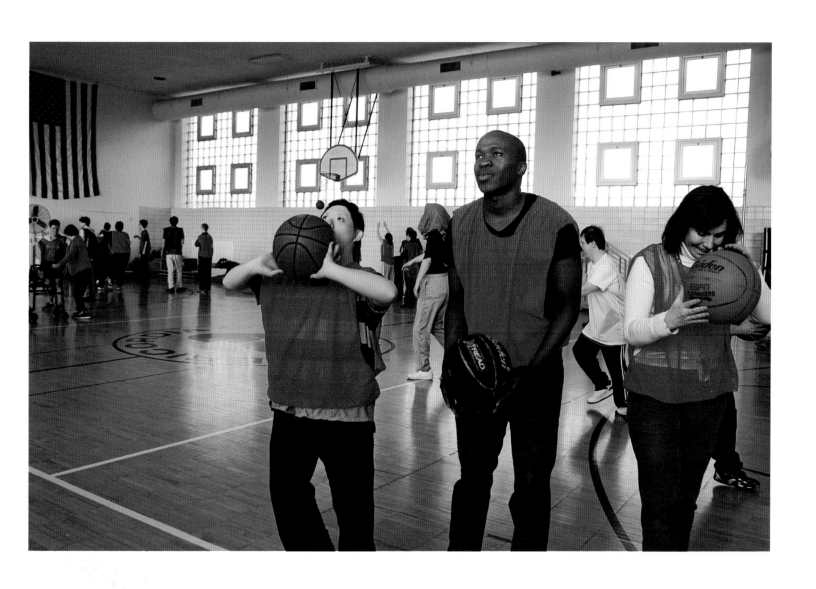

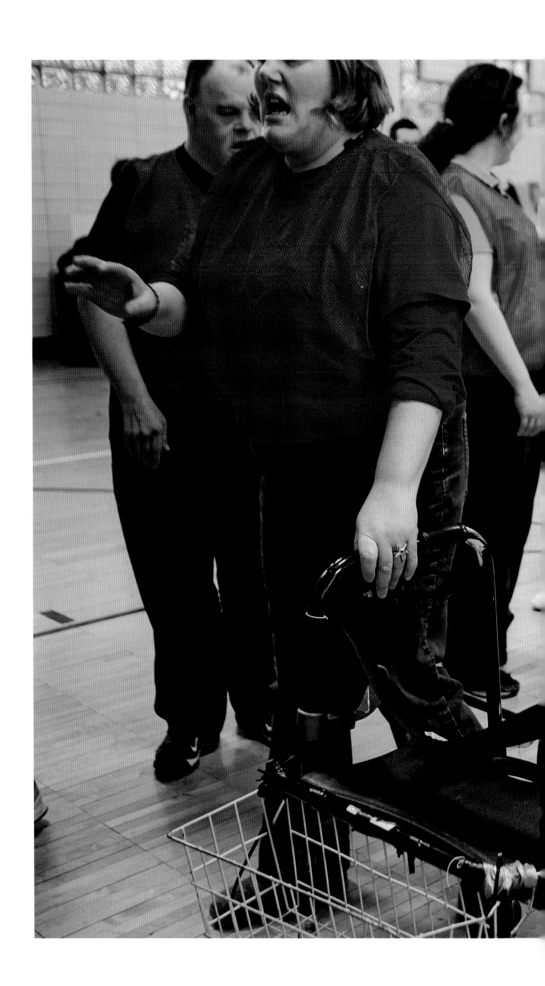

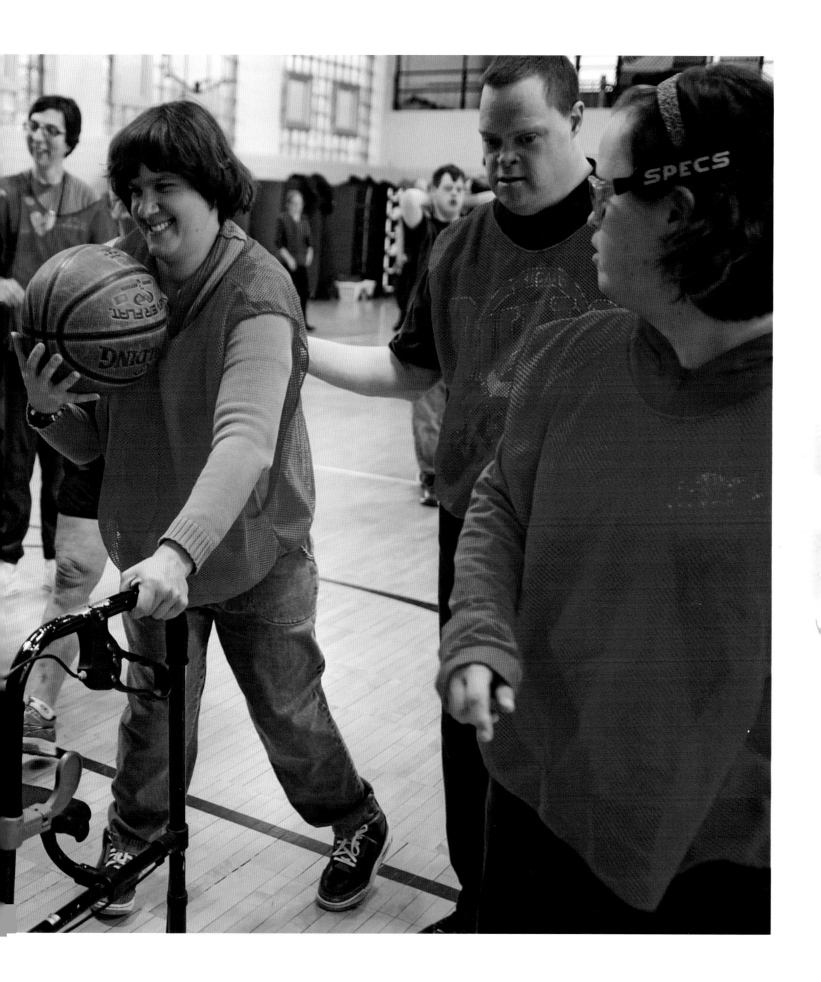

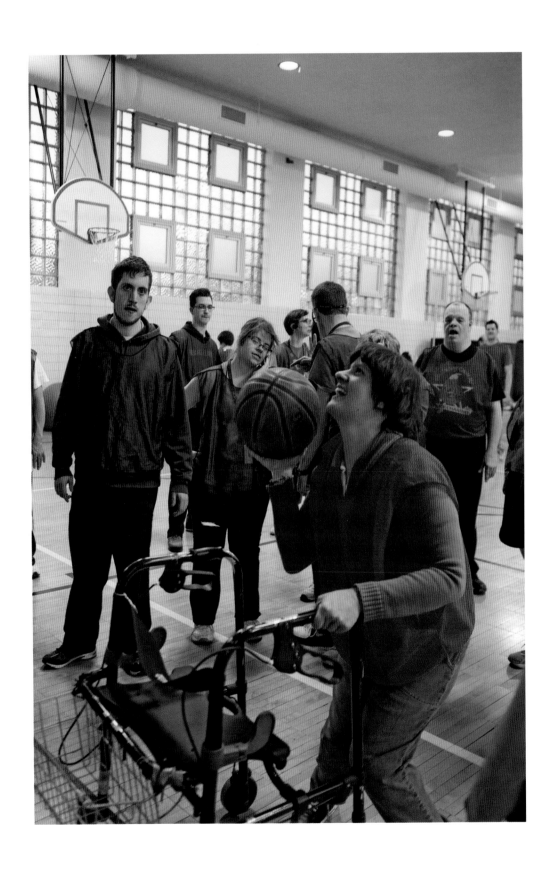

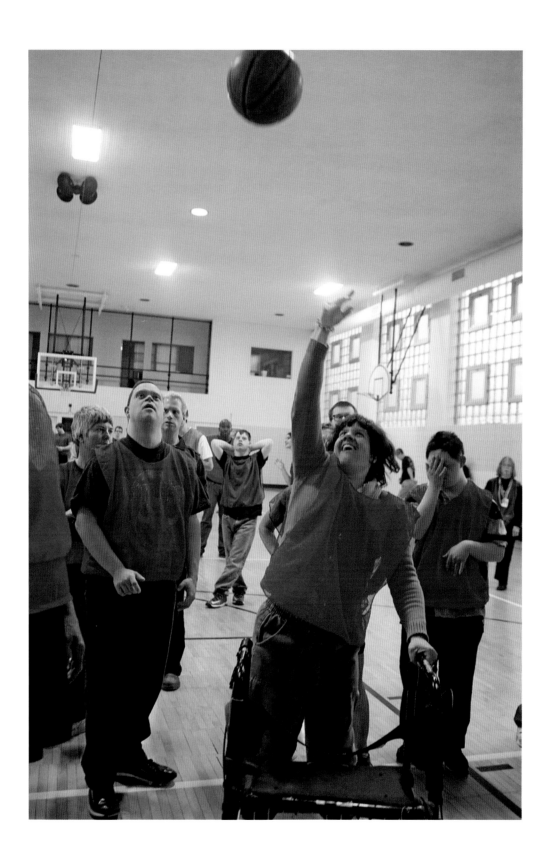

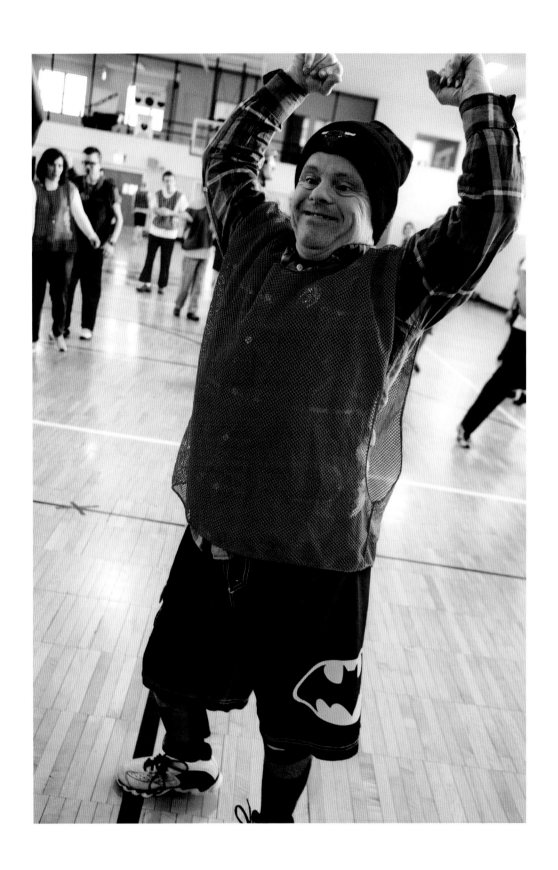

Somewhere you've got to come to a point in life where you can get your priorities in line and say what's important and what isn't. And Misericordia is important to me.

Mike Ditka
Chicago Bears Head Coach 1982-1992,
Pro Football Hall of Fame 1988

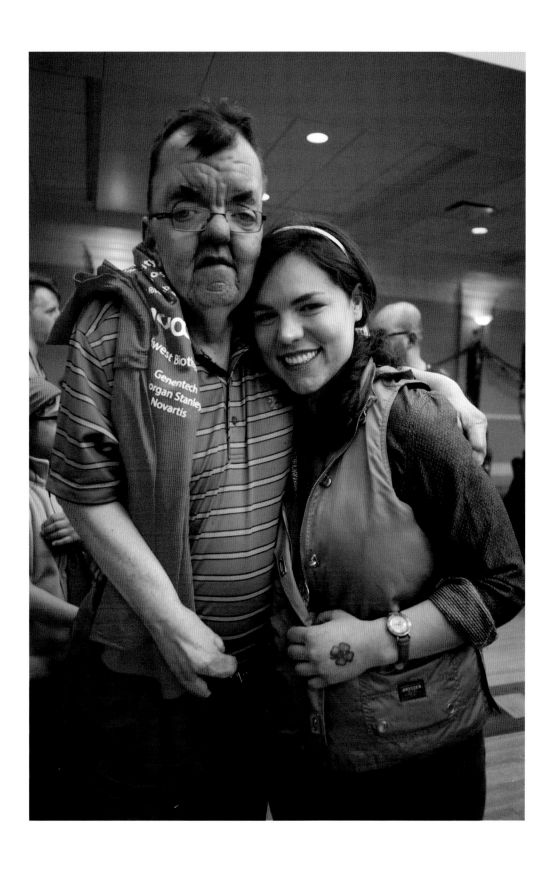

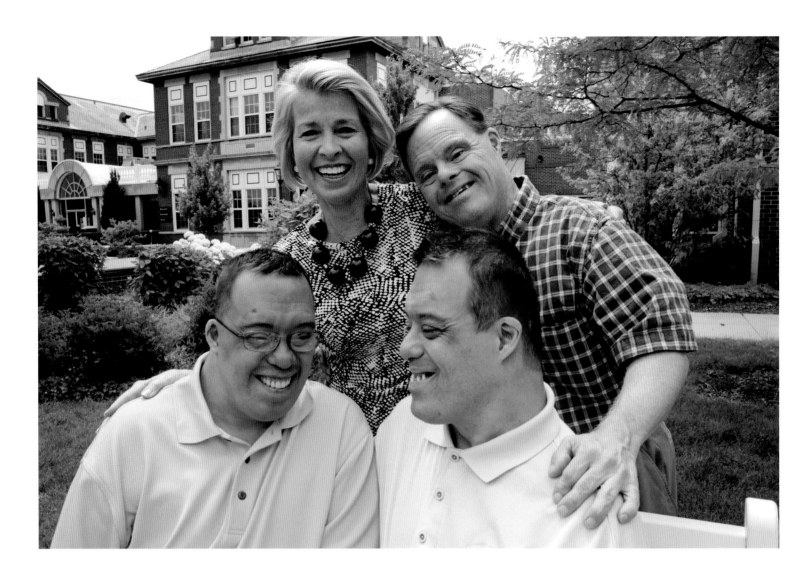

From its inception in 1921, Misericordia has been a place of "mercy," a place of compassion, a place of hope. The ever-changing services have touched and healed the bodies, souls, and minds of God's most vulnerable people. When Sister Rosemary Connelly was appointed Administrator in 1969, she found 132 children and infants with intellectual and developmental disabilities all under the age of six. They spent most of their day in bed and had no programs available.

And so the journey began. Sister Rosemary and her dedicated young staff set out to enrich the lives of the children entrusted to their care. This dynamic team has, since the beginning, aspired to instill in the residents that compassion is what makes Misericordia such a loving and nurturing place. The residents of Misericordia also have much to teach, through their innocence, humor, and faith.

Today, Misericordia provides a continuum of care for over 600 children and adults. Each person is viewed as unique with special gifts and talents. The possibilities are endless. Each day is a challenge, as work opportunities and recreational programs allow residents to live fulfilling lives. I lovingly remember my own dear brother, Fred, who fully enjoyed life at Misericordia for eighteen years; without a doubt, the best years of his life here on earth.

After many years of service I have learned much and still have more to learn. I am as passionate about my life's journey at Misericordia as the day I first met Sister Rosemary in 1970. She changed my life forever and continues to inspire me. With profound gratitude, we thank Sister Rosemary for her unwavering devotion that continues to make the world a better place for all of us.

Lois Gates
Misericordia Heart of Mercy
Assistant Executive Director

As a parent of a Misericordia resident for the past 29 years, words cannot do justice how much I value the day when our youngest and most vulnerable child came to reside at Misericordia Home. Each day has been one filled with meaning and love from Jenny's caregivers to Sr. Rosemary, who has fulfilled the promise she made to us in 1987. Each parent comes to Misericordia with hopes and dreams for the long term. When we were told about the parental expectations which Misericordia has for its parents, I accepted the challenge as a sacred pledge. Now looking back, I am content knowing that Jenny will be safe and loved long after I am gone.

Gerald Turry
Misericordia Parent,
Village President,
Lincolnwood, Illinois

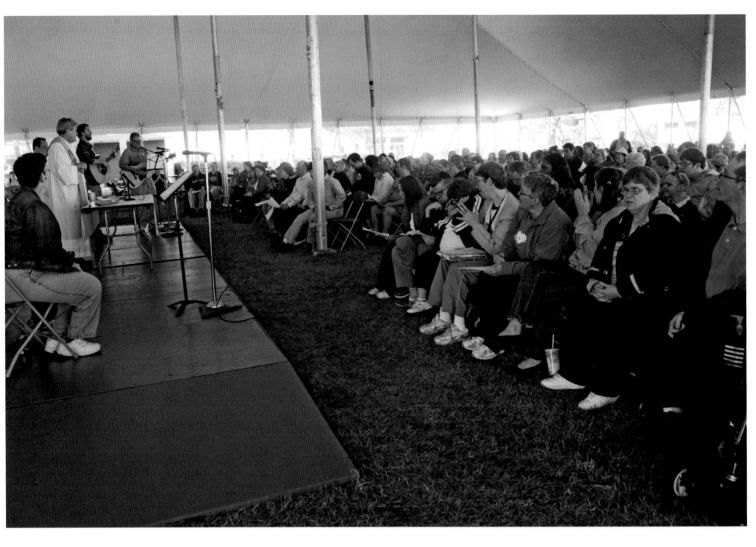

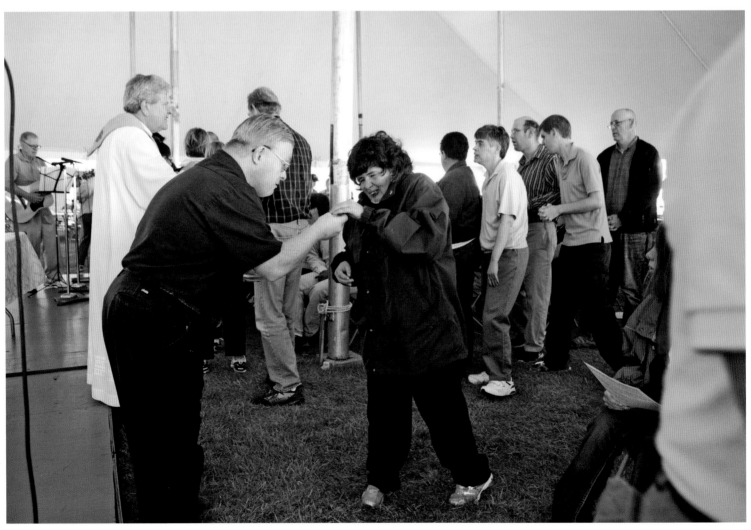

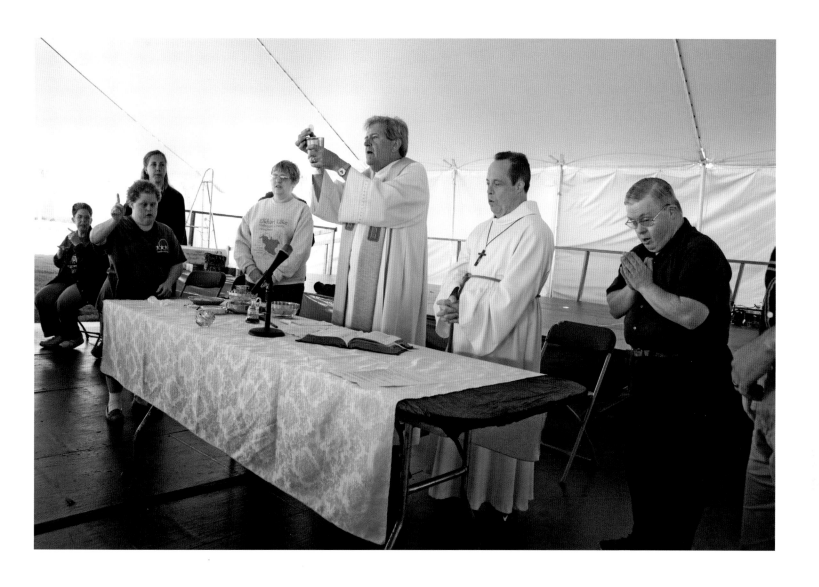

Each day at Misericordia is a gift!

Misericordia is a gift to all of us who are part of the Misericordia Family. For our residents it truly is the gift of meaningful lives. They are gifted with love, compassion, structure, and beauty. The staff is a gift to us all. Their work, or rather their ministry, makes our residents' lives so rich, so full, and so safe. I also marvel every day at the gifts of our supporters and volunteers. How wonderful that God has led them all to us. Misericordia has been a real gift to my priesthood. Here I have encountered the Lord in new and beautiful ways. My ministry gives me such joy. Finally, the gift of gratitude fills my heart. Each day we gather to thank the Lord for all who make Misericordia the community that it is. We are so grateful to so many people, but most grateful to the Lord.

Fr. Jack Clair
Misericordia Heart of Mercy
Associate Executive Director

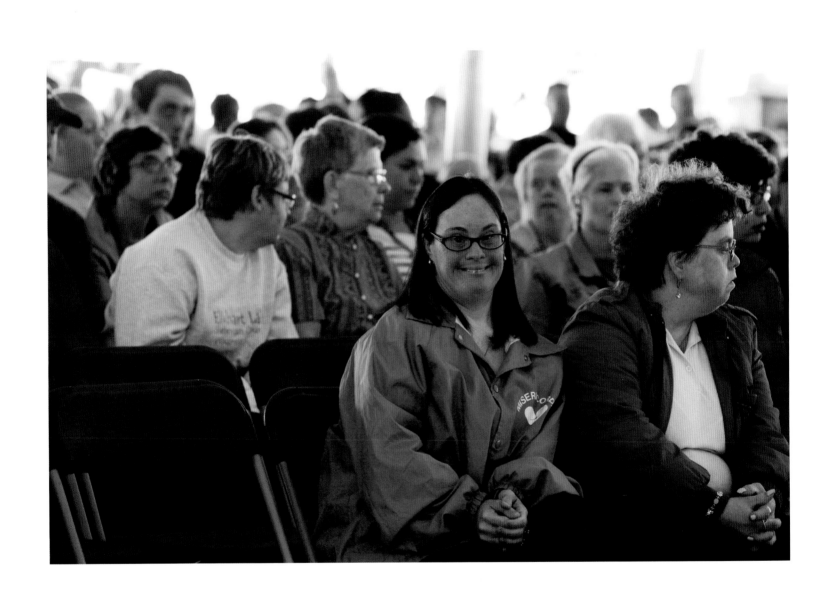

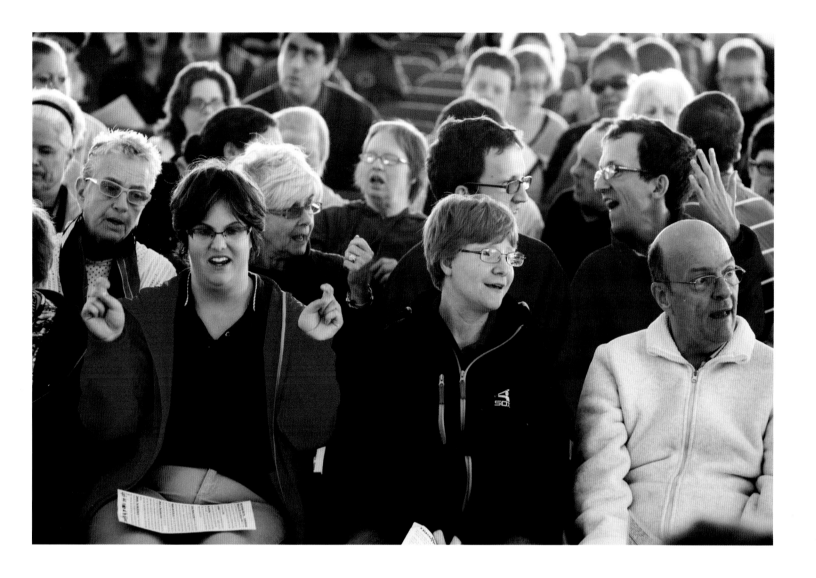

Mark has always been surrounded by the joy, adventures, and love of family, but his life expanded exponentially when he moved to Misericordia as an adult. At Misericordia, Mark has developed deep and real friendships in a community of love that is a beautiful complement to our family. Thanks to Misericordia, Mark has become his own person. He has discovered he has musical and artistic talents that far surpass what any of us could accomplish, and in which he takes quiet but justifiable pride. Misericordia gives Mark the opportunity to mentor and to be of service to others; to interact with people of all backgrounds and abilities; to set and achieve goals; to experience faith and blessings; and to live a life of purpose and joy. Misericordia has nurtured Mark's beautiful heart, and we are forever grateful to be the beneficiaries of that tremendous gift.

Bill Dempsey, Bob Dempsey, Mary Dempsey,
and **Sheila Dempsey Ryden**
Misericordia Siblings

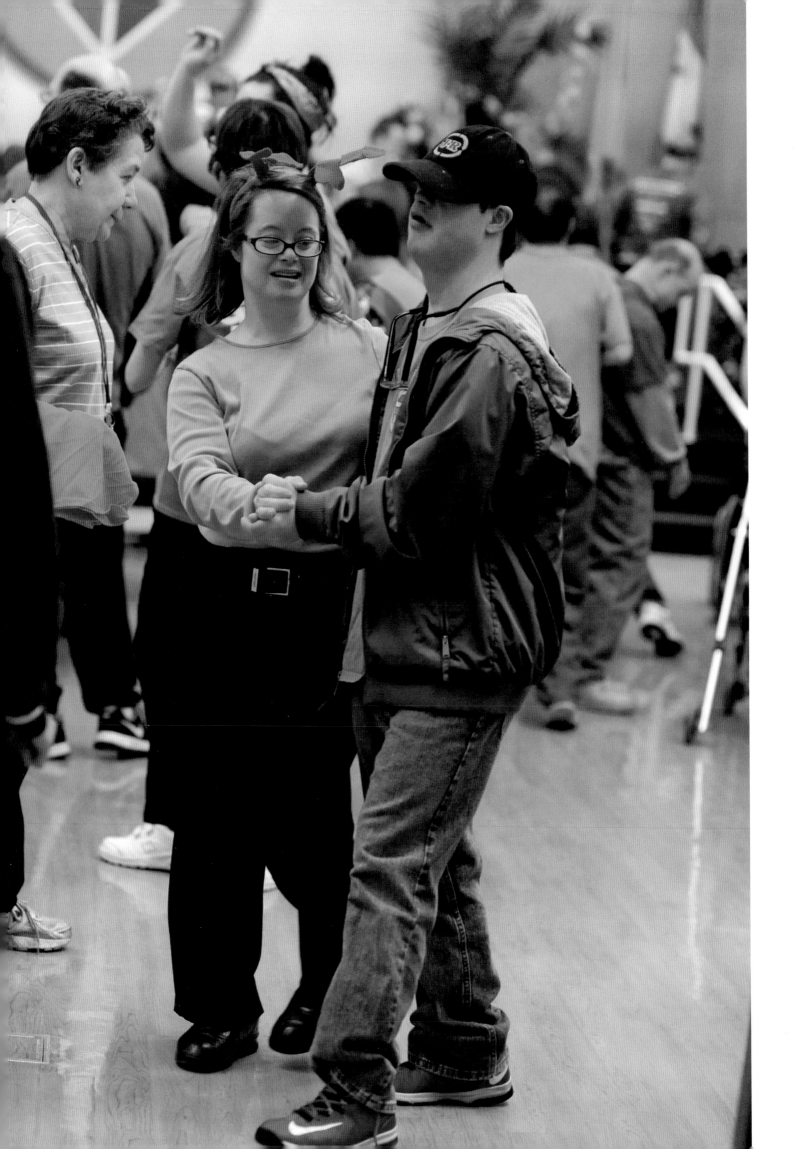

Parties

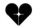

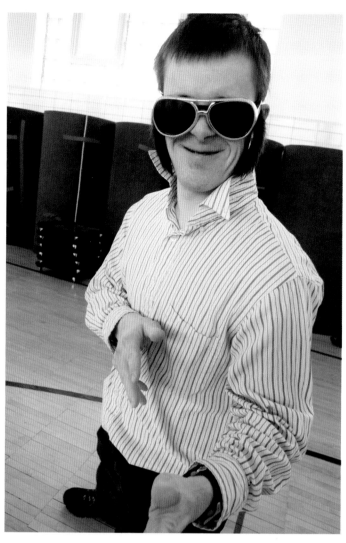
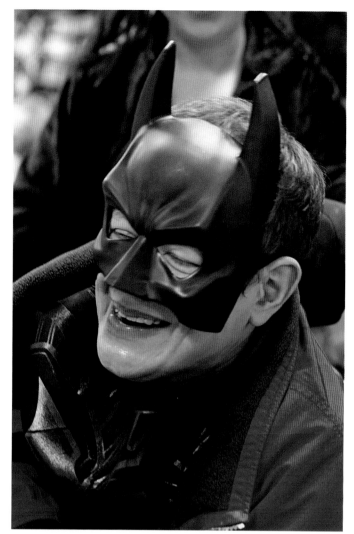
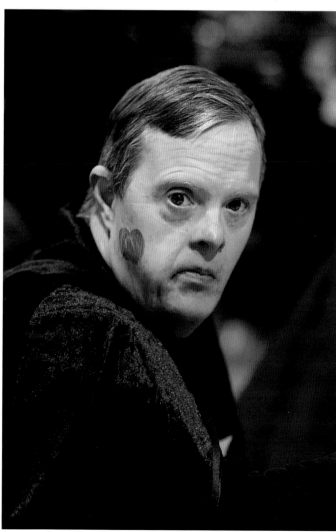
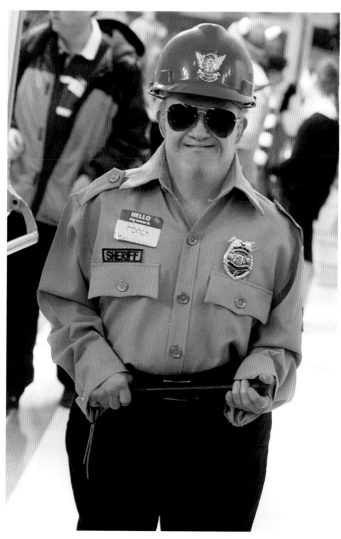

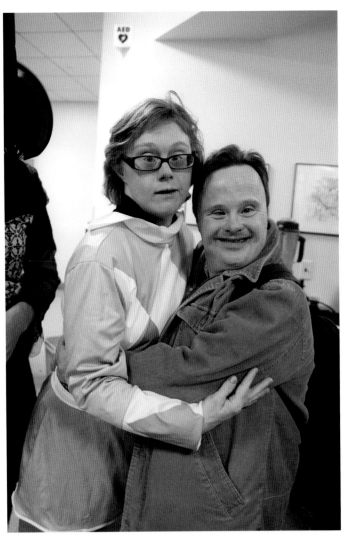
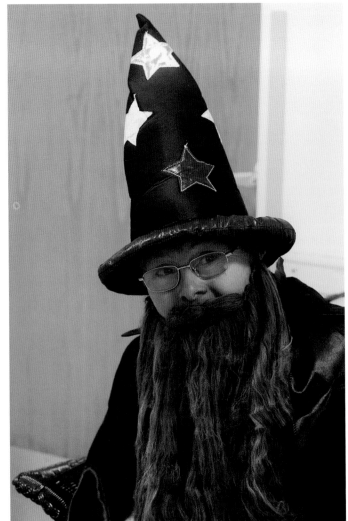
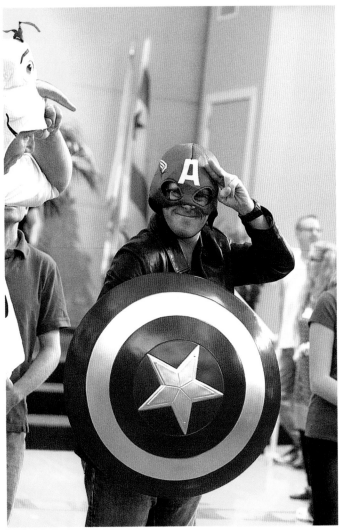
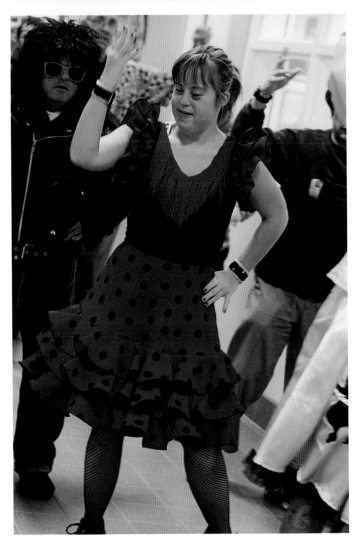

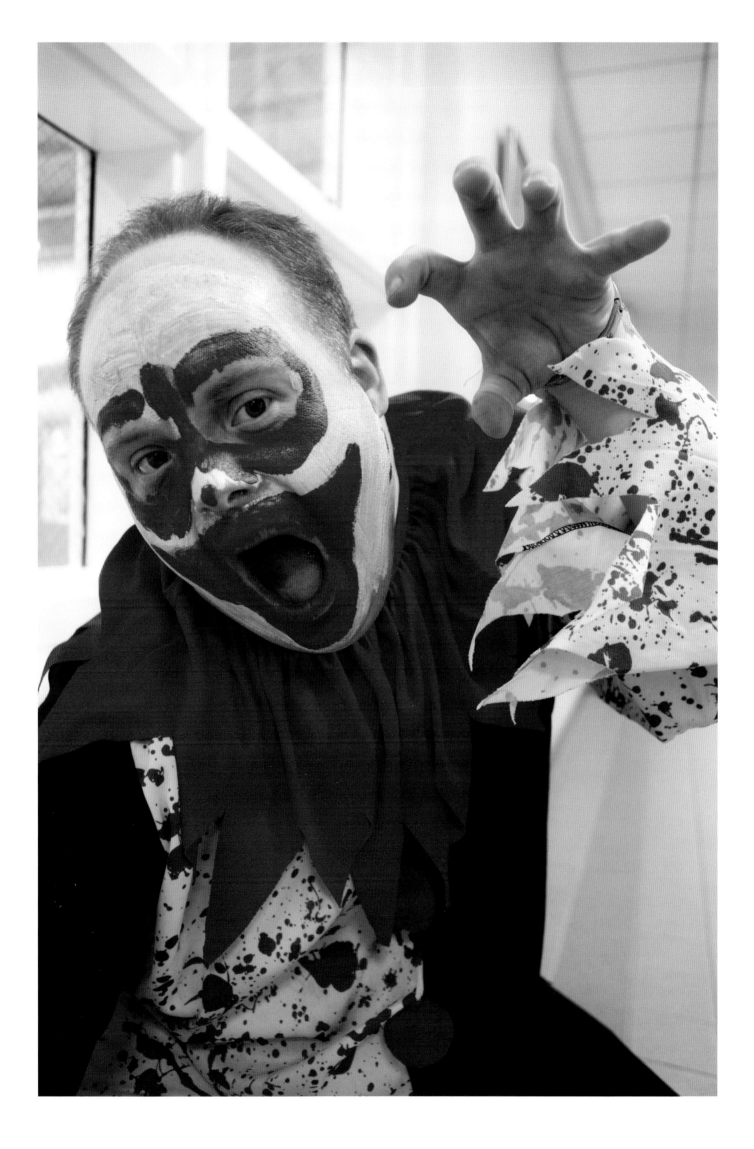

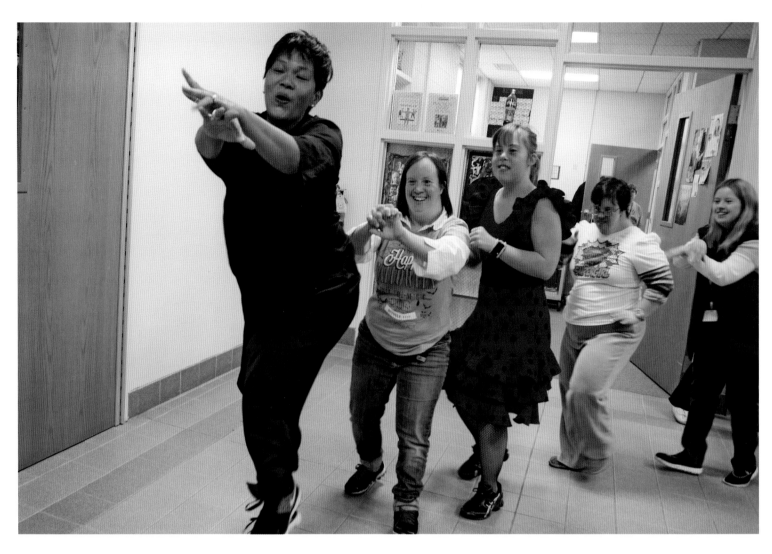
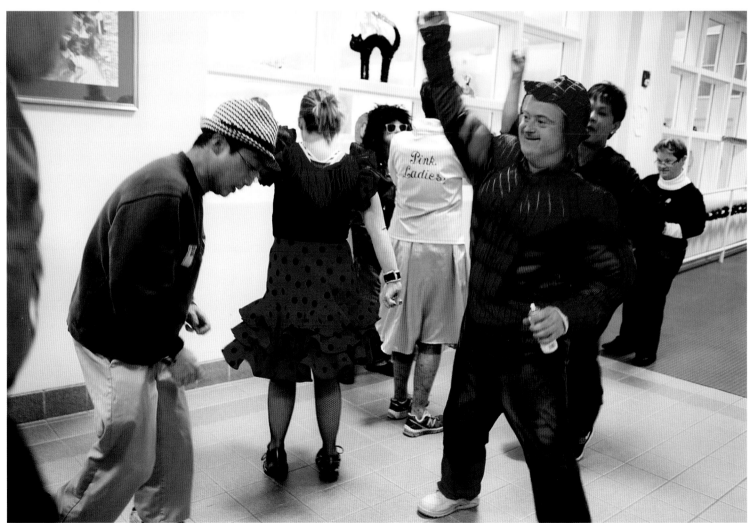

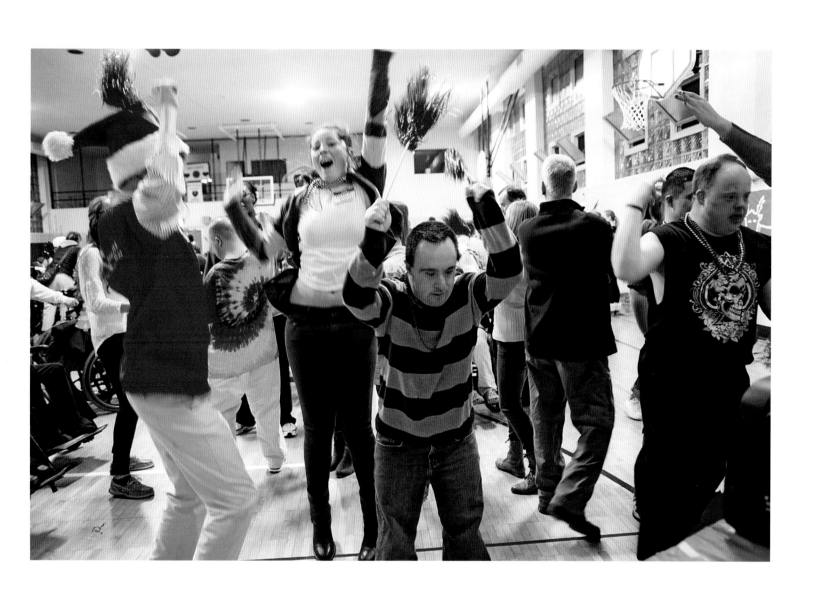

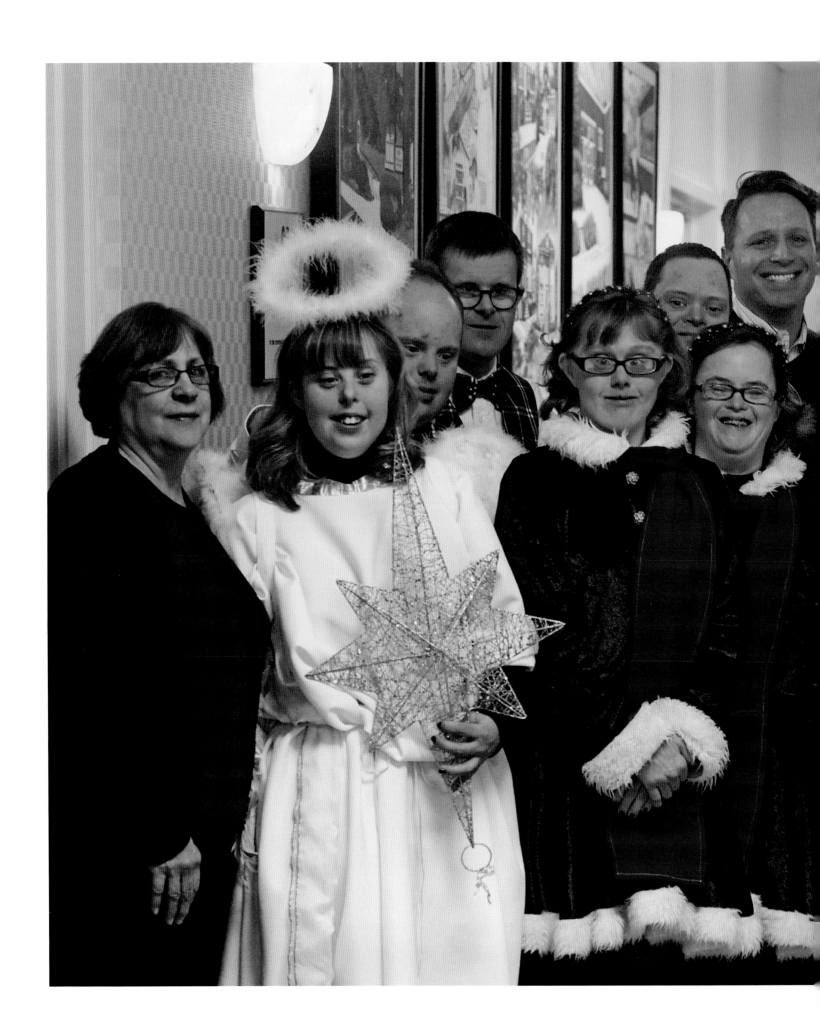

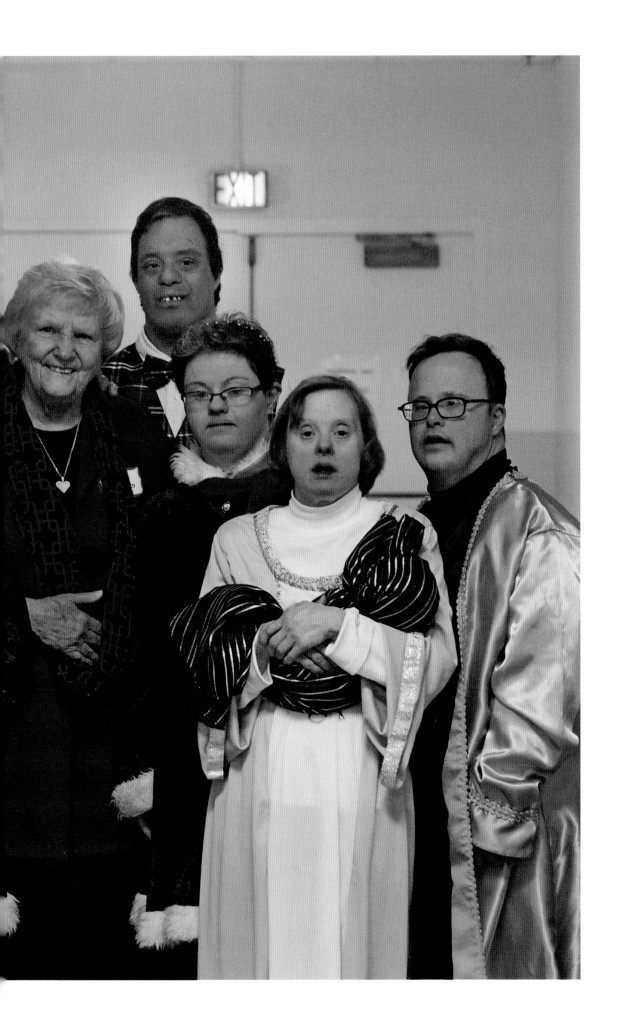

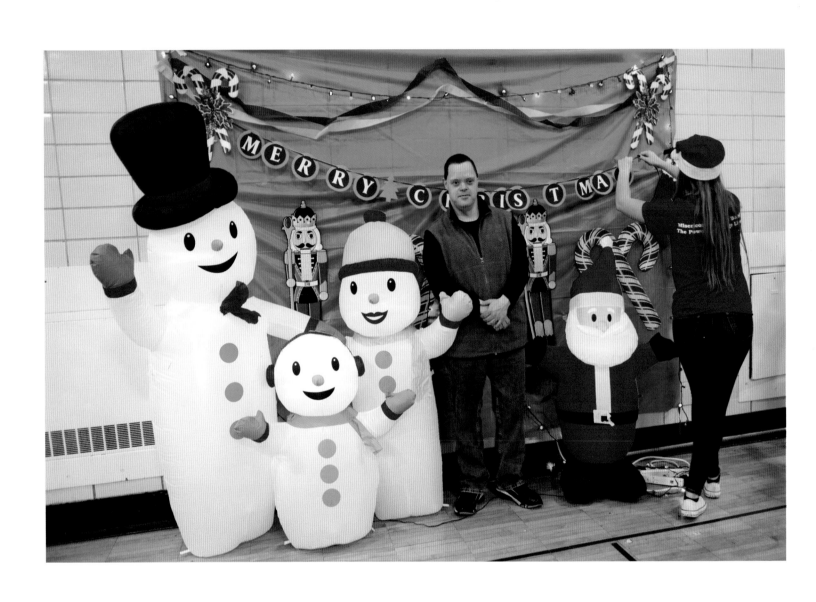

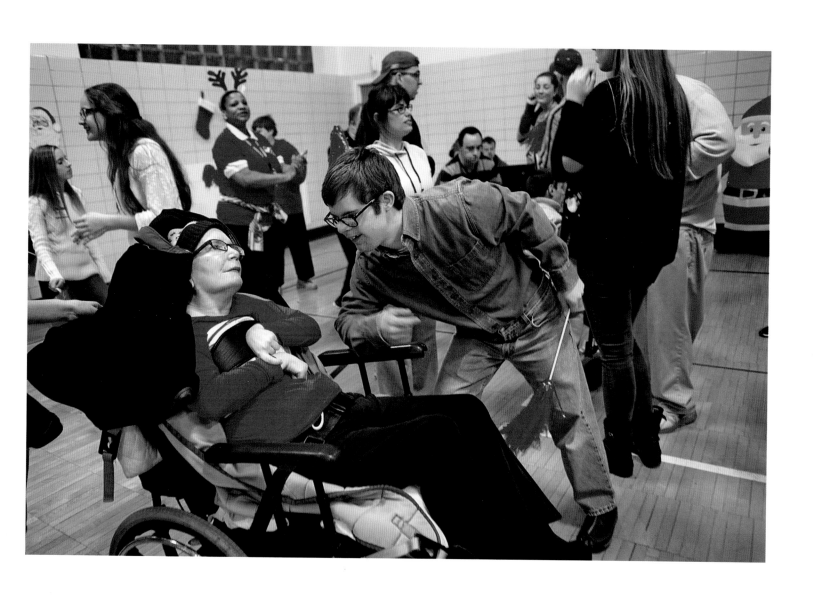

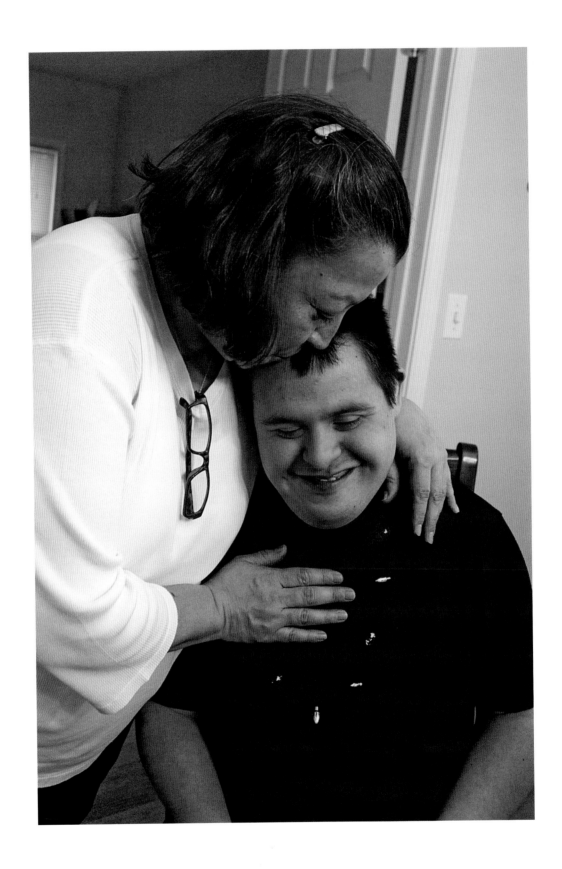

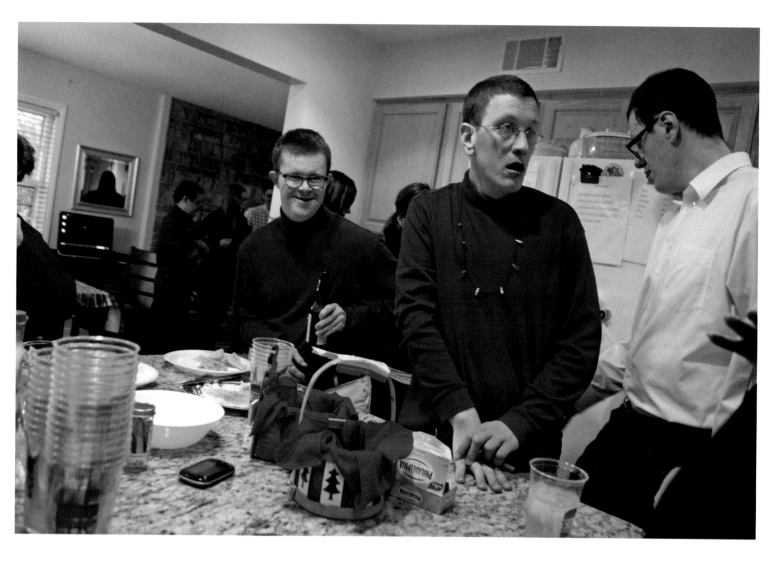

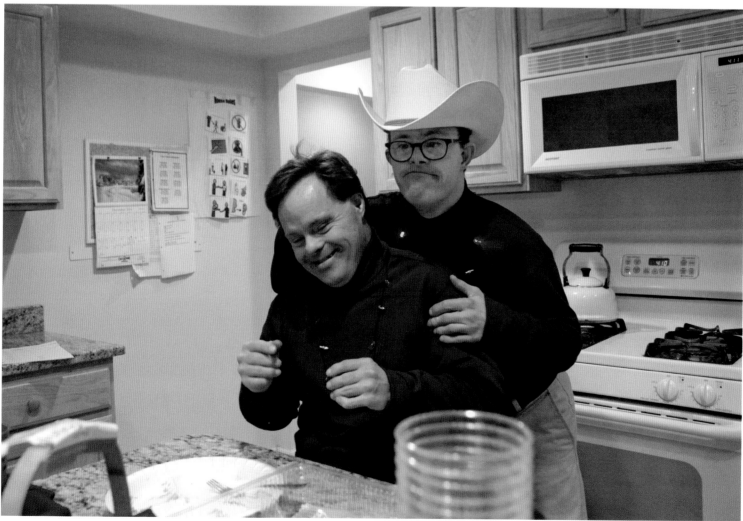

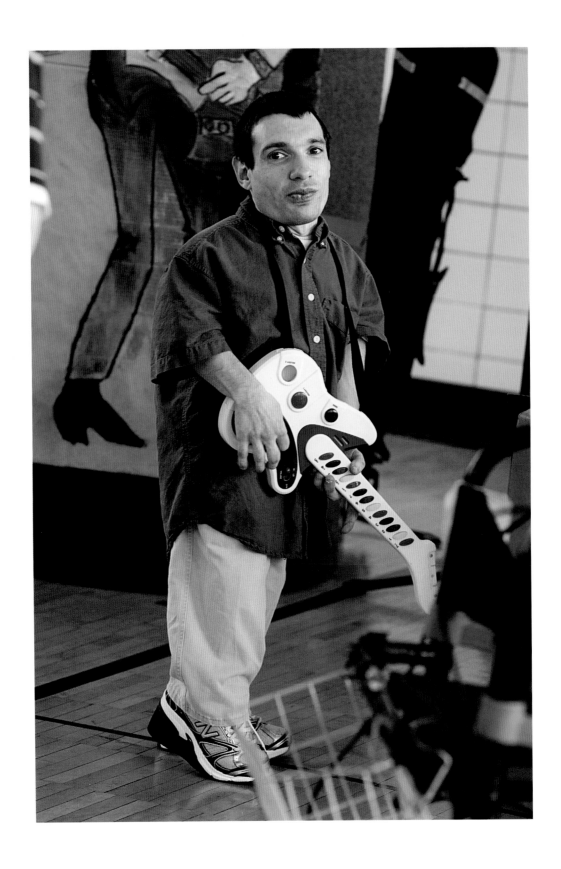

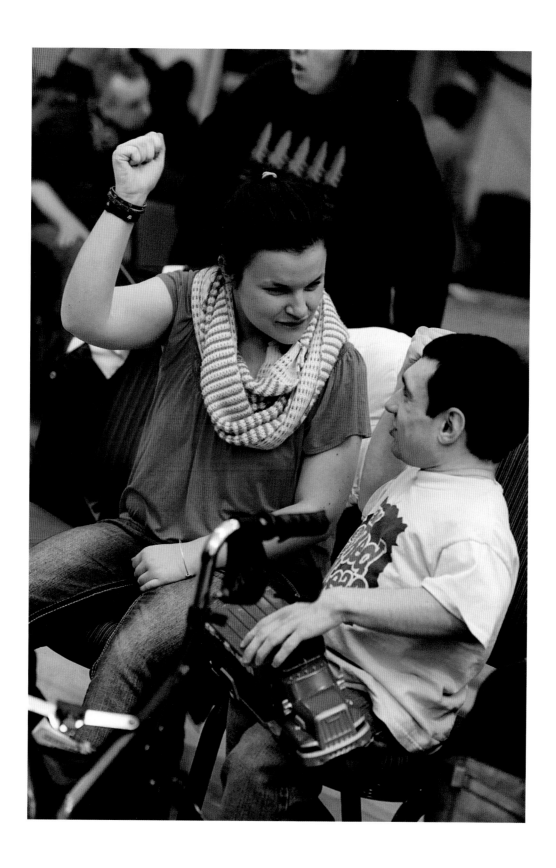

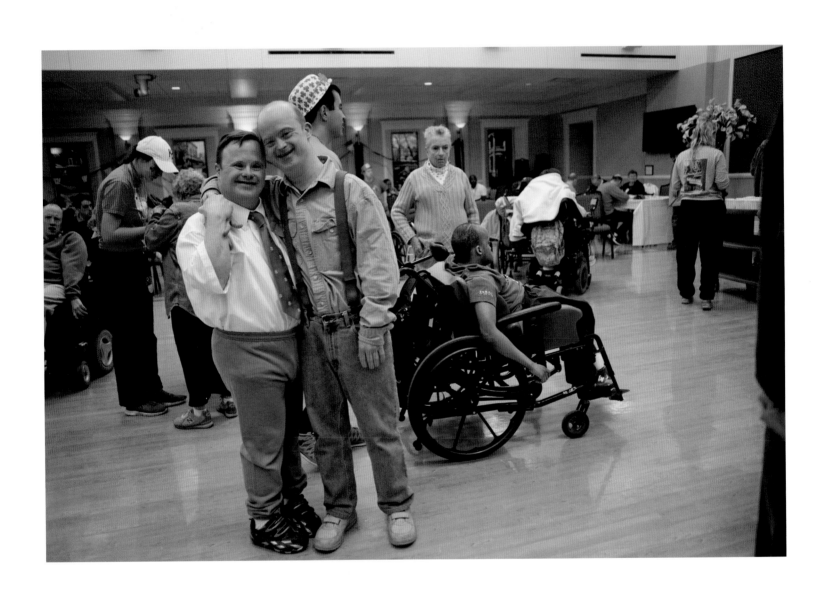

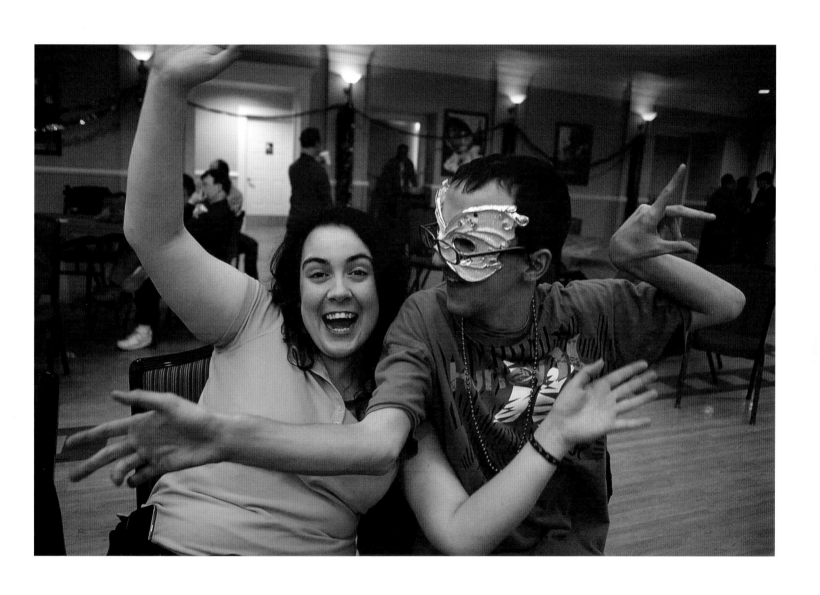

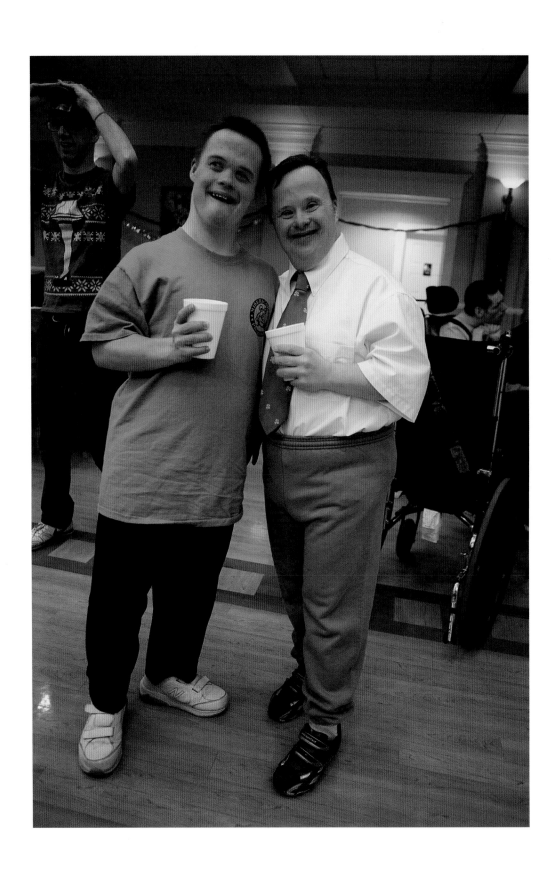

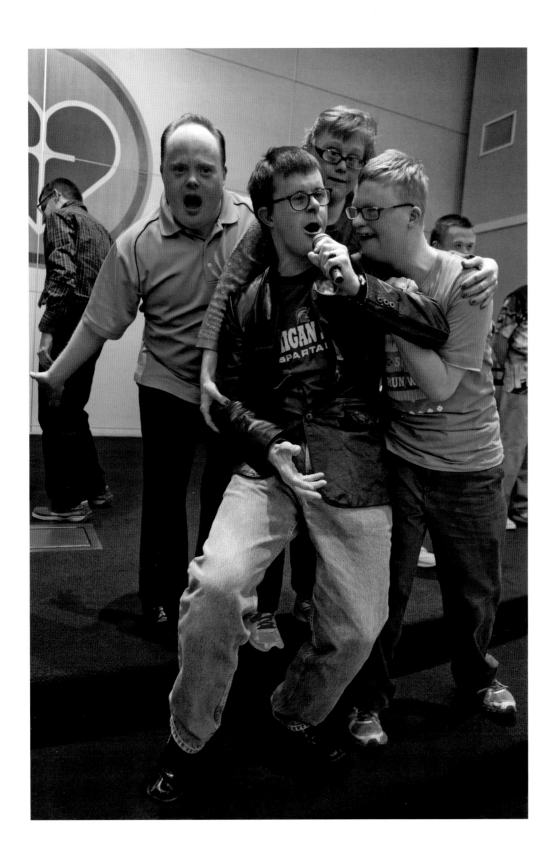

Here is a place that has blossomed into a connected community of care for over 600 individuals. It is also a place that is constantly evolving because that is what is needed. There is something special about Misericordia. It is the love and respect that all involved have for those being served. As Sister says, "It is God's work," and my wife and I are just two additional people trying to help.

Lou Manfredini
"Mr. Fix-It," WGN Radio

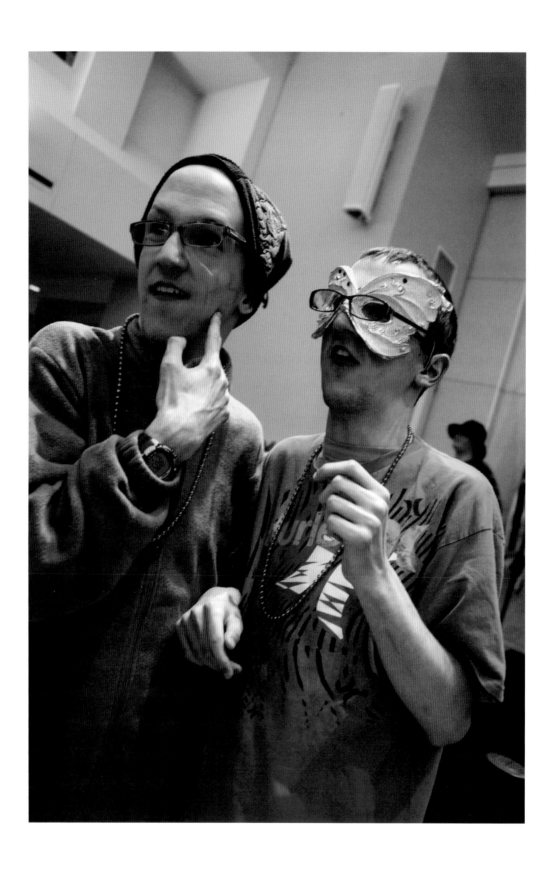

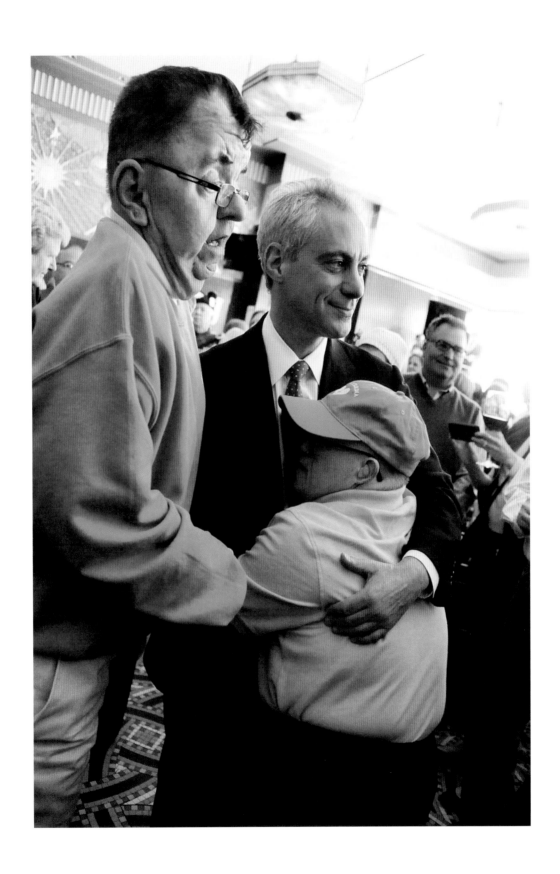

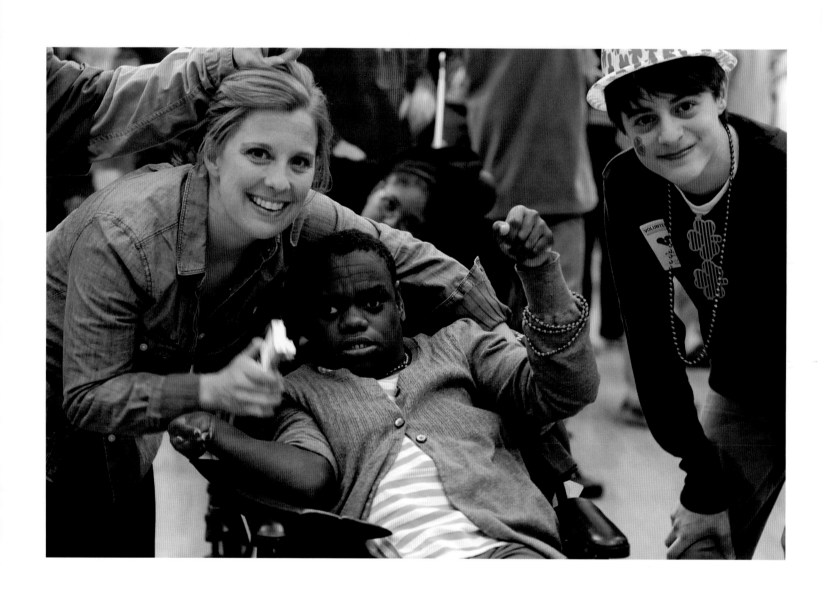

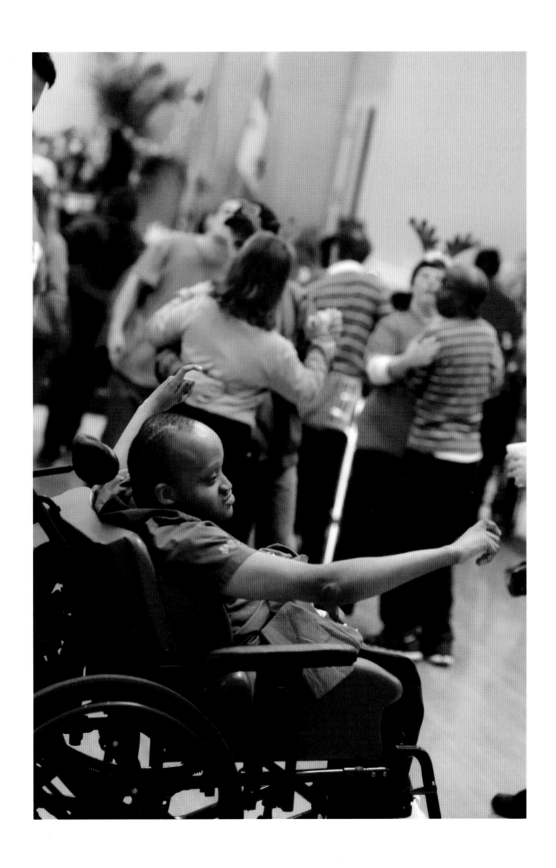

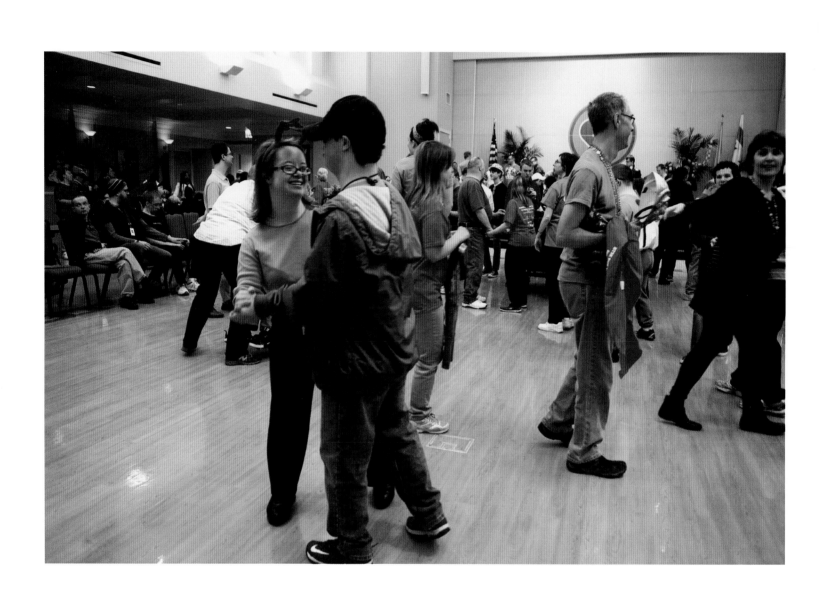

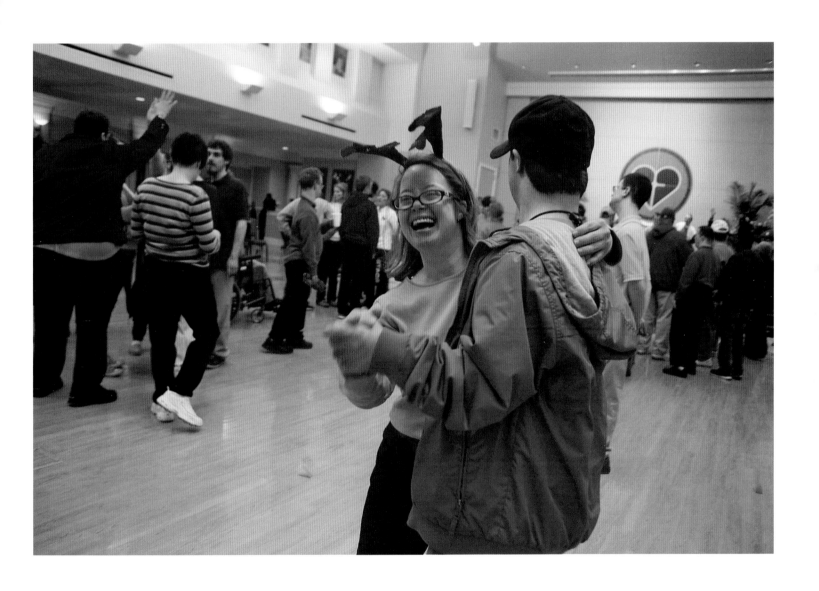

MISERICORDIA
Together We Celebrate

Photographs © 2016 Steve Schapiro

Introduction © 2016 Sr. Rosemary Connelly, RSM

Published in the United States by powerHouse Books,
a division of powerHouse Cultural Entertainment, Inc.
37 Main Street, Brooklyn, NY 11201-1021
telephone 212.604.9074, fax 212.366.5247
e-mail: info@powerHouseBooks.com
website: www.powerHouseBooks.com

First edition, 2016

Library of Congress Control Number: 2016950509

Hardcover ISBN 978-1-57687-817-0

Printing and binding by Midas Printing, Inc., China

Book design by Krzysztof Poluchowicz

10 9 8 7 6 5 4 3 2 1

Printed and bound in China

Acknowledgments

Thank you to Eileen Quinn who kindly introduced us to
Misericordia Home and Sister Rosemary Connelly.
Thank you to Julie O'Sullivan who accompanied us on our
photo journey and to Lois Gates, and my wife Maura Smith.

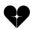